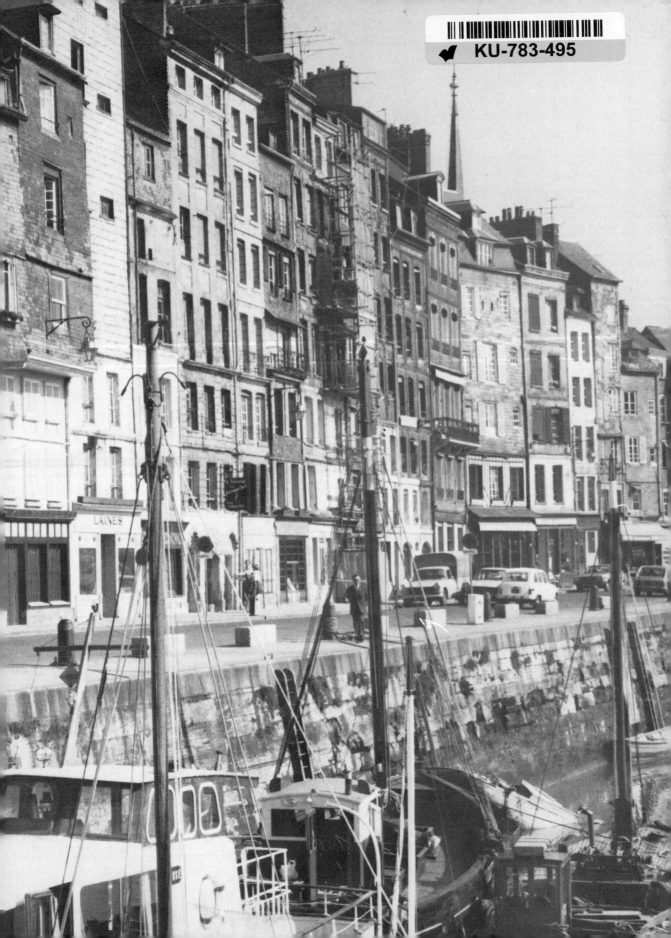

Creative Techniques in Travel Photography

To Mother Dorothea, my first teacher.

In gratitude and with affection.

John Douglas

1st December 1982

OLD FIDELIS BOY.

Creative Techniques in Travel Photography

John Douglas

B T BATSFORD LTD, LONDON

This book is dedicated to two very courageous young girls: Sarah Jane and Mary Douglas

First published 1982

© John Douglas 1982

ISBN 0 7134 3905 X

Photoset in 'Monotype' Photina by
Keyspools Ltd, Golborne, Lancs

Printed and bound in Great Britain
at The Pitman Press, Bath

for the publishers B T Batsford Ltd,
4 Fitzhardinge Street, London W1H 0AH

Contents

Acknowledgments

My travels and photography have been aided by countless individuals and by many public and private institutions. I gratefully acknowledge their help. Assistants, fellow expedition members, guides, interpreters, baggage carriers – I thank you. I must also thank those who, knowingly or unknowingly, have been subjects in my photography, those who have given patient assistance and encouragement during the preparation of this book and, especially, those associated with the Geoslides Photographic Library.

All the photographs in this book were taken by me with the exception of those on the following pages: 74–5, 90–91, 102–3 and 143, by Peter Corrigan/Geoslides; 15, 105 bottom, by Nicholas Nugent/Geoslides; 65, 101 and 122–3, by Ronald Watts/Geoslides. Those on pages 10, 19 and 24 are from my family's archives (by permission).

It should be noted that most of the photographs reproduced in monochrome are from colour transparencies, the medium in which I usually work. The quality of such photographs, especially in tone, should be judged with this in mind.

John Douglas,
London, 1982

Introduction

There was a time when the traveller, returning home, brought with him his memories, his diaries and his sketch books. On these he relied for his traveller's tales. Today the memories will be just as vivid or hazy but the diaries and sketch books will have been almost entirely replaced, or at least substantially reinforced, by the film record.

Stand for a few minutes and watch the world go by at any international airport. What distinguishes the traveller from the well-wisher seeing him on his way? It is not the suitcase or that look of apprehension, but the camera. Everyone, or so it seems, who travels today carries a camera. For some it will be an inexpensive model with a couple of spare rolls of film. The enthusiastic, affluent amateur may be festooned with equipment like an overdressed Christmas tree. For the serious traveller and the expedition photographer, the camera and its accessories will be the most important equipment he carries. It is primarily for this latter category of traveller-photographer that this book is written.

Travel or expedition photography is like no other and every other photography. It is portraiture, it is landscape photography, it is record photography, it is wildlife and nature photography. And it is something different. The difference lies in the context in which the photography is carried out. The subject and surroundings are alien and possibly present unfamiliar difficulties. The photographer is away from his base and from the support he may usually expect from his studio or his technician or his dealer. Travel means movement and shortage of time will be his constant companion. More often than not, the travel photographer will be seeing his subjects not only for the first time but also for the last. An opportunity missed will probably be an opportunity lost for ever.

In the 1950s and 1960s, with low fuel costs, the travel industry expanded as never before. The rising cost of oil in the last decade has not so much put a brake on travel as make it relatively more expensive. Certainly, frontiers have been pushed back as new areas have fallen to the traveller's insatiable appetite for the unusual and interesting. Remote locations and high costs combine to make it all the more important for the traveller-photographer to return with a satisfactory film record. For the expedition photographer or professional travel photographer, the need to sell his work, to meet some of the expedition costs or to provide a livelihood, makes a successful collection of photographs the prime aim of his travel. Perhaps it is just that, the priority of photography, that identifies the true travel photographer. He travels in order to practise his art whereas the tourist with a camera collects his photographs with the same casual interest as he does the rest of his souvenirs.

All the same, who takes photographs of his travels and does not want to show them to his friends? And who wants to exhibit his disasters? Whether the traveller returns with a score or so of prints or a couple of thousand colour transparencies, there is no reason to be disappointed by failure. The quality of today's equipment and film usually prevents the workman justifiably blaming his tools. More likely failure comes from the lack of preparation, a misunderstanding of the equipment (especially its limitations), an inadequate appreciation of the environmental (physical and social) problems of the working locale, or an insensitivity to the opportunities that are offered on location.

Travel photography is not easy. It is physically hard work. I hardly ever travel abroad without my cameras. When I do, I feel guilty, like a schoolboy playing truant. True, it is more relaxing, but in next to no time I am regretting my indiscretion. The trouble is, I suppose, that I have learnt to look at life as though through a viewfinder. I find myself seeing in photographic images and gauging the picture potential of what I see. Maybe it is not the most restful way to travel but, if you are serious about your art, then perhaps it is a necessary state of mind.

Quite apart from scientific expeditions, today's serious traveller is loathe to recognise bounds. You

do not have to be a polar explorer to travel to Greenland or even to Antarctica. Nepal and the Himalayas are known to thousands of visitors who have some difficulty in climbing a flight of stairs. China, more recently, has joined the rest of Asia in opening her doors, albeit with some irritating restrictions for the photographer. The cold and the hot, the humid and the arid, the subterranean and the sub-aqua, all manner of exotic environments are considered fair game by the travel photographer.

This presents photographic problems not always fully appreciated by even the most seasoned traveller. Techniques appropriate and successful in New York or Newcastle may be totally inapt in north Borneo or Narssarssuaq. So-called equipment failure can often be more accurately attributed to an inadequate knowledge of the environmental hazards. If one's photography for most of the year is in, say, the cool temperate zone, then there are probably no problems with the storage of exposed or unexposed film. Similarly, if we work for the most part in one climatic zone we tend to develop an instinctive appreciation of the natural light qualities. Move, for example, to the humid tropics and all manner of difficulties will be encountered with film and with light. Even the changing length of daylight, such as in the long polar summer days, or the rapid onset of sunrise and sunset at the equator, must enter one's calculations. The environment must affect, and even dictate, the equipment to be used, its preparation and its care.

The camera is accepted as a commonplace object in most of the world, but not everywhere. Suspicion of the camera may be political or social or religious. Point a lens in the wrong direction and invite arrest or attack. Use a camera in one place and be surrounded by everyone nearby. Bring out a camera in another place and everyone will scatter. A lack of familiarity with local opinion or customs or regulations can cause more problems for the travel photographer than all the technical difficulties he might encounter.

No single book can hope to cover all the circumstances which the travel photographer is likely to come across but I hope that in the following pages there will be something that will prevent that disaster of disasters – the expensive, perhaps hazardous, journey from which the traveller-photographer returns only to find that his film record falls far short of his hopes and expectations.

1 Equipment

A variety of criteria will decide the travel photographer's choice of equipment but the most important are likely to be cost, weight, size, the photographic objectives and the locations to be visited.

It can be assumed that the photographer already owns a selection of equipment before embarking on his travels. This being so, the main consideration will be what complementary items will be required for the particular travel assignment he has in mind. It is important to remember at this stage that, as with all the traveller's impedimenta, the less that has to be carried the easier will be the journey. It is largely a matter of deciding what is really necessary and not confusing this with what will be a much longer list of desirable items.

If some purchases are to be made they should complement existing equipment as far as possible. There is little point in purchasing an additional camera body if it is incompatible with the lens system in use on cameras already owned. Interchangeability is especially important if the cost is to be kept in check and the total load of equipment reduced to a minimum. It is true that in some circumstances a twin-lens reflex camera may prove more useful than a single-lens reflex, or a large-format camera may be superior to a 35mm camera if the sale of photographs is a vital consideration. But mixing camera types will add substantially to both the cost and the weight of equipment.

It is not uncommon, however, for the traveller intent upon photography to add at least some items to his system before he sets sail. Should this be the case, costs can be reduced dramatically by buying secondhand items. Secondhand purchases, however, pose two special problems. First there is a greater likelihood than with new equipment that some failure may occur with any moving parts. It is particularly necessary, therefore, to make purchases well in advance of departure in order that adequate trials can be made.

Second, there is the problem of satisfying Customs on returning home that you did not make the purchases abroad. It is essential to obtain adequate evidence of purchase including a statement that any duty due has been paid. This presents little problem if a reputable dealer is used but there are real dangers in a private transaction. There is little to be gained in negotiating a bargain price only to be charged duty on your return home.

If new equipment is purchased it is usually possible to ensure that one is not being overcharged by making careful scrutiny of the photographic press. Some retailers claim never to be under-sold on any item. Most of these claims are quite genuine and the larger retail outlets, by their greater turnover, can afford to be generous with discounts.

Unless the travel photographer is an established professional, it will be difficult to persuade manufacturers or their agents to donate equipment. However, in the case of expeditions recognised by award-giving bodies such as the Royal Geographical Society or the National Geographic Society, equipment may be given or lent. If a manufacturer is launching a new camera or lens system, he may agree to give equipment in return for field trials and advertising concessions. As for film, if this is donated a tricky copyright problem can arise in the UK. Under the 1956 Copyright Act, and excepting commissioned work, copyright is vested in the film owner, not in the photographer. This point may need clarification with any donor of film.

It is most unwise to leave any purchases of equipment until one is actually abroad. There is a temptation to do this, especially when travelling to or through such places as Japan, Hong Kong or Singapore. It is worth remembering that prices for photographic equipment in the UK and the USA are not exorbitant and the savings effected by buying in the country of manufacture or in areas claiming to be a shopper's paradise are not large when duty is added on returning home. Further, there are the twin problems of lack of redress in the case of faulty goods and the impossibility of giving adequate trials to the equipment.

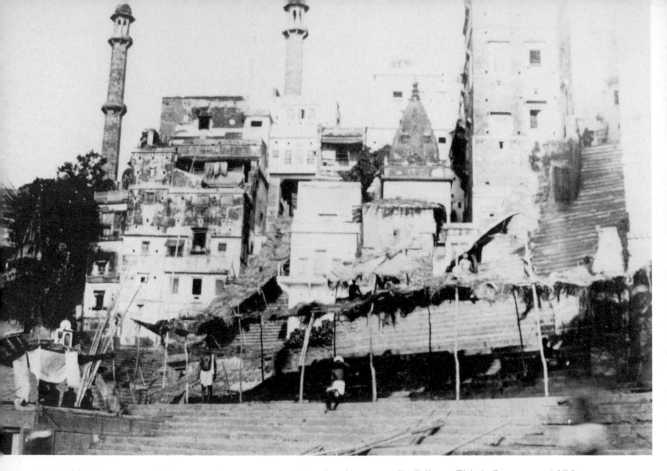

Much early travel photography concentrated on landscapes or buildings. This is Benares c. 1870.

In recent years, camera manufacturers have fought something of a battle over the size of bodies and lenses especially in the field of 35mm SLRs. To my mind, the body battle and its results have given little advantage to the photographer, even to the travel photographer. The difference in size between a fairly bulky and inexpensive camera like the Zenith series and, say, the Olympus OM, is undeniable. But the relative weights are not *necessarily* reflected in the size differences and, even when they are, a lightweight body or lens is not necessarily as robust as a heavier model. A very small camera may be difficult to handle with cold hands or when wearing gloves or mittens.

The body-size battle may have been a useful sales point for the manufacturers but reductions in the size, and especially in the length, of long focal length lenses has been of much greater value to the travel photographer. The shorter 200mm, and even 300mm, lenses now available for 35mm SLRs have been a boon to the photographer not wishing to carry awkward tripods.

Except in the very special case of travel which includes some mountain walking or climbing, the weight factor can be thought of as secondary in importance alongside such criteria as objectives and locations. With these more important considerations in mind it is possible to make some general statements about particular items of photographic equipment.

CAMERAS

The most popular camera for travel photography is undoubtedly the 35mm single-lens reflex. Its versatility is unmatched. Compact, lightweight and adaptable through the large range of lenses and accessories available for most models, it has become the standard camera for most expeditions and travellers. This is the basic body that can be recommended. As to make, that is another matter, but there is a wide range in terms of price and, by and large, one gets what one is prepared to pay for. In travel photography, an unfussy, easy to use camera is important. As in photo-journalism, the photographer may have to work very quickly. A quiet shutter is helpful in situations where it is

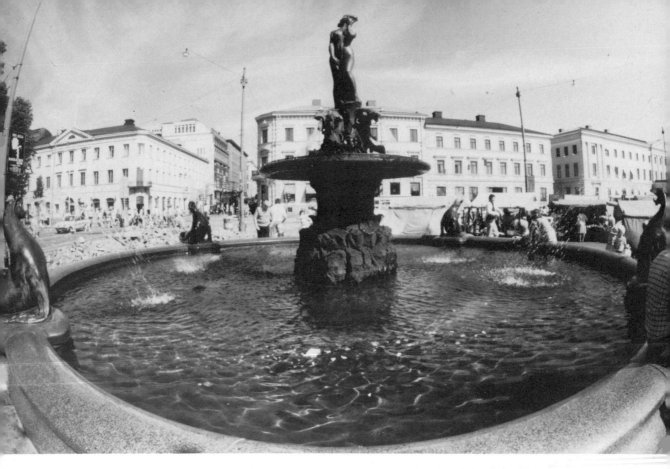

A fisheye lens can prove effective with selected subjects.

important not to attract attention. Unusual makes of camera should be avoided because problems might occur if you need repairs to be carried out, or you are looking for spares, when in a foreign country away from your dealer or agent.

At least two bodies, identical or, at least, accepting the same lenses, should be carried. Ideally, three bodies should be taken on long or difficult trips. Three bodies allow the photographer to load one with monochrome film and the other two with colour. This also obviates the potential problem of mechanical failure of one body and reduces the amount of lens changing that is needed. For my own colour work I use one body for standard and short focal length lenses and another for long focal length photography. Often there is little time to change lenses and there is nothing more infuriating than missing a shot while engaged in this task.

In addition to 35mm SLR cameras, three other camera types can prove useful although the help of an assistant or travelling companion may be needed to share the load. These are twin-lens reflex cameras, large format cameras and instant cameras such as the Polaroid. The first of these is especially useful for candid photography in sensitive situations (see Chapters 2 and 8). Large format cameras, preferably with interchangeable backs, are often expensive but can be necessary if the sale of photographs for the calendar market, for advertising or for travel posters is an objective. Instant cameras have a special place in photographing people, particularly in the Third World (see Chapter 8).

Most travel photographers, however, will rely largely or even exclusively on their 35mm SLRs and throughout this book this will be assumed except in those circumstances, which will be identified, where an alternative is to be preferred.

LENSES

For general travel photography, at least three lenses should be considered as a necessary minimum. Firstly, a standard lens (50mm or 55mm, for most 35mm SLRs), which gives natural perspective, can be looked upon as the lens giving a

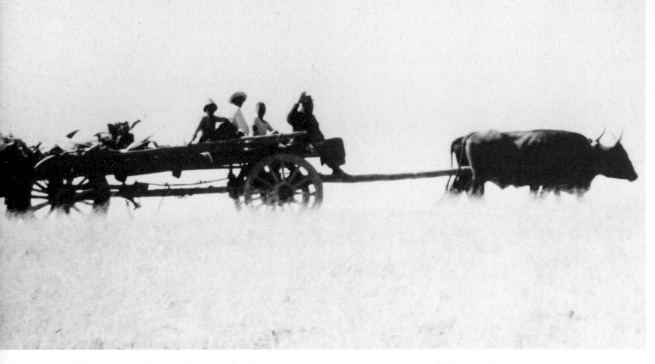

A friendly wave from a Transkei family as I photographed them using a 300mm telephoto lens.

picture closest to that seen by the human eye. Secondly, a wide-angle lens, say 28mm, which has particular value in confined spaces and is much beloved of press photographers. And finally, a long focal length lens, say 150mm or 200mm. Of course, if three camera bodies are being used it will be easier to employ a larger range of lenses. If I restrict myself to just three lenses I use a 28mm with a fairly large maximum aperture (f/2), a 50mm (f/1.2) and a zoom telephoto with a range of 80–200mm.

Using three cameras, I can add one further standard lens, an ultra wide-angle 20mm and a low-range zoom (35–70mm). For safari wildlife pictures it is desirable to include a 300mm lens in one's equipment. If photography of plant and insect life is an objective, then a 55mm macro lens should be carried rather than making use of lens attachments to achieve similar results.

The use of tele-converters and of mount adaptors is not recommended unless their selection is dictated by cost.

Such lenses as fisheye, semi-fisheye or long telephoto in the range of 400mm to 1000mm, will generally prove of little value to the travel photographer. The only justification for these sorts of lens being added to the equipment list will be planned objectives which call for their use. If taken simply on the chance they might come in useful, the likelihood is that they will remain in their cases at the bottom of the camera bag. However, the use of fisheye lenses *may* be called for if special effect photography for the travel industry market is intended. In particular, photography at beach resorts and around hotels can be enlivened by their use. A very long focal length lens, similarly, may prove desirable or even necessary for wildlife photography. But the bulk and weight of such lenses, as well as the need for tripods (few above 200mm focal length can satisfactorily be hand-held), puts them in that category of equipment which the photographer will be wise to question carefully before he starts packing his camera bag.

To improve the speed of lens changing, bayonet fittings are recommended and lenses which have rubber grips rather than all-metal cases are preferred. If using a lens without a rubber grip and when working in conditions in which the fingers might easily slip, for example through perspiration or cold, a strip of adhesive bandage may be wound round the lens body taking care that it does not foul any moving parts.

In selecting lenses, fast rather than slow should be the rule because of the greater tolerance of such

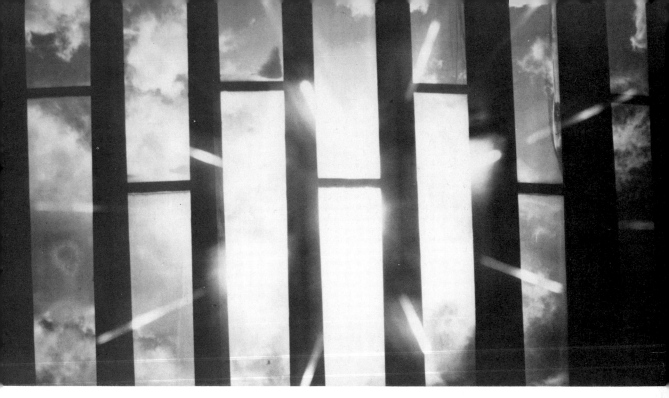

Filters and attachments are easy to carry and relatively inexpensive. A starburst filter was used for this shot, through a window, of the sun partly hidden by cloud.

Fountains in a park seen through a multi-vision attachment. The ordinary becomes extraordinary.

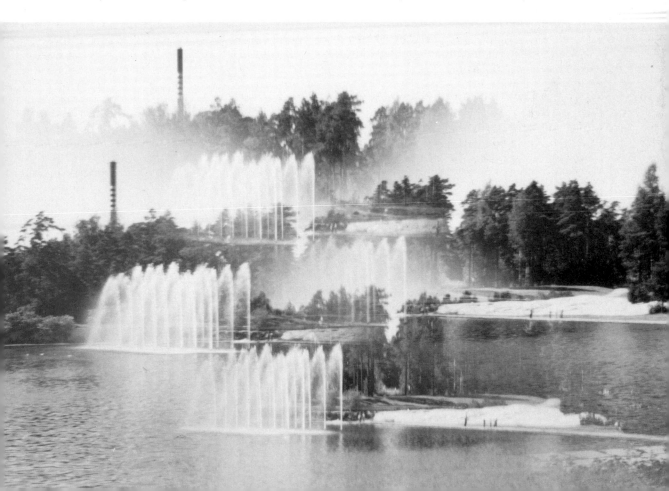

lenses of poor light conditions. The cost of lenses usually increases with larger maximum apertures, for example, an f/2 lens may be three times the price of an f/2.8, but the travel photographer cannot choose his lighting and it may often be necessary to work in sub-optimum conditions. It is also important to aim for the highest possible quality of lens. In general there is much to be said for using the lenses that are produced specifically for the camera body in use. The temptation to add variety to one's stock of lenses at the expense of quality ought to be avoided. There is little point in using a high quality camera body and a low quality lens.

Lens hoods should always be used because they offer not only protection from unwanted ambient light, but also a guard against physical damage to the lens or filter. For this reason I prefer metal hoods to rubber, and screw-on hoods are less likely accidentally to be knocked off than are their clip-on equivalents.

FILTERS

The creative use of filters will be dealt with more thoroughly in later chapters but it must be said here that they are especially important items for the travel photographer. Yet they require very selective use. The only filters that can be considered standard equipment are ultraviolet, skylight and yellow (No. 8). UV and skylight filters can be used in colour photography and with monochrome, but the yellow filter has a general use only with mono.

It is often said that it is worth keeping a filter on a lens simply to protect the latter from scratches. This is good advice but it ought to be pointed out that there is no advantage in having a damaged or poor quality filter covering a good lens. All filters should have bloomed surfaces to reduce light loss by reflection and, if working with lenses of varying diameter, different filters will be needed for each lens.

The UV or skylight filter can be left on a lens in colour photography for all general purposes. Both filters reduce the effects of ultraviolet radiation and its consequent haze but, of course, neither will actually cut through the haze produced *directly* by atmospheric conditions. A skylight filter, with its faint tint, will also improve photographs shot out of doors by eliminating the excessive bluishness which can occur in open shade under strong light. My own preference is for skylight especially when changing lenses, but not filters, from a camera loaded with colour to one with monochrome film.

Working with black and white film, a skylight or UV filter can be of use in eliminating an apparent fogginess, but it is arguable that a better general purpose filter will be a light yellow for all outdoor shots. The difference this filter will make, as it converts an uninteresting sky into one of sharp contrast between clear sky and cloud, can be quite dramatic.

Although the travel photographer may well see these filters, described above, as automatic choices for his equipment, it is as well to remember that a great deal of fun can be obtained by increasing the range taken on a trip. After all, filters, even good ones, do not cost much, nor are they bulky or heavy. Polarizing filters, which some might consider as alternatives to UV filters, colour correction filters and filters for special effects can all make for better and more interesting pictures. All the same, a word of warning might be necessary. Filters *do* impair the lens performance, especially when attached to wide-angle lenses. Thin gelatin filters, which are less troublesome, are not likely to be used while travelling so it is important, perhaps, to justify the use of a filter on technical or creative grounds rather than to assume that one should always be fitted.

To carry filters easily it is best to dispense with all cases and to use simple stacking caps which can be purchased. These allow the descriptions, engraved on the mounts, to be read, permitting selection of a particular filter without difficulty. It must be remembered, though, that separate sets of caps will be needed for different sizes of filter.

MOTOR DRIVES AND AUTOMATIC WINDERS

It is not only in sports photography that rapid shooting is desirable. Ability to take three or four, or more, frames a second can be a great asset in wildlife photography, in photography of, say, dances and rituals, and even in obtaining relaxed pictures of people. Motor drive units are expensive not only because of their initial cost but also because of the rate at which film is exposed. If fitted, there is a temptation to over-use the facility and this is especially so if the camera is equipped with a bulk film magazine as well. As with the bracketing of exposures, it is all a question of discipline and care. Properly used, motor drive can enable the photographer to capture shots which would otherwise be lost in the process of manual operation. Careless use will simply produce a large number of unwanted pictures. Because they are generally the more robust (as well as faster), motor drive units are preferred to auto-winders.

FLASH

Discussion, by photographers, of the use of flash is always likely to give rise to controversy. There are those, and I am one, who strongly prefer available light. Others commend the creative utility of supplementary illumination. For the travel photographer, flash may extend the working day and allow photography inside poorly lit buildings. If flash is to be used, it is important to remember that, in the difficult environmental conditions often experienced by travellers, even very expensive equipment may malfunction. There is much to be said for choosing flash bulbs rather than electronic flash-guns if working in very cold or hot and humid areas.

It is a fact that all pieces of equipment, such as motor drives and exposure meters, as well as flash guns, which rely on electrical energy rather than mechanical power, must be suspect when used under severe climatic conditions which may be met by the expedition or travel cameraman.

EXPOSURE METERS

Even when using cameras with built-in meters it is advisable to carry an additional separate meter either as a check or for selective use.

TRIPODS

A lightweight tripod is probably insufficiently rigid to give much support to a camera. A heavy one is almost certainly an unwanted encumbrance to the traveller. Using lenses of up to focal length 200mm, a tripod may not be needed unless working in areas, such as at the coast or in mountain regions, where high winds might be expected. Alternatives to the conventional tripod will be discussed in later chapters dealing with such conditions.

If any form of support is taken, a quick-release mechanism ought to be fitted. This enables the camera to clip on to the tripod head rather than screw into it. The simplest and most effective way to keep a camera steady when shooting without a tripod is to use a pistol grip of some sort.

Tripods are awkward to carry but may be necessary for shots like this, taken with a telephoto lens and using a slow shutter speed. Ambon Island, Moluccas.

CABLE AND REMOTE RELEASES

A good quality, long and lockable cable release can prove invaluable in a variety of situations and it is a necessity if any form of support is to be used. Remote releases also have their uses in travel photography (see Chapter 8). These can be highly sophisticated electronic, ultrasonic, or radio devices. Much less expensive, yet effective and reliable, are air-releases. These pneumatically operate the shutter button and can be helpful when photographing people in sensitive situations.

REPAIR AND MAINTENANCE EQUIPMENT

No matter how careful the preparation or how well made is his equipment, the travel photographer must expect some damage or failure. Cameras and accessories are liable not only to knocks and environmental hazards, such as exceptionally high or low temperatures or high humidities, but are also likely to be in almost constant use during a trip abroad. Screws come loose, films jam or dirt clogs the mechanisms. The minimum that a photographer might take with him to overcome or avoid such difficulties would be: a set of fine screwdrivers, a pair ot tweezers, a blower-brush, some fine artists' brushes, lens tissues, lens cleaning fluid and a changing bag. The fine brushes can be used to clean otherwise inaccessible crevices and corners. A changing bag can be helpful when carrying out repairs on a loaded camera. Lens tissues or lint-free cloths should not be treated with silicone and cans of compressed air are not recommended for travellers. A small tin or match-box is useful to store screws or other small items of equipment temporarily removed during a repair. A very small bar or horseshoe magnet is another aid worth taking.

FILM

It is unwise to turn to unfamiliar film when making selection of stock before embarking on a journey. Most photographers develop a feeling for the eccentricities of particular brands of film and automatically compensate for them. Both monochrome and colour stock should be taken but the proportions of each will depend very much on the photographer's personal preference. I find that a ratio of 2:1, colour to mono, is about right for general purposes. The reason for this imbalance is that it is easier to make improvements on less than perfect black and white shots during processing than is the case with colour. Colour stock must be

reversal film if there is any intention to sell the product. Reversal film has a narrow exposure latitude which sometimes calls for bracketing and a consequent greater expenditure of film.

Even if three or four cameras are to be carried, there is little point in taking a great variety of different types of film. Three would be adequate for most purposes. A fast (ASA 400) mono stock and, for colour, a slow (ASA 32) or medium (ASA 64) together with a high speed (ASA 400) film can be recommended. If it is certain that most of the photography will be in good light conditions, choose a slow film. If the lighting may be very mixed and a single colour film is preferred, then ASA 64 is remarkably versatile. Panchromatic film will be the most likely choice for black and white photography and this is assumed throughout this book where reference is made to coloured filters for black and white work.

Whatever film is used, it ought to be remembered that the most common mistake of all travel photographers is to take too little. Buying film away from home is often a risky business as well as an expensive one. Calculate how much you think you will need and then double it, is good advice to any travel photographer no matter how experienced. If you take too much it often is possible to sell it at a profit towards the end of your trip, especially if travelling in the Third World.

Despite the inconvenience of more frequent loading it *can* be advisable to select shorter rather than longer rolls of film (e.g. 20 exposures rather than 36 on 35mm stock). If travelling in very hot climates it is unwise to leave film in the camera too long and a few shorter rolls might be useful at times when the photographer can forecast the likely number of shots he will want on particular occasions. However, Customs regulations may dictate that long rolls should be taken (see Chapter 2).

It is a good plan to contact the manufacturers of the film that has been selected. They will readily offer their advice on the use and storage of their stock in particular environments.

PREPARATIONS AND ADAPTATIONS

Time must be allowed for adequate testing of equipment before setting out on a trip. It is vital that the full range of functions should be tested, not only on the basic cameras and lenses but also on all accessories. Obviously the same film types as will be used should be loaded during testing but, less obviously, the trials should be in the light conditions expected. This may mean that testing

may need to commence perhaps six months or more in advance of a journey. This can be the case if snow surfaces will be encountered or particularly strong light conditions will be met. As far as possible, environmental conditions for testing should be as close to the real thing as can be found. There is probably no difficulty in carrying out tests for, say, coastal photography at a coast, but it may be impossible to simulate conditions of, say, high humidity or high altitude.

When checking cameras in a variety of light conditions it is important also to check built-in meters on the cameras against independent light metres.

As well as testing the whole range of optical functions of one's equipment, care should be taken to examine for such potential problems as loose screws and wear of mechanical parts. Listen to the camera as well as looking at it. The noise of film levers or shutters, for example, can be very revealing. Carrying equipment, straps and bags, and camera supports should be inspected and replaced if their reliability is at all suspect.

Some equipment may need to be adapted to make it more suitable for travel photography. Cameras should be marked clearly to indicate the film loaded. Clip-on coloured labels may be used for this purpose. Lenses, too, should be marked if confusion could occur. This may be necessary to distinguish between, say, a standard lens and a wide-angle lens and thus prevent the use of a lens hood with too narrow an acceptance angle. Filters and lens hoods may also need marking for easy identification. To mark filter mounts or lenses, self-adhesive colour symbols such as can be found in any stationers may be adequate.

The travel photographer's equipment is likely to be at risk through unavoidable knocks. Some extra padding might be helpful if attached to the back of camera cases and this may also serve to insulate the camera (and its film) from heat conducted from the photographer's body.

Narrow leather carrying straps should be replaced by broad webbing with easy release clips. Particularly useful when both hands must be taken off the camera are chest harnesses. With these straps attached, the camera will not swing away from the body when the photographer is climbing or just clambering over rough ground. If a tripod is being employed, it may be carried most easily if straps have been attached to allow it to be slung from a waist belt.

The gadget bag to be used must be one which will stand up to the rigours of travel, allow easy access to equipment and be relatively light and comfortable to carry. If being used in the field, the colour and material of the bag may be important when considering its insulating properties in hot climates. That it should be waterproof goes without saying. There is a lot to be said for strong canvas bags with leather or webbing straps. They are easy to carry and do not so readily attract the attention of the would-be thief as do expensive-looking leather bags or aluminium cases. However, they are less resistant to knocks and may not be as easy to stow under an aircraft seat.

It may be advisable to rearrange the gadget bag to improve accessibility. It is possible to save the cost of new dividers by cutting pieces of plastic foam which can be bought cheaply. In any event, it is a good plan to clean the gadget bag thoroughly before finally packing it for the trip.

When it comes to cleaning the cameras and their accessories, care must be the watchword. More will be said about this later in the book (see Chapter 3), but before a journey it might be worth having the cameras overhauled by the makers or their agents. This can be costly but, on the other hand, it might prevent malfunction in the field. If an overhaul is carried out, it is best done *before* the photographer carries out his own tests.

Film will be purchased just in time for the start of an assignment but it too needs some preparation. There is never any point in carrying unnecessary bulk so get rid of all the cardboard boxes and makers' instruction leaflets. Leave the film in its container, whether a heat-sealed drum or envelope, and label each one with a stick-on disc in order to keep a check on the film used and also assist in keeping the record book (see Chapter 2).

Finally, there is the not unimportant matter of the right clothes, not only for the location but also for the job. Obviously it is the location that will dictate the clothes to a large extent but what may be perfectly all right for the general traveller may not properly suit the photographer. Four main *needs* can be identified: the need for freedom of movement, particularly of the hands and arms; the need for protection from the elements (photographers often have to be stationary for long periods in an exposed position); the need to have a firm foothold over rough ground, leaving the hands free to hold the cameras; and the need to carry and protect equipment which often will be carried in or on the clothing rather than in a gadget bag. With these needs in mind, clothing can be recommended for particular environments and this will be done in Chapter 3.

2 Travelling with a Camera

Travelling with a camera is fun but it also has its drawbacks. Experience is the best safeguard but, equally, an awareness of potential problems is at least half an answer to them.

INSURANCE

Cameras are expensive and thus attractive to thieves, especially in countries where there are restrictions on imports or camera ownership is considered a status symbol. Most ordinary travel insurance policies are quite inadequate for a photographer carrying two or three cameras and a gadget bag full of accessories. Limits are often imposed and can be as low as £50/$100 per item. Obviously special insurance cover is necessary.

Most photographers will have a limited all-risks policy on their equipment in their home country and, for a modest additional premium, it should be possible to extend this for travel abroad. However, there may be special exemptions, such as while travelling in private aircraft or mountaineering, and the policy's small print will need scrutiny. If anything is lost or stolen, do report it to the local police if at all possible. In many countries, they may be singularly lacking in interest in one's loss, but will usually supply an authoritative rubber stamp to a prepared statement. Insurance of film is also possible but only at its intrinsic (i.e. un-exposed) value unless impossibly high premiums are paid.

CUSTOMS

Not all countries welcome photographers and may impose restrictions on the import of photographic equipment and film. Whereas a single camera will pass easily through Customs, a full gadget bag may cause problems. It is even unwise to have more than one camera actually carried on the person. If it is impossible to spread the load among one's travelling companions, it is best to pack the gadget bag neatly to give the appearance of fewer items than are actually being carried.

If it is thought that there might be problems abroad, call at the relevant Embassies or High Commissions before leaving and seek their advice. Very occasionally they may even offer a letter of introduction to Customs seeking their co-operation. It is important not to forget that there can be as many difficulties with passage through a foreign country as in the country of final destination.

If photographs are not going to be taken during a journey through a particular country which has import restrictions, be prepared to allow Customs to seal the equipment while in transit. Regulations concerning film imports are usually expressed in numbers of rolls permitted. In these circumstances, it is sensible to take longer rather than shorter rolls (e.g. 36 exposures rather than 20 exposures on 35mm film). In this way one can quite easily almost double the film available and remain within the regulations. It is as well to be aware of countries which restrict the import of *photographs*. In such cases, even undeveloped but exposed film or negatives may be classed as photographs and the only solution is to send home any film already shot before crossing the border.

If restrictions are known to be stringent and your equipment or film supply exceeds permitted limits, then a temporary import licence may be the only answer. But be prepared to negotiate for this well in advance of departure. If excess equipment is impounded at a frontier, get a receipt and be ready to argue.

In countries which require the registration of equipment on entry, it is important to keep the relevant forms with you at all times. It is not unknown in the Eastern Bloc countries to be asked for documents during a journey as well as on departure.

Rules and regulations change without notice and it would be unwise to rely on outdated information. Some travel and photographic books attempt to tabulate the rules but such lists are often out of date even before the book is published. There is no alternative but to make enquiries at Embassies or the relevant government department before starting a journey.

Did these young travellers in the Himalayas have a camera hidden in their *dandy*?

TRANSPORTING EQUIPMENT

The majority of travel photographers will wish to carry all their equipment with them as hand baggage. Whereas this causes no special problem when travelling by road, rail or ship, there can be difficulties if flying. Most airlines restrict passengers to one piece of hand baggage plus a single camera. If travelling with a bulky gadget bag, this may have to take the place of any other small in-flight bag. The practised traveller can usually get round the problem but it is important to know the rules. The bag itself should be of a size and shape such that it will fit under the aircraft seat. There is nothing more annoying, to other passengers as well as to oneself, than having a bag which restricts movement or legroom on a long flight.

If travelling by car or coach, it is important to remember to stow the gadget bag or cameras away from positions in which they are likely to suffer from vibrations or heat from the engine, the exhaust pipe or the sun. Only by sea is it likely that any equipment will be carried in a suitcase. If it is, then it should be packed so that it will be protected by clothing and near the handle which is probably the strongest part of the baggage. It is most unwise to consign equipment to the hold of an aircraft or ship.

TRANSPORTING FILM

Film is, perhaps, less likely to be carried personally by the photographer on a long journey. He may well feel that a few rolls are sufficient for the long haul to his destination before he starts work in the field and that the bulk of his film can be put in the hold with the rest of his baggage. This can be injudicious. Apart from the problem of theft, the conditions of temperature and humidity may be damaging to film stock. Additionally, much aircraft baggage is examined by X-ray.

The increasing use of X-ray devices at security checks is worth guarding against. Unprocessed film can fog if subject to more than a very low dose. Airport checks are the most common but these devices are also used at some frontier posts and at sea ports, particularly in the Near East. The best plan is to have your film separately packed and to

show it to the security guards for visual checking only. If this does not work, then the film can be protected against low dosage X-rays by packing it in lead foil bags made for just this purpose. Film is offered no protection by being in a camera and it is best to unload before going through a check. Remember that security guards may also ask you to open your camera with disastrous consequences to the film inside. This happened to me once, in Paris of all places, where security is not especially tight. I have since made certain that I never take a loaded camera through a check-point.

In the last few years, some of these security check-points have put up notices to the effect that 'our X-ray devices will not damage photographic equipment'. Believe this if you wish but it is better to be safe than sorry. Of course, other checks such as ultra-sonic and magnetic devices do no harm whatsoever.

I find it most convenient to pack my film completely separate from my equipment. Some travel photographers use commercially produced film cassette holders which clip on to a belt or pocket. Quite apart from the fact that they can look like a cartridge belt, it would seem to me to be an unnecessary addition to the traveller's load. If the film is carried in the manufacturer's drums or envelopes, and labelled as described in Chapter 1, used film can be numbered on the disc and easily distinguished from the unexposed stock.

Film needs even more care and storage than do cameras and lenses. Some of the particular hazards will be described in Chapter 3 but it is easier to take precautions with separate film containers than with the whole bulk of the rest of the equipment. Once in the field, a good proportion of the film stock will not need to be taken out for each day's work and the surplus can carefully be stored in the best possible conditions of temperature and humidity that can be devised.

It is equally true that for a particular day's work, some of the photographic equipment may be left behind at base. Depending upon circumstances, the gadget bag may well be used only when moving base and for the greater part of the travel photographer's work, he will daily be carrying his cameras, accessories and film on his person and in his clothing.

KEEPING RECORDS

One of the most important tasks of the travel photographer is the keeping of records. Days, or even weeks, can be wasted on returning home with records that are inadequate properly to identify each shot. Amateurs, and even some professionals, are sometimes obsessed with the recording of every aperture, shutter speed and film type. This sort of record is all right to impress the local photo club but it is of no use whatever to the travel photographer. What he needs is precise and accurate information of the subject of the photograph and its location.

To obtain such records is not as easy as it sounds. Not only are there problems in actually finding out the information one needs, but also practical difficulties in setting down the record. If more than one camera is in use the problems multiply. I find that a suitable practical method is to prepare the record book in advance of a day's work such that the only entry to be made while engaged in photography is a note of the subject and its location. All headings and frame or film numbers are already in the book. This is best done on a daily basis because the number of frames being shot on any one camera will quite unlikely be the same as on any other camera in use. It takes very little time to enter this sort of information and adjustments to frame numbers can be made during a lull in photography after checking the counter on the camera. In addition, a cross-check with the other cameras can be made whenever a film is changed in a particular body. If all the information is not immediately available (for example, the name of a street or of a mountain), then this can be entered later from, say, consultation of a map, provided there is sufficient indication in the record book to make this possible. Much of the missing data can be entered in the book in a routine way at the end of a day's photography. Likewise, the book should be checked each day, spellings of place names verified, hurried abbreviations spelt out and possible ambiguities removed.

An example of a record book of this type, using three cameras, is shown in fig. 1. Here camera 2 was being used most often although (see Film Number) it had not been used the day before. Camera 3, loaded with black and white film, was not being employed as much as the cameras with colour stock. By noting the frame number on the counters of cameras 1 and 3, when reloading camera 2, it is possible to follow the sequence of the photographs more easily. As the film is unloaded from the camera and put back in its can, its number is recorded on the can, previously labelled with a disc for this purpose. If a camera is not immediately reloaded when the film is fully exposed, then the frame numbers on the other cameras should still be recorded but at the time the last frame is shot by the camera in question. At the end of each day, again a record can be made of the

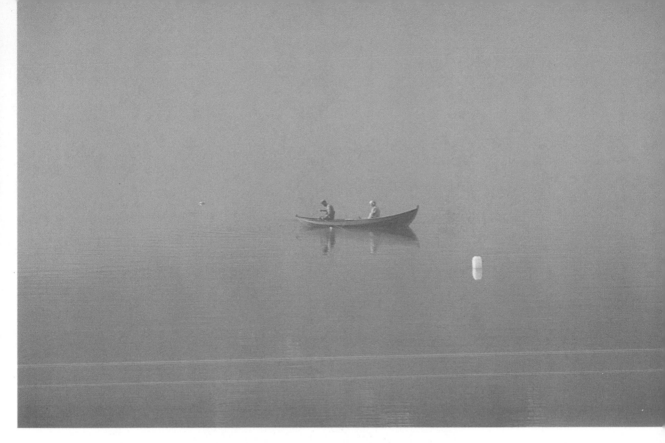

Fishing scenes provide a variety of opportunities.
Above Mist and lake merge as a horizonless backdrop to
this scene. *Below* Malay fishermen clear their nets.

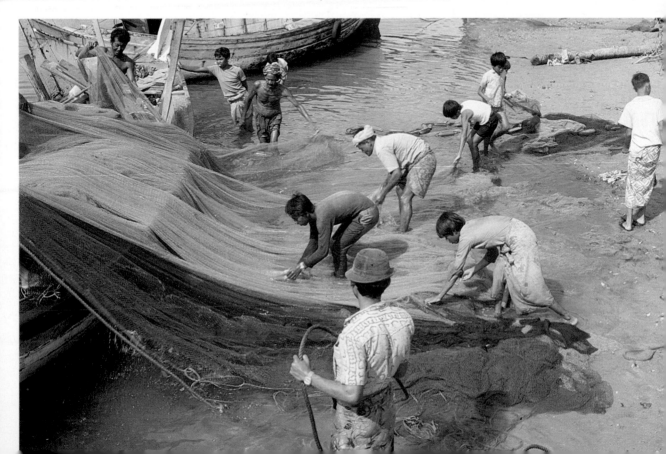

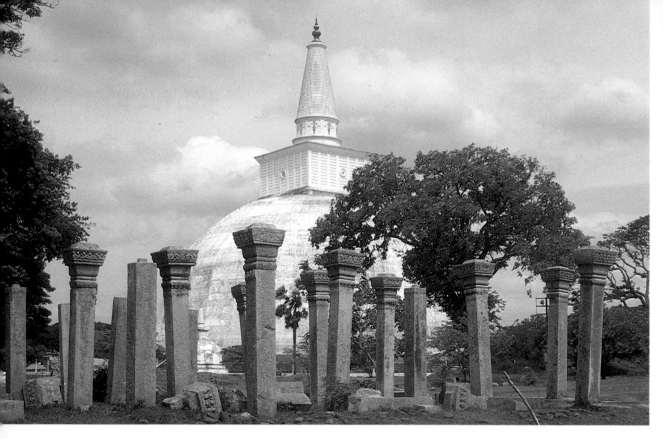

The wonders of nature and man. *Above* Ruvanvali
Dagaba seen through the pillars of the ruined palace,
Anurhadhapura, Sri Lanka. *Below* Mirror images. The
foreground offers a contrast in scale, hue and shape.

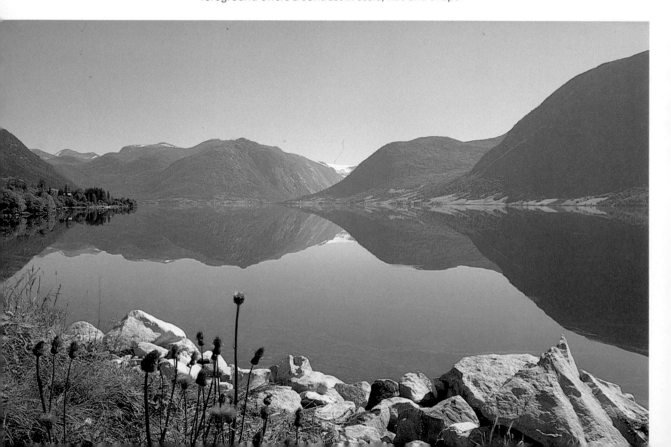

Date: 07.10.80　　　**Base:** Colombo Sri Lanka　　　**Day's Location/s:** in and around Colombo

Camera 1: Col K-64		**Camera 2:** Col K-64		**Camera 3:** b/w FP4	
Film No.	**Frame**	**Film No.**	**Frame**	**Film No.**	**Frame**
16	9 } Nat. State	12	32 Nat. State Assem.	6m	22 Fort Rly Sta.
	10 } Assembly		portico & crest		entrance
	11 } bldg. front		33 } Police outside Nat.		23 } Fort Rly Sta.
	12 Nat. State Assem.		34 } State Assembly		24 } interior
	N. side		35 } Sri Lanka flag		25 Nat. State Assem.
	13 Statue Gov. Barnes		36 } on above		south elev.
	14 Birds on 13	17	Camera 1 at Frame 12		26 Nat. State Assem.
	15		Camera 3 at Frame 26		front elev.
	16		1 officials arr.		27
			2 at Nat. State Assem.		

Fig. 1

film and frame numbers for each camera and these will be the starting points for the next day's entry.

If the photographer is fortunate enough to have an assistant, then the record is best kept by him with the photographer calling out the frame numbers and other details.

Even with the method described above, there is a lot of work distracting the photographer from concentrating on getting the best possible shots. In some circumstances I find it possible to dispense with a written record in the field by using a pocket dictaphone. Even more information can be stored in this way until such time as it can be transcribed into the record book. The cassette tape is then erased and ready for re-use. I have found this system particularly helpful when time is pressing although, after a hard day in the field, it is something of a chore to write up the data.

If I am using a local guide or driver, I give him a note-book so that he can write out difficult place names or translations of, say, inscriptions or notices. This is by no means a foolproof way of gathering information, relying at it does on your guide's standard of literacy and mastery of the English language. It can even have some hilarious results as when an African guide wrote down the word 'hill' every time he was asked the name of peaks in a range of mountains. Spellings and other data obtained by this means must be checked.

MAPS AND CLOTHING

It is as well to be armed with an adequate supply of maps, if only as aids to maintaining the record book's accuracy. Street plans, if they exist, for town work, are probably most easily purchased locally. Other general maps may well be more conveniently obtained (and at lower prices) at home in the UK or USA. This may seem surprising but, particularly in the case of Third World countries and those of the Eastern Bloc, it is often impossible to obtain even out-of-date maps on location. Map making in many parts of the world was a bi-product of colonialism or of military interest by a foreign power. Hence, Great Britain, France and the USA can be important sources of maps for many parts of the globe. If it is not possible to *buy* relevant maps, the travel photographer may have to resort to consultation and note taking at a national map library such as that at the Royal Geographical Society in London.

There is, however, some danger in being in possession of a large supply of maps when entering countries which are especially sensitive about security. A roll of maps and a bag of cameras may well be thought of as sufficient proof that your intentions are not strictly innocent. It is little use being well-informed if you land in jail on suspicion of spying. A similar word of warning might be said about clothing. In some countries, anything that could be mistaken for a military uniform must be avoided. Women have little difficulty in this matter but many male travel photographers seem to affect a para-military style of dress. There are practical reasons for this. Combat jackets are often a patchwork of useful pockets. All the same it is wiser to steer clear of anything that is khaki, or camouflaged or suggests the SAS!

RISKS AND PROBLEMS

Travel photography in some countries carries with it special risks and difficulties which should not be dismissed too lightly. The areas which seem to cause the biggest perennial problems are the USSR and other Eastern Bloc countries, and some parts of the Third World. Of course, regions of high political sensitivity vary from time to time and it is as well to take advice from your own relevant government department before you embark on a journey to a country known to be politically unstable or hostile. It is important to point out that you are a photographer.

The so-called Iron Curtain countries make life very difficult for the travel photographer. There is so much that is interesting yet forbidden to the camera. It is not simply a question of avoiding what are clearly military subjects. The definition of 'military' is as wide as it is irrational. I am sometimes amazed at the stupidity of some tourists who feign surprise when their film is confiscated – or they suffer an even worse fate – because they have been photographing, say, a military airfield. But I have some sympathy for those who fall foul of officials when trying to obtain pictures which have no apparent political or martial significance. A dissident demonstration at Lenin's Tomb may be considered fair game by a photographer but some degree of stealth will be needed if the film is to be saved from the hands of the police.

A number of do's and don'ts might serve as practical advice for travel photographers in Iron Curtain countries:

Never carry more than two cameras and avoid taking a loaded gadget bag on a day's work.

Avoid long focal length lenses, especially if long barrelled.

Don't use a tripod.

Don't openly make notes in the record book. Leave this task, if you can, until you are in the privacy of your hotel room or car.

Don't spend too much time adjusting the camera for focus and shutter speed. A still camera held to the eye for a long time might be mistaken for a cine camera and the shooting of movies is often regarded with even greater suspicion.

Do not compound your *crime* by getting involved in any demonstration or other sensitive situation. Even questioning other on-lookers can draw attention to yourself. Take your pictures, get away while the going is good and find out what it was all about later.

Don't carry all your exposed film with you when you are working. If your film is confiscated you may save the previous days' work by leaving it behind in your hotel.

If you are told that photography is forbidden, heed the order.

If with a guide, always take advice and ask permission before pressing the shutter button.

Use a wide-angle lens (24–28mm) if you must take photographs of what might be considered a forbidden subject. By this means the camera can be pointed somewhat away from the subject itself but still keeping it in the picture. I have found this ploy to work on numerous occasions. The average person is totally unaware of the large field of view of these lenses.

Stand around for some time until your presence is accepted before starting to use your camera.

Carry your equipment openly rather than hidden under your coat or jacket.

On unloading the camera, wind off the film completely into its cassette.

Check that any permission that is granted for photography really is valid for *you* in the *exact* circumstances in which you find yourself. Permission to take photographs of a building, for example, will probably only apply to the exterior. If you start working with your camera inside the gates you may well be exceeding your licence.

It is *not* suggested that all the tactics described above will be necessary in every Eastern Bloc country or that they will apply to all circumstances in any one country. Largely it is a matter of being sensitive to the host country's sensitivities. Most of the time the traveller behind the Iron Curtain will be able to photograph just as he would anywhere else in the world. The majority of hassles which travel photographers experience are of their own making and result from a misguided belief that possession of a camera is carte blanche to photographing where and what they like.

In the Third World the problems will usually be different but there are many emergent countries, and others with unstable political regimes, which share the Eastern Bloc's hypersensitivity to photography of all things which might have a military significance. In such cases, hostility towards photography of *innocent* subjects like railway stations, factories or bridges, knows no bounds. The problem is often exacerbated by a total inconsistency such that it is almost impossible to obtain guidance either before leaving home or on

location. In these circumstances, some of the suggestions made above for Iron Curtain countries may prove useful.

However, there is another sort of sensitivity characteristic of the Third World, and shared by some other countries, which is not attributable to military or political attitudes. This arises from the cultural or social order in which certain subjects are taboo as far as the photographer is concerned. People, buildings, ceremonies, even street notices can be on an unwritten list of proscribed subjects. The list will vary from place to place within any one country. What might be perfectly all right in the capital city may be forbidden in the less westernized interior.

As always, the golden rule is to respect local customs and life-styles and refrain from pointing a camera in a direction it is not wanted. There will almost always be some other way of obtaining a particular photograph without causing offence. Stratagems which might be employed are discussed in later chapters.

GUIDES

It is in the Third World that the need for a local guide is most often felt. He will not only advise but also negotiate for permission to photograph. It may be surprising how many *cousins* and *friends* he has scattered across the state, but if he can get you the pictures you want, that is all that matters.

Invariably, I try to use reliable local guides or drivers. They have saved me from many an unpleasant confrontation and it is always worth paying for the best, keeping him for as long as possible. Picking up a volunteer guide on the spot on a daily basis is best avoided.

BRIBERY

Bribery is part of everyday life in many countries. The photographer is particularly vulnerable not least because it will often be assumed that the possession of expensive-looking equipment is clear proof of untold wealth. *Official* bribery may well start at the port of entry when Customs Officers begin to question the import of film or equipment. It continues as the traveller seeks permits to photograph in, for example, national museums or at archaeological sites. Whether or not to succumb to the temptation to bribe an official must be a matter of judgement on the spur of the moment, but there can be as many penalties for bribery as there are frustrations at the lack of co-operation one may receive from state servants.

The most amusing incident of attempted bribery

that I recall occured in Kuala Lumpur when I asked a security guard on a public building if I might photograph a notice affixed to its wall. He agreed but made it clear that I ought to give him something in return for the permission. The notice I wished to photograph proclaimed that the building housed the 'Anti-Corruption Agency'! Needless to say, I gave him nothing, stepped across the road and obtained a perfectly satisfactory photograph using a telephoto lens.

A different sort of bribery occurs when the general public wish to make a quick profit from the photographer who suddenly appears in their midst. In next to no time there will be demands for money on any, or even no pretext. Stop to photograph a baby in the street and father will immediately appear, snatch the child away and ask for money before the picture can be taken. While I have every sympathy for those who feel that they are being exploited by the rich foreigner who treats his camera like a licence to ignore sensibilities of his fellows, I am less sympathetic towards the attitude of those who see the travel photographer as a source of unearned income. Of course, this attitude is neither peculiar to, nor typical of, the Third World. Contrasts occur within particular countries. The big towns, especially those touched by tourism, are worst and rural districts cause the least problems. I was struck by this sort of regional variation most recently when working in Sierra Leone. Without the protection of my locally recruited driver, I might well have been attacked on occasions in Freetown, but up-country I was met by nothing but warm friendliness.

Again, some of the techniques that might be adopted to avoid these sorts of difficulty are described later in Chapter 8.

SECURITY

As has been said, cameras are a real attraction to thieves everywhere. When travelling in crowded areas, I make sure my equipment is always in sight even to the extent of never carrying a camera slung over my shoulder in such a way that it could be cut from its strap without my knowledge. When I am carrying a gadget bag, I put one foot lightly on the bag when I stop to shoot in a busy street. Working with an assistant or a local guide can give greater security, but any temporary help should be vetted carefully.

Theft may be a particular problem in areas where photographic equipment is in short supply or it is very expensive. In such places there is the added nuisance of the would-be purchaser who

offers you cash or kind for your cameras and lenses. Unless you are especially hard-up it is probably best to resist the temptation to sell, even if at the end of your travels. You may find that you are contravening the laws regarding imports. Alternatively, the cash you receive may turn out to be counterfeit or a currency note issue that has been withdrawn. The persistence of some of the enterprising entrepreneurs who engage in this sort of business has to be experienced to be believed. My most memorable encounter of this kind was while operating in Bangalore. A charming young man appeared at my side several times a day, following me on a motor-scooter whenever I took flight. He did not get his, sorry, *my* cameras, but I hoped he learnt a little about the work of a travel photographer.

Left, good guides can be recruited locally.

Selling one's equipment – like this young hippy in Kathmandu – should be considered a last resort.

FILM PROCESSING

When travelling with a camera a photographer will be faced with the perplexing question: what should I do with my exposed film? Should I keep it with me until I return home, or should I get it processed as quickly as possible? Expeditions to remote areas may find it advisable to set up their own darkroom in the field, but this has become uncommon unless the party is totally cut-off for a long period. An expedition to Antarctica might be such an example. Most expeditions and, more especially, the individual traveller will find this expedient unnecessary or even impossible.

All film should, in theory, be processed as soon as possible after exposure. However, the rate of deterioration, if stored in optimum conditions, is so slow as not to cause any alarm. Problems arise when less than ideal storage is unavoidable. In these circumstances it may be advisable, either to turn to a local processor, or to send the film home. The major film manufacturers will provide information about their own overseas processing laboratories and this may take care of colour reversal film. Embassies and High Commissions can sometimes provide lists of major film processors but these will be no guarantee of quality.

Because of the risks involved in abandoning film to untried laboratories, most travel photographers will prefer to send it home. Even this can be something of a gamble. Postal services are often unreliable and international mail may be checked by X-rays. If the photographer is unwilling to accept these chances, it may be possible to find a compatriot who will take material home and, on arrival, forward it to a given address. If this cannot be done, then it is worth trying the nearest Embassy or Consulate to see if arrangements can be made for film to be included in the diplomatic mail. For the unknown travel photographer, this may prove difficult but a recognised expedition may find this an ideal solution if arranged in advance.

Whatever method is used to return film to the home country, it is essential that it is properly labelled in order that identification shall be foolproof. The need for adequate records to be kept is never more obvious. It is best to make a decision about sending film home before leaving so that arrangements for its reception and treatment are unambiguous.

Should it be decided that the best plan is to keep the film and not risk returning it unaccompanied, then storage will be an important factor in ensuring the least possible deterioration. Methods will be discussed in the next chapter.

RESEARCH

Something has already been said about maps but perhaps it should not be taken for granted that the travel photographer is also supplied with helpful travel books. No serious traveller will venture abroad without having prepared himself by reading others' impressions of the areas he is about to visit. This should be considered an essential part of planning. Good travel guides may be hard to come by but they are worth searching for in order to make certain that, on arrival, the photographer knows at least the more important features of the region which might provide subjects for his camera.

I suppose it is just possible to arrive in Agra and not be aware that the Taj Mahal is its crowning glory, but it is quite likely, without some preparatory reading, to be unaware that some of the best views can be had from across the river and that here too is the tomb of Itmad-ud-Daulah, which was the inspiration for the Taj. It is all too easy to return home, turn to the literature, and discover with horror that ignorance has robbed one of the opportunity to photograph some particular subject which is unique to an area which one may never again visit. It is not worth the anguish. The solution is simple: read first, travel later.

General guide-books from reliable series, such as

Travel photography should be about making new friends. I made this one at a fishing village at Black Volta Bridge.

Appropriate transport is not a luxury but a necessity. Drakensberge Mountains, Lesotho.

the *Nagel* or *Fodor* guides, can be carried by a travel photographer. These should have been read prior to departure and annotated to make for easier reference. Further, more detailed travel/guide books should have been studied at the planning stage of the trip and notes made. Locally available travel guide-books should not be ignored although they may need some finding.

It is not a bad plan to look at other photographer's work in regions about to be visited for the first time. I recall returning from Nepal some years ago and then being invited to look through

Back-packing and camping may be necessary when landscapes run out of roads.

the Royal Geographical Society's photographic archives. Not only was I surprised to see photographs of the areas from which I had just returned which, although taken eighty years previously, depicted scenes exactly like those I had just captured on film, but I much regretted I had not seen the collection before I had left for Nepal. Had I done so, I would have made some efforts to repeat as closely as possible some of the shots for a comparative record.

The result of pre-departure reading should be a notebook of potential subjects for the camera.

3 Environmental Problems

Most photographers, unless they have unlimited opportunities for travel, will work for most of the year in their home region. They will become used to the problems presented there but, perhaps, be totally ignorant of the difficulties that may be experienced elsewhere on our planet. Not all the problems, as explained in the last chapter, will be those of the physical environment. The experienced travel photographer may even argue that in some parts of the world the hazards of extremes of temperature and humidity, or of dust and high winds, and so on, are far outweighed by socio-cultural problems. Nonetheless, to work in an unfamiliar part of the world does present a challenge to the ingenuity and creativity of the photographer.

One of the attractions of travel is the experience of an infinitely varying scene. No one location is quite like any other, but it is possible, all the same, to distinguish five potentially difficult environments which a travel photographer may encounter. These are: the humid tropics, the arid tropics, cold environments, coastal locations and mountainous areas.

Each of these will be dealt with in turn. Stress will be laid on extremes because a traveller should bear in mind the unpredictable characteristics of climate and always be prepared for the worst. A photographer must remember that his equipment does not acclimatize as he might.

THE HUMID TROPICS

These areas present three main hazards: those of high temperatures, high relative humidities and heavy rainfalls. It is almost impossible to say which of these is likely to be the most troublesome.

The dangers of high temperatures are almost entirely those affecting film rather than the rest of the equipment. Loaded cameras must be kept out of direct sunlight as far as possible and away from any position of high temperature. If a loaded camera is put to one side, even for a short time, it should be covered by something that will reflect insolation. This may be no more than a sunhat or a handkerchief. Black bodied cameras give rise to a special problem and, in exceptionally hot conditions, it may be advisable to cover the body with strips of white tape. This might be especially important on the back and film ends of the camera where heat transmission to the film will be greatest.

At the start of a day's work it may be necessary to allow film and lenses time to warm-up. Quite likely both will have been stored overnight at temperatures significantly lower than the working ambient temperature. If this is the case, warm-up time must be allowed. The correct warm-up times, and they can be substantial, can be obtained from the manufacturers of the film being used. These vary according to the rise in temperature which stored film has to undergo when taken into a warmer atmosphere. If film is at a temperature below the dew point of the atmosphere, condensation will occur on the surface.

Much the same applies to lenses and to mirrors in reflex cameras. Misting will immediately occur when cold glass surfaces suddenly experience a hot-humid atmosphere. It is unwise to try to accelerate warm-up times, especially those for film.

Temperatures alone, that will be experienced in the tropics, are unlikely to affect camera bodies or other equipment unless carelessly left in full sunlight. If equipment does become overheated, problems will occur with moving parts and such accessories as bellows. Any interface between different metals or alloys highlights the difficulties and some jamming might be expected, for example, in winding on film. Simple precautions will prevent such embarrassments.

Of greater consequence is the high relative humidity which accompanies tropical heat and which is, in fact, a function of the temperature. Other than dust and dirt, nothing is more harmful to photographic equipment. In the tropics, any relative humidity in excess of sixty percent spells danger.

Apart from film, items of equipment most

sensitive to high humidity are those relying on electrical power. Flash units, electrical drive units, batteries and so on, are especially vulnerable. Some malfunction can be expected unless electrical fittings and apparatus are kept dry and frequently checked. The next most likely pieces of equipment to be affected are bellows and mechanical working parts. In very damp conditions, rates of corrosion are often greatly accelerated.

Leather reacts unkindly to a humid atmosphere and all sorts of minor irritations can occur such as the peeling of labels from containers or the containers, themselves, becoming rusty or deteriorating in some other way.

If a travel photographer is in the humid tropics for a relatively long time, say, three or four months, he may experience fungus growth on his equipment. The greatest difficulties occur with temperatures in the range of 25–30° Celsius and relative humidities above seventy percent. Because fungus spores thrive on such materials as leather and have a liking for the dark, growth may begin inside camera or accessory cases. While it is a nuisance there, it is lethal to the optical glass of lenses to which it may spread. Finger prints on a lens surface may be an attractive home for fungus and keeping the equipment spotlessly clean and dry is the only answer.

Processed film, stored in these conditions, may also be attacked by fungus and film manufacturers will advise on chemicals which might be used to clean off the resultant spots. Colour transparencies are very often affected and I have seen a valuable collection of slides almost totally ruined in this way. Black and white prints are rather easier to clean but, again, prevention is better than cure.

Unprocessed film, properly stored, can be isolated from fungus spores, but, in general, it is film storage which causes the greatest headaches of all in these climatic conditions.

Most films are packed in hermetically sealed containers by manufacturers so they are almost immune to varying ambient conditions. Troubles are greatest when the film has been exposed but not processed and the latent image may be damaged. Ideally, storage temperatures should be below 10° Celsius, difficult to achieve in the tropics unless some refrigeration or air conditioning is available. On expeditions it is sometimes the practice in the field to bury film in airtight, waterproof containers.

It is important not to take out of storage more film than is needed for the day's work and to avoid leaving exposed film in the camera. If a particular camera is not in daily use, the best plan is to remove unexposed film and put it into store or reload it into another camera being used. The changing bag may come into its own here.

Emulsion damage, shifts of colour balance and of film speed are such great problems with film kept in the tropics that efforts to get the material processed or stored in optimum conditions are a priority and some of the suggestions made in the last chapter may be helpful.

Most photographers are familiar with the use of desiccants such as silica gel. A plentiful supply of indicator-dyed silica gel should be taken on any visit to the humid tropics. The high porosity of the gel ensures that, in damp conditions, much of the atmospheric moisture will be absorbed so offering protection to photographic apparatus and film. Silica gel, in bags or loose, should liberally be used in all containers used to store or carry the photographer's equipment.

Because saturated silica gel is useless, it is better to take blue-dyed grains rather than natural white. As moisture is absorbed, the dyed silica gel will turn pink on saturation. It should then be replaced temporarily so that it can be dried. As it dries it will return to its original blue.

The humid tropics are not just humid, they are, at times, positively wet! Heavy rainfall may be unavoidable and will add to the problems already described, but they should not deter the travel photographer. If rain cannot be avoided then equipment that has become wet must be dried with almost fanatical care. In the field, a light piece of waterproof or mackintosh can be attached to the back of the camera body and draped forward over the body and lens when the camera is not in use. Hoods offer some protection to the lens and, between shots, a dry piece of cloth can be pushed into the hood to cover the lens. If very heavy rainfall is accompanied by strong winds, it may be wise to use extended lens hoods of the funnel variety to ensure that no rain drops hit the lens glass while photographing. If these are employed, it is important to check that they do not cut the field angle.

There may well be times when equipment has to be put down on the ground. At such times it should be protected by placing it in a completely waterproof bag. For even greater safety it is possible to buy inflatable camera bags which will prevent damage to equipment should the bag be knocked or fall. I have used such bags when canoeing in the Arctic because their envelope of air makes them buoyant even when loaded.

Of course, if it is necessary frequently to photograph in heavy rain, it may be worth

investing in an underwater housing for at least one camera! The cheaper alternative, specially made plastic camera bags in which the camera controls are operated via an in-built glove, can aggravate humidity problems.

The photographer's clothing can contribute not only to his own comfort in adverse conditions, but also to the efficiency with which he will operate. A wide-brimmed hat not only shields the camera from rain but it may also prevent unwanted light from entering the viewfinder. Shirts or light jackets should have plenty of pockets but these must be waterproof if rain is expected. At least one pocket should be reserved for lint-free drying cloths. Because any waterproof compartment may become a trap for humid air, one or two silica gel bags should be kept in each pocket that is used for cameras, film or accessories.

Cameras should not be carried so that they are in contact with moist skin or wet clothing. I find that two light shirts, the outer one quite loose, can be the solution other than in very heavy rain. Cameras can be carried between the shirts and not against bare skin which may be wet with perspiration.

Shorts, all right in many circumstances, are inappropriate in forests and footwear should always receive special attention. A photographer is often standing still for long periods and good boots or shoes should be the order of the day. It might be wise to take some precautions against bites. There is nothing more attractive to insects than a stationary target.

The use of wide carrying straps has already been recommended but, in the humid tropics, a light cotton pad should be attached to those parts of the straps which are in contact with the neck. Thin or unpadded straps are very likely to chafe moist skin.

A common fault in the tropics, humid or arid, is to assume that there is more light than is the case. This is especially a problem for photographers used to much cooler temperatures who will subconsciously associate high temperatures with bright sunlight. Light meters, not only those built-into the cameras, should be used with care, especially in the first few days of a trip. It should not be assumed that lens hoods are less necessary in the tropics because of the high angle of incidence of the sun. With colour film there may be a temptation to bracket exposures but this is very wasteful of film. Although it is wrong to assume that a constant adjustment should be made to exposures in the tropics, some precautions are necessary.

In the first place, the timing of photography is even more critical in the tropics than elsewhere, except perhaps in mountain regions. Although it is always a good plan, in almost any conditions, to photograph in the early morning or late afternoon, in the tropics it can be especially important when shooting in colour. The difficulty is not directly in the increased light intensities when the sun is high, but in the strong lighting contrasts. Detail in shadow areas is almost impossible to reproduce even when the *correct* exposure can be measured. White walls and water surfaces present special problems.

With monochrome, the same problem is more easily overcome because overexposure of the brightly lit areas can be compensated for at the development stage thus producing more shadow detail. However, two other tropical light problems affect mono and colour equally.

When the sun is almost directly overhead, there will be a near absence of shadow. Although this can be something of a problem in urban areas and in photographing people, the real handicap is in landscape photography. The lack of shadows produces uninteresting pictures, without dimensional quality.

Finally, it must always be remembered that the length of the tropical day is strictly limited. The sun may rise at 6 am but be gone by 18.00 hours. Sunrise and sunset are rather sudden happenings. This fact emphasises the need to plan the day's work carefully and not be caught out by the rapid onset of dusk. It is wise to start very early in the day, when light is good and the temperatures relatively low, avoid midday and complete one's work with a short session in the late afternoon before 16.30 hours.

THE ARID TROPICS

Some of the problems, outlined above, of the humid tropics are shared by hot dry areas. The same difficulties of high temperatures and light intensities will be repeated but, in addition, there will be dust and an increased diurnal temperature range.

Most travel photographers will agree that dust is the greatest enemy. Dust spells ruin to film, camera and lenses. Many desert and semi-desert areas are further characterised by strong winds and the penetrative ability of dust is quite extraordinary.

Precautions must be taken by providing protection for equipment and by frequent, scrupulous cleaning.

Lens caps must be placed in position whenever a camera is not in use and extended lens hoods provide some protection during photography. All equipment must be carried in dust-proof bags or

It is not lack of water but dust that is the hazard of the arid tropics. Kalahari Desert.

pockets. For spare lenses, soft leather pouches are ideal but care must be taken to keep any containers as clean as the equipment itself. Plastic bags can be used. Certainly they are dust-proof but beware of airtight bags used to store optical equipment for any length of time. Despite the general aridity, silica gel should be used in containers.

If caught in a dust or sand storm, the best reaction is to abandon photography for the time being. You are unlikely to be successful in any attempt to obtain dramatic shots of the event. Much more likely, you will spend the next twenty-four hours unsuccessfully trying to clean the camera. Simply put the equipment in a dust-free, dust-proof bag and sit out the storm. Only the uninitiated will doubt the penetrative powers of dust and fine sand particles.

The cleaning of lenses and other equipment in the arid tropics should be at least a daily task and it is a good habit to carry out a cleanliness check immediately before taking a sequence of photographs.

It is in dusty conditions that the blower is especially useful. Special high-pressure air syringes are ideal but the effect of high temperatures on cans of compressed air constitutes a potential danger. Dust *must* be removed with a blower *before* a brush is used on any glass surface or even on non-optical surfaces. Blower, brush, cloth should be the cleaning order. Fine brushes can be employed to remove dirt which may collect in the tiny crevices under and around the camera controls such as film advance levers, rewind knobs, shutter speed dials and so on. Any brushes carried should be carefully wrapped or put into plastic bags to prevent the brush itself from becoming greasy. A dirty brush can do untold harm.

When dust has been removed from affected lenses and viewfinders, these can be polished using an anti-static cloth. It is important to use such a cloth in arid areas otherwise static electricity may be induced and this will exacerbate the very problem the photographer is trying to eliminate. If lens cleaning fluid has to be used then it must be applied sparingly.

A filter is the best of all protection for a lens but care must be exercised to prevent dust from being trapped between lens and filter when the latter is being fitted or changed. What has been said above about the cleaning of lenses applies equally to filters.

The insides of cameras must also be cleaned, particularly around the film spool sockets and the surface of the film pressure-plate. Any dust specks on the pressure-plate will score film easily and this is a very common occurance unless cleaning is done with an almost religious fanaticism. (In any environment, a similar problem may result from tiny chips of film breaking off from around the sprocket-holes and being left in the camera body.)

If fine dust particles lodge inside moving parts, on the camera or lenses, it may be necessary, as a last resort, to dismantle the affected parts of the equipment. This should only be attempted by photographers who have a clear understanding of the mechanisms involved and no *major* repair or cleaning task should be carried out on any camera or lens unless by a trained technician. Fine screwdrivers, which may be part of the travel photographer's equipment, are best kept for simple jobs such as tightening any screw which has worked loose. Many a camera has been ruined by a photographer wielding a screwdriver with more confidence than knowledge.

Film inside its cassette will be immune from dust but once it is drawn out to load into the camera, dust is very likely to attach itself to the surface. Careful loading is essential. If particularly adverse conditions exist, it may be wise to load inside a changing bag. One way in which dust is transferred to film is via the felt lips of the film cartridge. These lips form an ideal harbour for dust and it is best to unpack the cassette from its drum only just before loading.

High diurnal temperature ranges in the arid tropics, and they can be of the order of twenty-five Celsius degrees, can cause some problems to film and to lenses. Even the mechanisms can be affected. Although *relative* humidities will be low, *absolute* humidities can be quite high. It is important, therefore, to guard against the same sort of humidity problems as described previously if equipment is stored overnight in artificial temperature and humidity conditions.

In the tropics, whether they be wet or dry, many photographers will wish to wear sunglasses. If correction spectacles are normally worn, it will be advisable to have sunglasses made to the same prescription. When glasses are worn, a simple rubber eye-cup, fitted over the viewfinder, will be a useful accessory. It should be added, though, that it is best to carry some spares because these cups have a propensity to drop off unnoticed. (An alternative to correction spectacles is a specially made prescription lens which will fit on to the viewfinder frame, but these are expensive.)

COLD ENVIRONMENTS

Until recent years, photography in very cold environments was largely restricted to expeditions. Now, with improved access to such places as Alaska, northern Canada, Greenland and even Antarctica, the independent travel photographer is as likely to find himself working in polar or sub-polar climes as in the tropics.

Because of the special light conditions of winter, to say nothing of the extreme cold, it will be most usual to confine work to the brief summer months. Even so, sub-zero temperatures may be experienced and the problems of snow and ice surfaces will be nonetheless.

To some extent it is a pity that, outside expedition work, the average photographer restricts work to the summer. Some of the most spectacular landscape and sky pictures are only possible in winter and, perhaps, a compromise might be effected by travelling to the polar regions in the short spring or autumn seasons. The advice which follows can be modified according to prevailing conditions but the most hazardous that might be met will be dealt with.

As with all travel photography, time spent in preparation before leaving home is never wasted. Unless cameras and equipment are old and in need of servicing, it should not be necessary these days to *winterize* mechanical parts. This used to be the practice but nowadays manufacturers, as standard, use lubricants which are effective at low temperatures. Most ordinary grease becomes solid at about minus forty degrees Celsius. If in doubt, the lubricant can be checked with the equipment makers and, if re-lubrication is required, a broad-range substitute will act as replacement. This is not a job for the photographer and cameras must be returned to the manufacturer's agent.

Cameras may need some adaptation to enable

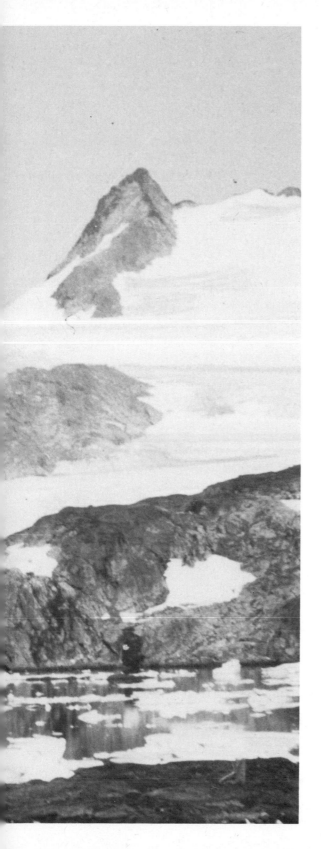

the photographer to work while wearing gloves. Shutter release buttons can be made easier to operate by the addition of oversize button attachments which can either be made or purchased. In the same way, it may be helpful to extend the film advance lever but care should be taken that any extension does not foul other parts of the camera or catch in the photographer's clothing. Black bodied cameras are to be preferred but a touch of matt-black paint can be an alternative. Because of the difficulty of changing film in sub-zero conditions it might be thought best to take more camera bodies than would otherwise be necessary.

There is a distinct advantage in taking at least one very simple camera. As will be explained below, in dealing with mountain regions, simplicity may be advisable for reasons of safety and, in very cold climates, a photographer may discover that he is rather less alert than normally. In any case, it may be wise to reduce to a minimum the time during which outer mittens and goggles are removed. A simple camera will almost certainly take less time to operate than a complex one.

Lenses should have rubber grips and, to give the gloved hand of the photographer a better hold, a simple rubber pistol grip can be attached to the tripod bush of the camera. I have found these grips invaluable in all sorts of situation.

Leather straps may be preferred to webbing because they will absorb less moisture and the risk of freezing and breaking is thus reduced. A few cameras, even expensive ones, have plastic straps or straps with some plastic fittings. These should be replaced because plastic becomes brittle and may break in sub-zero temperatures. Rubber eye-cups should be used with direct viewfinders. These prevent accidental contact between the metal of the camera and skin around the eye. If these are found to be awkward to fit and easily lost, a simpler substitute is sticky tape such as elastoplast.

Electrical power problems are common in very cold climates. Dry batteries will not function at full power and nickel cadmium batteries are similarly unreliable. This should be recognised in choosing equipment and it is wise to take check instruments, for example, cadmium sulphide meters can be checked against selenium cell meters.

A polar location should be attractive for the unique opportunities it offers to photograph landscapes untouched by the hand of man. East Greenland.

If a tripod is to be used then the photographer should also take something to form a solid base when using the equipment on a snow surface. A simple triangular piece of waterproof cloth can be cut to form such a base, with eyelets fixed into each corner. If working on an ice surface, a tripod with spike legs should be used and these can be hammered into the ice. In every case a wooden tripod, heavy enough to resist strong winds, is preferred to a metal one.

In selecting clothing for photography in cold regions, several points might be borne in mind. Film and any equipment using electrical current must be kept warm. For this purpose, a multi-pocketed inner vest is ideal, although some photographers prefer a belt with large insulated pockets. If electronic flash is being used, a dry battery feeding power direct to the flash unit capacitor can be the answer to many problems that might otherwise arise. This battery can be housed in a pocket close to the photographer's body.

A tip I have found especially helpful is to sew ring clips to the outer parka to be worn, so that additional safety straps can be attached to cameras and prevent that worst of disasters, a camera falling into snow.

Although more feel is possible using cotton or silk gloves, their insulation properties are poor and fine woollen gloves are preferable. These should, of course, be worn inside thick woollen mittens. Outer mittens need wrist-straps so they can be removed quickly but not dropped, when operating the camera.

In the field, cameras will best be carried in the outer pockets or pouch of the anorak. Some photographers carry them in a small knapsack but I have always found this an unnecessary burden. It is questionable as to how far cameras should be insulated from the ambient temperatures. If kept at too high a temperature, as in an inner pocket, condensation may become a problem. Ideally, cameras and lenses might be kept at around zero degrees Celsius, except when necessarily exposed to lower working temperatures. Even when the photographer returns to base, he should ensure that he does not store film or equipment in a warm room. Condensation can occur inside, as well as outside, the camera and is as difficult to cure as in the tropics. It is sometimes suggested that small hand-warmers should be attached with tape to the back of cameras. My personal view is that they are unnecessary.

Film changing, as has been said, is difficult. Loading should be avoided in exposed conditions

but, when unavoidable, some shelter should be sought, even if only that provided by the photographer's parka. In very low temperatures, film becomes especially brittle and advancing and re-winding should be done slowly and steadily to avoid breakages. Cleaning to remove small fragments of film has already been explained, but if a breakage occurs a pair of scissors can be used to cut the film before re-attaching it to the take-up spool. If a break occurs so that the re-winding or advancement is impossible, the film can be saved by using a changing bag.

If a travel photographer is working in the polar summer, he will be able to use the same film as he might employ at home. But if he is working in the cold season it will be advisable to take fast or very fast film after checking temperature effects on film with the manufacturers. More will be said about film speeds and exposures in Chapter 6 where the use of filters will also be explained.

In heavy snow, giving white-out conditions, it may be necessary to follow the advice for dust storms and sit it out. On the other hand, photography may successfully be practised, and without too much difficulty, in light snow. Lens hoods are essential and extended hoods may be advisable. Hoods also help to reduce flare risks. As before, metal rather than rubber hoods are recommended, not least because, in very cold regions, there is a possibility of rubber hoods cracking.

If snow gets on to the camera or lens it should be brushed off at once. It should never be blown off because warm, moist breath will freeze on to the camera and exacerbate the problem. If a camera or other piece of equipment fails to function, there is a natural reaction to remove one's gloves in order to investigate the trouble. This would be a foolish step because, not only is there a risk of frostbite, but slightly moist skin will freeze on to a metal surface.

COASTAL LOCATIONS

The itinerary of most travel photographers will take in the coast at some time or another. Indeed, it is likely that many photographers will want to combine business with pleasure and spend some time at a sea resort, especially after a difficult overland journey.

The problems of these environments are more technical than physical and Chapter 7 is devoted to coastal photography. However, there are some physical hazards which will be mentioned briefly here.

Salt water is a deadly enemy to optical glass, and breaking waves are difficult to capture on film.

Salt water is unkind to cameras. It is corrosive to an extent which will lead to the destruction of the surface polish of lenses and can cause mechanical parts to malfunction. Prevention, as always, is better than cure and equipment should be kept dry in waterproof bags until it is needed. Should some salt water get on to the camera body or lens then it must be wiped clean and dried. It is not sufficient to dry the affected parts because some of the dissolved salts may be left behind. The best plan is to carry a small plastic bottle of fresh water and some lint-free cloths. The camera can then be wiped with a dampened cloth before being dried. A lens can be further wiped with a cloth moistened with lens cleaning fluid, but use the fluid sparingly. It is unlikely that re-lubrication will be necessary but, if it is, care should be taken not to be over indulgent with the lubricant.

It is not unknown for cameras to be dropped into the sea even by the most careful of photographers. Should this happen, water will almost certainly enter the majority of camera bodies and any loaded film will be spoilt. Now the inside of the camera must be wiped clean and dried as quickly and as meticulously as possible. In the long term the best safeguard is to have the camera expertly cleaned and overhauled. Such is the magnitude of the misfortune if a camera does get badly affected by sea water that underwater housings should be used if there is a very real likelihood of such an event.

The only other major environment problem at the coast is that caused by sand or dust blown off beaches. The precautions recommended above, for the arid tropics, are equally applicable to the coast.

MOUNTAIN AREAS

I hope it does not need to be emphasised that mountains can be dangerous places and mountain climbing, as distinct from mountain walking, must be left to the experts. All the same, more travel photographers seem to be taking to the hills these days and mountain trekking is becoming increasingly popular.

At high altitudes, in say the Alps or the Himalayas, many of the problems described above, under Cold Environments, will be met and these will not be referred to again here. In addition, though, there will be difficulties resulting from low atmospheric pressure, strong winds, and the general physical hazards associated with mountains.

Reduced pressure, with altitude, puts a strain on all who are used to living at or near sea-level. For the photographer, it means special consideration must be given to minimizing the weight and bulk of equipment. Not only should lightweight equipment be carried, but the actual range of lenses and accessories may need to be reduced. It might be advisable to dispense with a standard lens and take along a wide-angle or ultra wide-angle lens (20–35mm) and a long-focus lens (135–200mm). Although zoom lenses may be ideal from the point of view of versatility, they may be too expensive to risk. Knocks and other damage may be unavoidable on a mountain trek.

The mountain environment is an established feature of travel photography but it has its problems. Jotenheim Mountains.

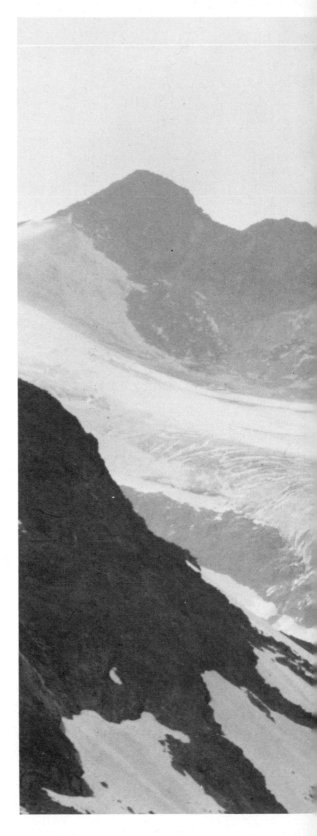

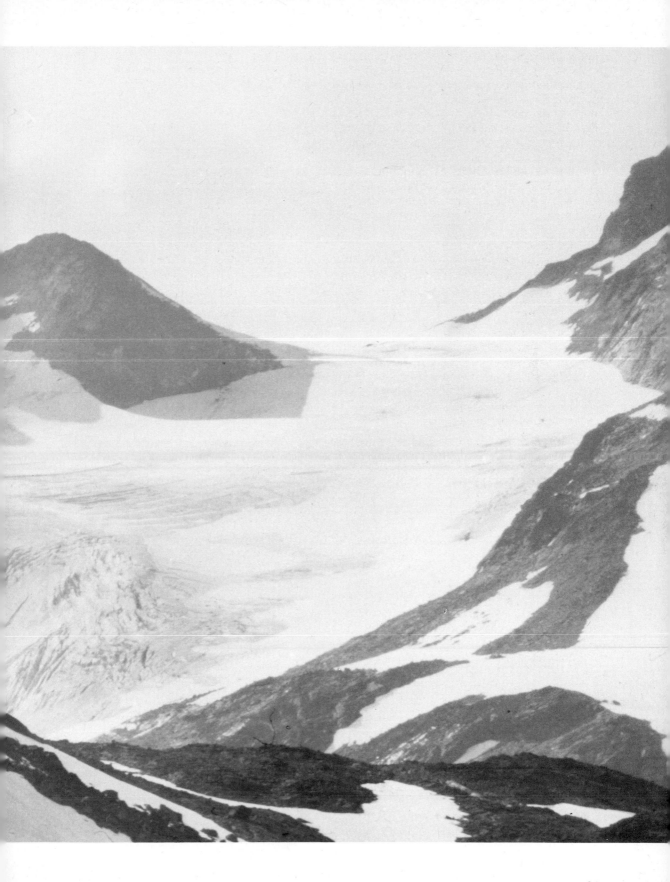

Compact cameras with fixed lenses should not be dismissed as unprofessional or too simple. Cameras with a fixed-focus lens can have their uses in mountain photography because they will usually have a good depth of field for distant shots. This latter point was put to me with emphasis in conversations with the Everest mountaineer, Doug Scott. Mountaineers need uncomplicated equipment. Their photography comes second to the serious business of climbing and staying alive. Yet we have all seen the superb results obtained with simple cameras by professional climbers who are amateur photographers. There is a lesson to be learned.

One special problem does occur when using compact cameras in high mountains. The photographer may well be wearing gloves and the controls of very small cameras are, not surprisingly, difficult to operate in these circumstances.

Low atmospheric pressure, especially when combined with cold, reduces mental alertness and, if the going is difficult, it is particularly important to use simple equipment that can be operated efficiently while the photographer's attention is often partly diverted to other matters.

One of the simplest lessons learned by every photographer is to avoid camera shake by holding his breath while he operates the shutter. At very high altitudes, especially when, say, scrambling over a none too static scree slope, this elementary practice can have its dangers. The photographer is left gasping and his carefully controlled breathing pattern is disturbed.

Yet there remains the problem of holding a camera steady when shooting. In all mountain regions, strong winds may add to difficulties, blowing, as they do, up slope during the day and down slope towards evening. Answers to this problem lie in using natural or artificial aids. The photographer can brace himself against any rigid object, such as a rock outcrop or a tree, or he can employ some sort of artificial support. Carrying a weighty tripod up a mountain is obviously out of the question, unless perhaps the photographer is helped by porters or mules, but simple light supports can give a measure of steadiness to the camera. These range from ground spikes, wood screws and universal clamps, all of which can be purchased, to adaptations of the photographer's climbing equipment. The commercially produced supports have a ball and socket head which screws into the camera's tripod bush.

The same sort of ball and socket head can be bought separately and used in conjunction with an ice-axe or alpine walking stick to make an adaptable monopod. I had my own ice-axe drilled at the top to accept just such a head which I carry in my pocket and use when I need.

Because of the strong ultra-violet radiations experienced at high altitude, film loading and unloading can be difficult and care must be taken if fogging is to be avoided. A changing bag is a simple solution to this problem and every photographer should be able to change films by touch alone.

On many mountain treks, especially in the Himalayas and in the Andes, porters will be employed but it is very unwise to consign photographic equipment to their care. It is unfair to expect them to treat cameras and lenses as anything but part of their general load and they will view a camera bag in much the same way as an air-mattress.

POSTSCRIPT

Most of the problems that have been described above will vary from season to season and there is little point in travelling to a location at the time of year that conditions are at their worst. Yet I often find that photographers, in common with other travellers, pay far too little attention to climate conditions when they arrange their journeys.

It is not sufficient to ask the girl behind the travel agent's counter. Her job is to sell travel facilities and she may well not be at all sure of the exact location of Darjeeling, let alone know that three-quarters of its 120 inches of rainfall occur in the four months June to September. To make a trip to Hong Kong and then be confined to one's hotel for four days of typhoon storms, or to arrive in West Africa on a landscape photography trip when the Harmattan is spreading Saharan dust thickly through the atmosphere, is an expensive mistake.

Even Embassies can be misleading about weather conditions and a wise plan is to consult books of climatic data at a library or, better still, try to contact someone who knows the country well and has some appreciation of the problems likely to confront a photographer.

Apart from temperature and rainfall figures, the intending travel photographer should try to find out about conditions of humidity and of seasonal winds and storms. Atmospheric humidity can play havoc with landscape photography and high relative humidities coupled with high temperatures should be avoided. Put simply, the drier the air the better.

In some cases it may be necessary to know in advance the probability of snow in a particular location. Just as anyone embarking on a skiing

Even storm phenomena can be photographed. This ghostly image of a waterspout vortex, produced by storm-force squalls, was photographed on Lake Gäutan in Sweden.

holiday will eagerly watch the snow reports, so too should a photographer who may with to include snow scenes in his winter travel schedule.

With wildlife photography another seasonal variation is important. There is always a good time and a bad time to photograph wildlife. It is not just a matter of arriving at a location to find that, quite literally, the birds have flown. Breeding habits, feeding habits and migration patterns play a part in deciding the best season to photograph particular species.

Lastly, there can be times when the travel photographer will wish to avoid well worn tourist routes in the middle of the holiday season. Not only is there a cost advantage to be gained by travelling off-peak, but many parts of the world are best seen when not over-crowded with holiday makers. This is especially so when *natural* pictures are required and scores of white faces in, say, an African street scene are out of place. A quick glance at travel brochures or a word with a good travel agent will usually provide sufficient information.

4 On the Move

It is possible to generalize and to classify a travel photographer's work as either making journeys or as travelling in order to cover a particular location in depth. The former would consist of moving quickly from place to place, practising photography en route, while the latter might be operating from a single base but away from home. In either case, some time will be spent on the move, by air, sea or land. This chapter deals with the opportunities afforded the photographer while he is travelling.

BY AIR

Two different opportunities are offered by air travel. Most commonly, a travel photographer will make use of scheduled commercial flights and, although somewhat restricted, there will be occasions when the camera can be brought into use. Quite different will be opportunities to photograph from light aircraft and helicopters. Except in very special circumstances, the travel photographer will be concerned only with air-to-ground pictures and with aerial obliques rather than with verticals. Air to air pictures can be dramatic, but except for distant shots of passing airliners, it is not easy to obtain good results without special cameras and pre-arranged conditions. Vertical air photography is best left to specialists with cameras and equipment adapted for the purpose. Nevertheless, some near-verticals are posslible from light aircraft and helicopters using conventional SLR cameras.

Anyone who has flown will know the fascination of seeing our planet from above. The bird's-eye view never ceases to be interesting, not least because it is different. A large part of the art of photography is in presenting a unique view of the ordinary, and thus it is with air to ground photographs. Despite all the difficulties, no travel photographer should spurn the chance to take shots from the air. Even if some results are disappointing, one good air picture is worth all the effort.

Some ten years ago I travelled with a party of academic geographers to a conference in India. As we flew low over the Agean Sea, the little islands were looking especially alluring in the soft light of early evening. Everyone had a camera. Everyone wanted to take pictures to illustrate his lectures to students. But the islands could be seen only from the port side. Suddenly almost the whole passenger load was transferred to that side of the aircraft. Just what the pilot thought had happened I do not know but he was quickly appealing for everyone to resume his seat as the aircraft's trim had been upset! Perhaps, too, there are dangers in air photography!

To take satisfactory pictures from an airliner requires preparation, quick reflexes and a certain amount of luck. Preparation starts at the airport or even before. Without increasing the cost of a journey, it may be possible to choose from a variety of routes one of which will offer the best opportunities for photography. Overland routes rather than trans-oceanic may be preferred and the greater the number of stops there are the more often will the aircraft be flying at lower altitudes. If stop-overs are permitted then, of course, the photographer can include these on his itinerary. Examples of journeys which offer different routes might be Europe-Japan, with the opportunity to fly a polar route; USA-Europe, with the choice of stop-overs in Iceland and a crossing of the Greenland ice-cap; and Europe-South Africa, with stop-overs in East Africa. All these journeys can be done more quickly but, photographically speaking, less interestingly. Clearly, decisions about times of flights should be made with photography in mind. It is little use flying low over the Alps on a moonless night. Even when cheap package flights are used, it may be possible to choose a different return route from the outward flight.

The ideal seat for photography (and it must be a window seat unless you want to risk the wrath of your fellow travellers), varies from aircraft to aircraft. The view from middle section seats may be interrupted by the wings and other seats may be of little use because of air disturbance from heat-

Photography is often concerned with presenting images seen from new viewpoints. Air travel provides unrivalled opportunities. As I shot this photograph of the Greenland ice cap, a low arctic sun gave shadowy emphasis to the protruding *nunataks*.

generating engines. In fact, with exhaust gases making for unsharp pictures from any aircraft, perhaps only a quarter to a third of the window seats will be satisfactory for photography. Try to find out what aircraft you will be using and then look up its configuration and consult a seating plan at the airline offices.

If it is possible to book a seat in advance, then this should be done. If not, get to the appropriate gate in good time to lead the dash on board. It is very important to ensure that the best side of the aircraft is chosen. The best being the side furthest from the sun. Thus flight path and time of day are important factors. For example, if flying to London on a noon flight from Cairo, choose the starboard side. This may, of course, be no help when the aircraft is landing or taking off but for the rest of the flight it can make all the difference between

good pictures and no pictures at all, except perhaps for some spectacular sky shots.

Once settled into a seat the camera should be kept at the ready. A standard lens (50–55mm on the average SLR 35mm) produces the best shots and any long-focus or wide-angle lenses can remain in the camera bag. The aircraft's perspex windows can be cleaned with a handkerchief to remove any smudges and hope that the outside of the window is dirt free. Back reflection from the window can present problems but a polarizing filter should not be necessary. Instead, use an ultra-violet filter as a matter of course. If you have a co-operative travelling companion and reflections are troublesome, it can be helpful if a dark object, an airline blanket, for example, is held up behind the camera. Window problems are least in old slow aircraft with unpressurized cabins, but

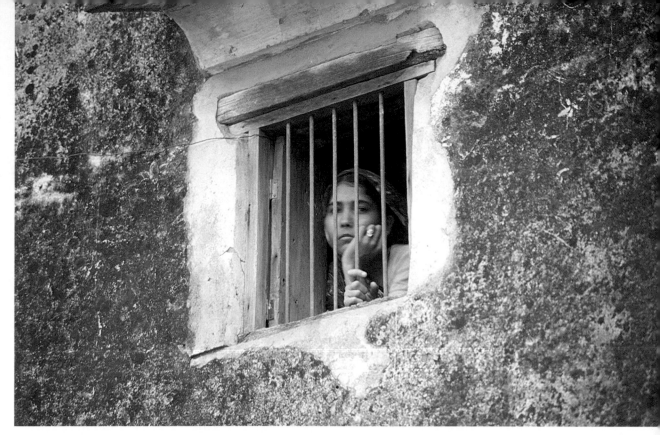

Who were they? The travel photographer records what he sees and passes on. *Above* Who was the girl watching me from behind bars in an Indian village? *Below* And whose was the hand that held the brass pot while the little girl washed her hands?

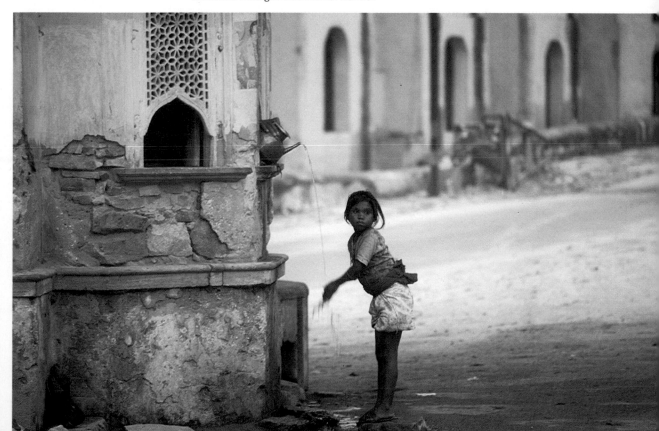

Wet and dry. *Above* An African rainforest. The sun, hidden behind the leaves, throws its light on the dense mass of vegetation. *Below* The scale of the Swartberge Mountains is emphasised by the tree in the middle distance and the foreground rocks.

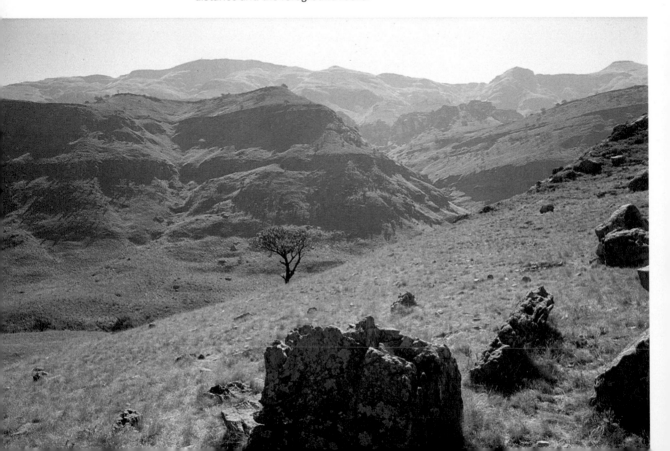

From the road I could see little of the form of this scattered Lapland village. From the air it was a different picture.

with a bit of care and luck, the window itself, out of focus as it will be, need not be thought of as a major handicap.

Because of the large mass of air separating the subject from the camera, the UV filter is essential, at least for colour photography, but for monochrome work, a pale yellow filter will improve shots which include both ground and sky. If working in black and white, panchromatic film is best with its sensitivity to all colours of the visible spectrum. For colour, a medium speed (ASA 64) rather than a slow speed film will give greater latitude in changing light conditions.

Shutter speeds should be fast rather than slow but one-hundreth of a second is adequate for most shots, increasing the speed at landing or take-off when the speed of the aircraft relative to the ground will be most troublesome. The camera should never be held against the window because of the effect of vibrations. The preferred position is about one or two inches (2.5 to 5cm) away from the window and tilted at the smallest angle to the plane of the window that can conveniently be allowed by the subject's position.

I find that it is a good habit frequently to check the light readings and keep the lens focused permanently at infinity. If this is done as a matter of routine, it is unlikely that opportunities will be lost. Through the lens metering should be sufficient for most purposes. If any adjustment is made to the metering it should be towards underexposure.

Turbulence problems are not unknown, even with large airliners, flying below the tropopause, but unless one is flying in very stormy conditions then it should not affect photography.

The subjects available to the travel photographer in a commercial airliner depend chiefly on the nature of the route. It is sometimes said that air to ground photography should be confined to heights of 1000 feet (300 metres) or less but this is neither practical nor necessary. Modern aircraft will often fly at more than thirty times that height and will climb to 1000 feet very rapidly after take-off. It is at low altitude, when climbing or descending, that aircraft vibration will be at a maximum and getting good pictures at these times is almost a matter of luck.

It is quite possible to obtain more than satisfactory results photographing air to ground at heights between 20,000 feet and 30,000 feet, and I have taken and sold photographs of the Sahara from 38,000 feet using a 35mm SLR camera.

Naturally, the more spectacular the landscape the better the picture potential but photographs of towns, harbours, even field patterns, should be sought. Aircraft frequently fly along coastlines and the conjunction of land and sea provides a wealth of interest, especially if wave patterns or shipping are visible. If the sea is calm, photograph the varying shades of sea-green which characterize the shallowing depth in the off-shore zone.

No air to ground view should be uninteresting. Over tropical forest look for a gap in the foliage canopy which may indicate a village or agricultural clearing. Flying over a sand desert, pick out patterns of crescentic dunes even when you cannot spot an oasis. Over ice masses such as Greenland, watch for a sudden break in the snow as a single peak, or *nunatak*, thrusts through the white blanket.

With air to ground photography it is important to look ahead as far as possible and be ready to shoot at the optimum viewpoint. At heights above 10,000 feet it will generally be possible to expose three or four frames on a single subject with manual wind-on.

There is no reason to confine photography simply to the ground surface itself. In the case of mountain ranges it is better to compose the shot to include at least one-third sky in the viewfinder. In this way the grandeur of the mountains will be more evident. It is when flying over areas of high relief that the air to ground distance will be least and some of the most dramatic pictures can be produced.

Modern aircraft fly high and for much of any journey little or nothing will be seen of the ground. At these times it is often difficult not to relax one's concentration, fall asleep or read the in-flight magazine. Yet by so doing plenty of good sky shots may be missed. Some of the best times for air to air sky photography will be at sunrise or sunset but it is worth looking out for unusual or spectacular cloud formations. Tropical skies often provide the best cloud pictures: towering cumulus, parallel lines of cloud giving wonderful studies in perspective, and even storms. A couple of years ago, in a battered World War II aeroplane in Thailand, I flew alongside a tropical storm fascinated by the sharp division between landscape bathed in strong sunlight and areas suffering a tropical downpour. The sky contrast was just as sharp, no gradation, just grey-black and sunlit blue.

On a long flight it may be possible to pay a visit to the flight deck to take pilot's-eye view pictures. If

travelling first class, or one is known to be a professional photographer, a visit can usually be arranged easily, otherwise a friendly stewardess in the economy class will often provide the necessary introduction. Photographs from the flight deck are best taken with some of the array of instruments in the foreground and for this purpose a wide-angle lens may be necessary and also give sufficient depth of field. Ideally, to avoid strong lighting contrasts, inside and outside the aircraft, photography should be with the sun behind the aircraft and late or early in the day.

Too many travel photographers fail to exploit the opportunities offered by working from light aircraft or helicopters. Perhaps they dismiss them as too expensive or even too dangerous. While the cost of hire of private aircraft in some parts of the world may be prohibitive, this will not be the case in more remote regions where the aeroplane is a commonplace mode of travel. The same will be true of areas where private flying clubs are numerous. High costs, in my experience, are most frequently found in Western Europe. However, in northern Scandinavia, for example, it is possible to obtain the use of light aircraft at very reasonable fees and the further north one goes the cheaper flying becomes. If commercial companies are either not interested or too expensive, it is worth trying the clubs. My own air to ground photography started in north Norway, using seaplanes and landplanes, and I have since used seaplanes to cover large stretches of the fjord country of western Norway. Elsewhere in the world, I have used aircraft which were even cheaper if somewhat less air-worthy. Before leaving home it is worth enquiring about flying clubs at one's destination. Bodies like the British Light Aviation Centre can be very helpful with information about overseas clubs.

The three main advantages of light aircraft over commercial airliners are the freedom to choose one's own flight path, the low altitude that can be maintained and the ability to photograph with the camera held outside the aircraft, or at least at an open window.

To make full use of the first advantage it is necessary to plan in advance either from a map or from ground reconnaisance. Often it is useful and interesting to obtain air coverage of subjects also photographed from ground level. If not flying oneself, discussion with the pilot may modify plans but most pilots welcome the chance to vary their usual flight routes. Once agreed, the photographer should not expect to alter the route after take-off although some short sections may be re-flown in

order, for example, to cope with rapidly changing light conditions. The photographer's work must go smoothly throughout the flight because errors would be expensive to correct by additional hours of hire. If weather conditions might be too poor for good photographic results it is almost always possible to postpone flights to another time.

I have been particularly careful about planning routes since an early, somewhat perilous experience in Norway. My assistant, who was also acting as my pilot while I did the shooting, and I had taken up a Piper Cub at short notice to photograph the Svartisen Glacier. We found the glacier, spent some time over it and then got lost on the way back. Our only navigational aid was a road map and we could see no roads. With the fuel tank almost empty, we caught sight of the airfield, a strip cut out of the forest, just as we had decided we might have to risk a belly-landing in a lake. Route planning is necessary not only for good photography.

The altitude at which to photograph from light aircraft depends on the subject as well as on local flying regulations. In open country it may be possible to fly as low as 300 feet (100 metres), ideal for detailed shots of anything from game to bush villages. Over towns, if flying is permitted at all, it is likely that the minimum height will be 1000 feet. However, compared with airliners, these low altitudes give far greater opportunities for air to ground photographs with sharp detail.

Photography from a light plane is exceptionally difficult unless using a high wing model. There are well over one hundred thousand light aircraft in the world but, unlike the situation in the 1960s when about two-thirds were high wing, the most modern are low wing and the proportion of high wing craft diminishes annually. The majority of high wing aircraft have wing struts and these can narrow the potential angle of view. This problem can be overcome by careful checking of the viewfinder before shooting or alternatively, the struts can be incorporated in the picture. There is something attractive about framing a shot of the ground in the triangle formed by the wing and struts.

I have found the ideal planes are two-seaters in which the pilot occupies the rear of tandem seats. This allows the photographer to have a commanding view and he can anticipate the approach of suitable subjects. With an open window there is no problem from reflections. The photographer should ensure that he is not resting against the aircraft body or there will be vibration problems. At speeds of around 100–150 mph it can be none

A seaplane is the most convenient transport for photography from the air. It is also a good way to carry supplies, like this giant salmon, to base camp. River Alta, Finnmark.

too comfortable working from an open window and, rather than face the onrush of air, it may be wise to shoot as the plane passes over a subject or when the subject is to the rear of the aeroplane. An exception should be made when photographing wildlife which may take fright at the noise of an approaching plane and disappear from view before the aircraft arrives over the subject.

Strong light contrasts may be expected between the ground and the sky and a lens hood should be used to cut out unwanted light. It may be necessary to overexpose the sky. A UV filter should be standard equipment.

When not working with an assistant it is advisable to have two or three camera bodies loaded so that little time is wasted changing film. Lens changing from camera to camera is a far faster operation.

For shots of ground subjects, without any part of the sky in the frame, and when the subject is almost vertically below the plane, it will be neccessary to ask the pilot to bank. With a high angle of bank a near-vertical photograph is possible. It may take a little nerve to do this for the first time if the photographer is unused to flying in light planes but concentrating on the photography is a fine distraction. It is very necessary to check that the camera straps are securely attached or there could be some difficult times ahead with an insurance claim.

It might be thought that all the advantages of air to ground photography from light aeroplanes will be enhanced when shooting from a helicopter. They are, but there is one serious disadvantage. The types of small helicopter that offer the best opportunities for photography are often those which also suffer most from vibrations and this can be an almost intolerable handicap even with fast shutter speeds. It may be necessary to work at speeds as fast as 1/500. On balance I prefer light aircraft but I must admit that the unique abilities of the helicopter, to hover and to fly at very low altitudes at low speeds, do sometimes outweigh the drawbacks. The helicopter really comes into its

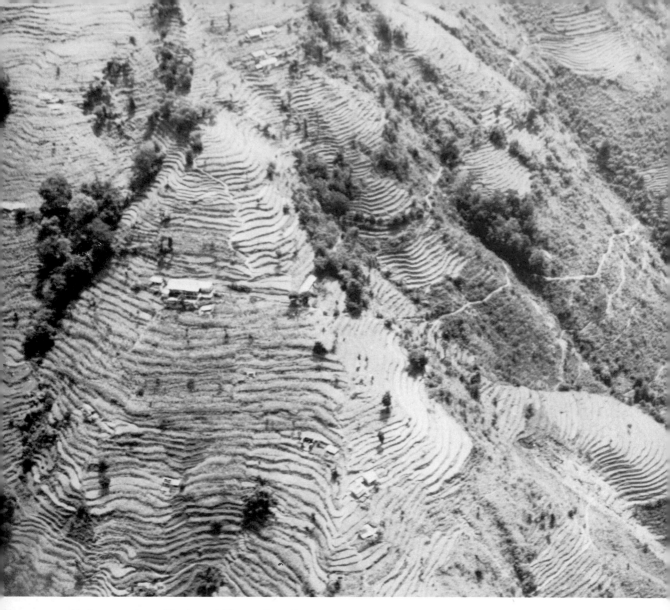

Helicopter view of intricate hill terracing of Sherpa farmers in Nepal. The *only* way I could see this sort of country without weeks of trekking.

own when photographing in mountainous areas. It can maintain an almost constant air to ground distance in a way in which no light aircraft would dare to emulate. Working from a helicopter in the Himalayan piedmont up to ground altitudes of 10,000 feet almost convinced me that here was the ideal way to photograph from the air. But over less rugged terrain I still believe the aeroplane is preferable.

One final point about air to ground photography must be mentioned. Many countries, not only those known for their sensitivity to matters of security, forbid aerial photography, either totally or in certain regions. In airliners crossing these

zones, the stewards may warn you about the regulations and it may be judicious to keep the camera out of sight as far as possible. Using private aircraft, the same rules will apply but even if you are not using your own pilot, it is not uncommon for local pilots to turn a blind eye. Although many countries require photographers to hold permits for work from private planes it is often questionable whether or not to seek one. For every country that applies the rules strictly, there are three which do not. I have only once been flatly refused a flight by a pilot, for photographic purposes, and that was along the Soviet border!

BY SEA

Other than for relatively short ferry journeys, few travellers now use sea transport but the travel photographer whose route takes in a sea crossing should be aware of the opportunities this form of travel offers. Many of the creative techniques which apply to photography at sea are the same as those appropriate to coastal locations generally and, as such, are dealt with in Chapter 7. It will be sufficient here, therefore, to deal specifically with sea journeys.

Most of the opportunities associated with a journey by sea occur at the start or close of a voyage, including the time the ship is in port. Photography in ports is dealt with in Chapters 7 and 10 but it should be emphasised that if travelling by ship it is important to arrive in good time to make the best of photographic opportunities. It is as well to mix port photographs to give a balance between those taken from the harbour side and those taken from aboard ship. Photography from the ship is best done from the highest available deck if the ship itself is to be included in the harbour pictures but from a lower deck if only the harbour is to appear in the frame.

The embarking of passengers, loading of cargo, farewell scenes and the casting off of the ship are obvious subjects. The bulk of the ship may cast deep shadows across the quay if the lighting is from the far side of the vessel and it may be necessary to

Tysfjorden from the bridge of a coastal steamer. An example of *natural* framing.

Activity on a quayside is easily photographed from deck level. Here, arctic islanders have come to collect milk and groceries brought in by ship.

overexpose slightly if no other solution can be found. However, it often is possible to find better lit sections of the quay by moving either to the poop deck or forecastle. From the forecastle it is usually possible to obtain pictures of the bridge and, using a long focus lens (135–200mm), of the ship's officers directing the departure. On vehicle ferries, interesting photographs can be shot from the car deck as loading takes place. The giant doorway of the car deck may act as a suitable frame for these

photographs and allow the photographer to stand well back, so avoiding interfering with the work in hand. Using a wide-angle lens (say, 28 or 35mm) will give a good depth of field for such pictures and also allow a viewpoint not too far back in the hold.

With many sea ferries, opportunities are multiplied as the ships call into small ports and harbours before arriving at their final destination. It is worth looking out for scenes of human interest such as a family reunion or the taking on of local produce. In

common with railway and bus stations, and airports, the sea port is by its function an active place and photographs should try to capture some of the sense of action.

During the voyage it may be possible to photograph the coast if the vessel is sufficiently close. There is a problem, however, if the ship to shore distances are such that a long focus lens is called for. Even on the calmest of days any ship will roll and pitch slightly and, on small ships, there may also be vibrations. To avoid a tilted horizon is especially difficult although it is, of course, possible to crop the picture later to obtain a horizontal coastline. The problem is aggravated using a long focus lens. If it is thought that trimming may be necessary, it is wise to allow for this by a margin around the central subject. This need not be particularly large but any essential element in the subject matter should be brought well within the viewfinder frame. A fast shutter speed is only a partial solution.

Coastline pictures often suffer from a surfeit of sea and sky. Again this can be cropped at the print stage but this is no real solution if coloured reversal film is being used to produce transparencies. There is nothing less interesting than a picture of a stretch of coast appearing as a hairline dividing sea from sky. If the shore is too far away to fill at least 20 percent of the frame it may be advisable to think twice about shooting.

On long sea voyages of the pre-war era, there was always a ship's photographer filling a role similar to that of the seaside promenade camera-man. He took pictures of the passengers on deck and in the saloons. I do not suggest that a travel photographer should see this as part of his commitment, but he should be aware of the picture potential of his fellow passengers at play and relaxing.

Deck pictures present few problems but interior shots are especially difficult on a ship. Bright shafts of light from port-holes contrast with the relatively dimly lit parts of the ship's saloons and gangways. Flash can be used rather than available light but discretion should be exercised to avoid causing annoyance. One subject that may be considered is the engine-room which passengers can often visit by arrangement. The restricted space will call for a wide-angle lens, the movement of machinery will demand fast shutter speeds and flash will be unavoidable.

Somewhat hackneyed but still effective shots can be had from the stern of the ship with plumes of foam stretching away to the horizon. If taken near a port or off-shore, these stern views will almost certainly include a colony of gulls which will be in attendance. If sailing by night look for impressive sea-sky shots incorporating the moon or setting sun. A long-focus lens should be used for moon pictures. In these photographs it is better to ignore the foreground and shoot with only the middle distance and background in the frame. It is the uninterrupted view that is compelling and it is as well to check the line of the horizon very carefully before exposing. The ratio of sea to sky should not be 1:1 but probably nearer 1:2 for a really interesting picture. Remember the sea, unless reflecting a lot of light, will appear inky in the late hours.

Sea birds have an uncanny sense of timing, seeming to know when food is at hand. Look out for the discharge of kitchen waste from the galleys and the hungry onslaught of the gulls. Another event to be anticipated is the arrival or departure of a pilot. Crew members may be helpful in supplying information about times and positions.

Finally, during a voyage of even quite modest length look for interesting close-ups of deck equipment such as capstans or anchor chains, or of the ship's flags or masts. Close-ups of little details like tell-tale rust deposits running down from a port hole make marvellous colour abstracts. In good weather there is plenty of interest for the observant picture-seeking travel photographer on any sea journey.

BY LAND

Photography on overland journeys is an essential part of the travel photographer's work. While sea and air journeys might possibly be considered interludes for relaxation, travel by land is an integral element of location photography. All forms of transport offer some opportunities but there are problems too.

Perhaps the greatest scope is likely to occur on trains. They cover long distances at moderate but steady speeds, tracks are often raised above the surrounding countryside and there is far less foreground obstruction than will usually be the case with roads. An additional advantage is that the photographer can probably move about the train with far greater ease than will be so in travel by bus, coach or car. The luxury of an observation car is not necessary to produce satisfactory shots from a train.

Unless the train is stationary, the photographer will have to balance the speed of the train with appropriate shutter speeds. Vibration adds to the problem and it is unlikely that work will be at speeds below 1/250. As already explained in the

A sharply curving track is one of the best places at which to photograph from a train. The bend allowed me a good view of the Chinese university and an approaching train on the Hong Kong–Canton line.

case of aircraft, it is important not to use the railway coach itself as a prop. The photographer should stand rather than sit, allow himself to move with the movement of the carriage but not brace himself against its structure. It is helpful to keep the elbows in against the body and, with a direct viewfinder, hold the camera against the eye, using an eye-cap. Slightly less vibration will be experienced in the middle of a coach rather than at the ends where the bogie movement is greatest.

Unless the train is air-conditioned, photography should be from an open window and, to avoid falling out with your fellow passengers, it is, therefore, better to operate from a corridor if the train has one. Should it be necessary to shoot through glass, the same advice as for airliners would apply and a polarizing filter may be helpful.

One particular difficulty with photography from trains is that it is often very difficult to see very far ahead. The best view is normal to the line of the track. To anticipate likely subjects it may be necessary to put one's head to, or even out of, a window. Obviously it is not necessary actually to

lean out of the carriage but, even so, it may be advisable to wear sunglasses to give some protection to the eyes if prescription spectacles are not usually worn.

Two variables, other than the train's velocity, will decide shutter speeds and the ease with which a sharp image may be obtained. These are the viewpoint and the proximity of the subject. The viewpoint is, of course, determined by the moment the shutter is released. It is advisable to turn the camera at an angle to the line of the track, shooting either at advancing or receding subjects rather than at the moment when the subject is normal to the line of the train's path. The simplest method is to watch for subjects as the train approaches them, then turn to photograph as the train pulls away from them. This will not always be possible, for example, when the subject cannot properly be seen except on approach, or the perspective is wrong, but for general landscape shots the viewpoint will not be critical. The speed at which the subject is moving across the field of vision is dramatically changed as the viewpoint alters.

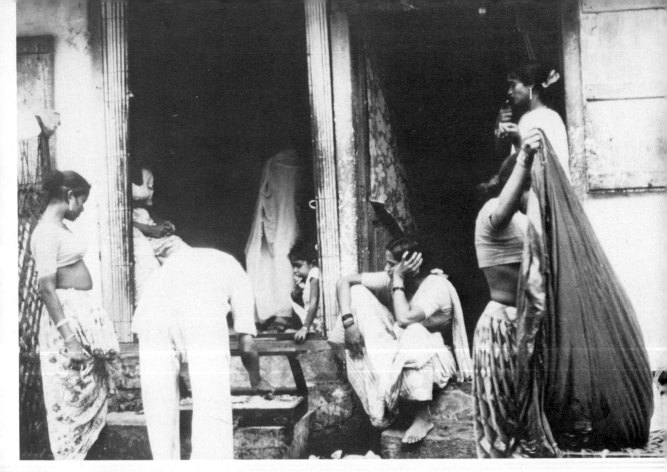

Only from a car did I feel it was really safe to photograph these prostitutes in an Indian street!

Unless the train is travelling at a very slow speed, it will not be possible to obtain sharp pictures of subjects close to the track unless very high shutter speeds are used. The camera is probably best employed in capturing subjects in the middle distance and background. Although a photograph from a moving train can be purposely blurred to suggest movement, there is little to commend a fuzzy landscape shot from any train.

The bane of the photographer attempting to shoot from a train are telegraph poles and wires and other obstructions to his view such as bridges and signal gantry. Anticipation is often the answer to these potential difficulties but it should be noted that telegraph lines will most often be restricted to just one side of the track.

The gauge of the railway determines the radius of curvature of bends in the track. With a narrow gauge, very sharp curves may be built into the system. If it comprises a large number of coaches, it is possible to take interesting shots of much of the train as it negotiates a sharp curve. From a position at the rear of the train, photographs of the engine

and its forward coaches can easily be shot and, in countries where trains are frequently overcrowded, something of the passengers will be seen even if they are not travelling on the roof! Particularly narrow gauges are found, for example, on some of the Indian lines, in South Africa, and in parts of Australia and South America.

Interior shots in trains often suffer from over contrast when a view through a window is included in the frame. Compensation at the processing stage is possible with black and white. With colour, it is best to have the interior subject, say, a travelling companion seated at a window, as well lit as possible. This may be achieved quite simply by moving from one side of a compartment to the other or by placing or choosing a subject forward or to the rear of the window. For such shots the shutter speed may now be slow enough to allow the view through the window to be blurred, thus showing the movement of the train. Alternatively the speed may have to be very fast if the exterior view is to be sharply in focus. A wide-angle lens will give an adequate depth of field while

Cable cars provide inexpensive bird's-eye views. I shot this photograph of Cape Town's Lion's Head on my way up to the top of Table Mountain.

also including a substantial amount of the compartment's interior.

Travel by train gives a photographer unique opportunities to shoot pictures of locomotives and rolling stock which may be drawn up near his train. In many countries, entry to sidings and track areas is strictly limited but the passenger on a train cannot be denied a degree of access. Countries, such as India, which still have a steam locomotive network, are especially attractive and the age of

photography when actually on the move. Vibrations, window reflections and foreground obstructions cause difficulties. If travelling by private car, then there is usually the alternative of stopping and leaving the vehicle. Only in the case of sensitive subjects, when a car may be used as a *hide* (see Chapter 8) should it be strictly necessary to shoot from inside. When travelling by public service bus or by coach, it may well not be possible to stop, yet it would be foolish to pass by the chance to photograph subjects seen en route.

A passenger on a double decker bus who wished to photograph would choose the front seats of the top deck. On a coach or single deck bus it may be necessary to photograph either from the rear of the vehicle or from the sides. Windows are often difficult to open or give inadequate space, when open, through which to manoeuvre a camera so that there is no alternative to shooting through glass. Much of what has been said already regarding avoidance of vibration and reflections will apply here but, since the angle of view will be especially limited, photography from inside a vehicle will make it particularly desirable to use a very fast shutter speed (say, 1/500). When photographing from a fast moving viewpoint such as a motor coach, the most appropriate lens is probably a medium wide-angle (35mm).

When travelling by coach it may be possible to use the roof for photography at stopping points. Coaches that have a rear ladder, used for loading luggage on the roof, allow easy access and few drivers will raise any objection if permission is sought. The only problem might be that you could start a stampede of your fellow travellers all eager to share your privileged viewpoint some eight to ten feet above ground level.

The easiest of all on-the-move photography, sometimes producing stunning near-aerial effects, is from cable-cars, funicular railways and bucket lifts. Many towns in developed countries that are near mountains have such attractions as, of course, do ski resorts. If the car tends to move jerkily, it is as well to try to *feel* the rhythm before shooting, but for a relatively small fare or fee it is possible to do the journey more than once as well as to photograph on both ascent and descent.

Despite all the difficulties it would be foolish for a travel photographer to pack away his cameras every time he set out on a journey and to restrict his work only to those occasions he has his two feet on the ground. A great deal of fun, as well as rewarding photography, can be had by keeping a camera at the ready no matter what may be the means of transport.

some of the railway stock makes for almost historic pictures. Whether or not we are railway buffs, there are few who do not find a certain fascination in old railways.

When photographing railway engines do not neglect close-ups of small details of machinery, the giant wheels, the opening of steam pressure valves, activity on the foot-plate and so on. Engines being cleaned or re-fuelled provide other subjects.

Road travel provides fewer opportunities for

5 In Town

Apart from expeditions to some of the more remote parts of the globe, most travel photography will include work in towns. Indeed, a town will often be the point of entry to a foreign country, certainly if travelling by ship or aeroplane. It may be the traveller's first or even his only experience of a particular region. Here he will wish to capture the sense of place which is the goal of much travel photography.

The opportunities for urban photography will depend, to a large extent, upon the length of stay and the size and complexity of the town. Stop-overs on long flights may be for as little as twenty-four hours. A town may be used to provide a few days' respite in the course of a long overland journey or an expedition. Alternatively, a town may be chosen as a base from which to explore the surrounding countryside or as what the travel firms refer to as a single-centre holiday. In any event, no opportunity should be missed, at least to get something of the flavour of the urban scene recorded on film.

The size of the town is just as important a consideration as is time in planning the photography. It is not simply a question of area but of the morphology and nature of the town. Assuming broad general objectives, it will be worth an attempt to list the variety of subjects it is hoped to shoot and to strike them from the list as a successful picture is obtained. Some of this preparatory work can be undertaken before departure (see Chapter 3) but there is nothing to replace reconnaissance on the ground.

The precise plan of action will vary according to circumstances and the photographer's personal objectives and preferences, but what is described below may serve as an illustration of the modus operandi of a travel photographer working in a town.

Although it would be foolish not to carry a camera at all times, it may be sensible to devote the first day or so to ground planning without serious photography in mind. While the central area of a small town may be covered easily on foot, a larger town may require a vehicle. Alternatives might be to hire a bicycle, to use a taxi or trishaw, or to use a city-tour tourist bus. No matter what the means of travel, the photographer should be armed with a street map (if available) or be prepared to make a simple map which at least *he* can read. A notebook would also be an essential piece of equipment.

If the town is very large, then more than one such planning excursion may be necessary. For example, it would be too ambitious to try to reconnoitre the City of London and the West End at the same time and, similarly, in Delhi, separate journeys would need to be made to the walled city of Old Delhi and to the imperial legacy of New Delhi. On the other hand, despite its large population and the dividing strait of Victoria Harbour, Hong Kong is sufficiently compact to make a day's reconnaissance just possible.

During the ground survey, notes should be taken of possible subjects and also of the likely difficulties. A major consideration in a town of high buildings or narrow street is lighting. The time of day for optimum lighting conditions can be estimated if the orientation of streets and buildings is known. Static subjects can be listed as morning or afternoon shots. Remember, optimum light does not necessarily mean brightness. Creative use of shadows of buildings and monuments, or of reflective surfaces may influence the timing decision.

Problems of access also should be recorded in the notebook. Knowledge of one-way traffic flows and of availability of public or hired transport may be important later.

Supplied with the data collected on the ground, and with information gleaned from books consulted before arrival, the travel photographer can now plan his work in detail. Additional information, such as the times of opening of museums and other public buildings, the need for permits to photograph or erect a tripod, the days and times at which markets are held, the dates of public holidays, and so on, can usually best be obtained locally from tourist kiosks, hotel re-

Planning in advance of a trip is essential. Without it I may easily have missed this rather seedy hotel and not realised it was the one made famous by Graham Greene's *The Heart of the Matter*. Freetown, Sierra Leone.

ception counters, town halls (or their equivalent), or even from shopkeepers or taxi drivers.

The plan of work will probably include the division of the central area of the town into regions so as to devote a day or half a day to each. In so doing, time and money will be saved in avoiding unnecessary cross-town travel. If the town is to be photographed with some degree of thoroughness it will be important to leave one or two days for return visits, perhaps made necessary by poor weather, and a similar time for excursions into the suburbs. (More will be said about photography in the suburbs later in this chapter.)

If only a very brief stay in the town is allowed, then two possible compromises suggest themselves. One plan might be to concentrate on the most central public buildings and streets or on a specific theme such as markets or, simply, 'people in the city'. Alternatively, using one's own or hired transport, an interesting view of a town can be had in a short time by means of a transect study. In this case, the photographer might follow a route drawn through the centre of the city and out through the suburbs, building up a collection of shots of the changing scene.

So far it has been suggested that the photographer should work to a carefully prepared plan rather than wander aimlessly through the streets looking for inspiration. What will form the subjects for his camera will, as said before, depend upon any number of variables but some suggestions for creative photography in a town are discussed below thematically.

BIRD'S-EYE VIEWS

Street scenes can immediately capture the essence of a town in a way which architectural photographs singularly fail to do. I always try to get at least some shots from high vantage points. The bird's-eye view photograph of a busy street or road junction is always interesting, not least because we so rarely have that perspective in our everyday lives. Most often we are pedestrians or travelling in cars or buses. We see little above head level and little beyond the person or vehicle in front of us.

Few towns boast no high buildings and even small Third World towns probably have a bank or civic building which stands above the rest. In many towns there will be modern blocks of offices or apartments, probably a skyscraper or two.

Every opportunity should be taken to photograph towns from above. For this low aerial oblique of Bergen, I was favoured by almost perfect lighting.

A bird's-eye view, from a balcony, shows much more of this Old Delhi street than any ground-level shot could hope to do.

Another bird's-eye scene, from the Guinea coast, shows women preparing a meal in the street. Again, far more can be seen from this viewpoint and the subjects were totally unaware of my camera.

Access to a high window or, better, the roof is, in my experience, not as difficult as it may seem at first. Public buildings are the least easy to penetrate and apartment blocks the easiest. It is usually necessary to seek permission and best to ask someone like the commissionaire or janitor. Janitors sometimes have quarters near the roof and are often most co-operative if some small payment is made. It is worth paying, and, just as important, it is unwise to try to gain access without permission, if the building is private, and risk detention as an intruder.

A roof position is better than a window because it affords an all-round view. Likewise, a balcony is to be preferred to a window. Once installed, a photographer can exploit the viewpoint. From a high roof or window, all manner of shots are possible. Using a standard lens will give the equivalent of an oblique aerial view. A medium range telephoto lens (150–200mm) is ideal for shots of people in the street, traffic incidents and the like. A wide-angle lens can be used for a panoramic view of the city and its streets. Even a fisheye or semi-fisheye can be employed to give spectacular views of the town with curved horizons and tilting buildings.

A polluted or dust laden atmosphere over a city can very easily reduce visibility to a level at which it negates the advantage gained by a high viewpoint. If using black and white film, some considerable improvement can be obtained using an orange filter of, say, a factor of 4x.

With the help of a medium to long-range telephoto lens, buildings and other subjects which have been or will be photographed at ground level can be picked out from this priviledged position and give an entirely different view of the subject. It may be worth exposing a lot of film from a roof-top because, unlike the street-level viewpoint, it will not be a recurring opportunity. Views from above, of markets, railway marshalling yards and city squares, will complement ground shots and more than repay the efforts required to obtain such pictures.

Panning, or camera swing, sharpens the image of a moving subject. In this shot, taken in northern Thailand, I wanted to show clearly the custom of the girls to ride side-saddle when travelling as passenger on a motor scooter. I used a narrow sector pan.

TRAFFIC

Street scenes taken at ground or near ground level will obviously be easier to photograph and will, therefore, outnumber those shot from buildings. More will be said in Chapter 8 about photographing people but they will often be the major component of street scenes, as will traffic.

Photographing traffic in towns may be a less simple matter than it first seems, at least, if effective shots are to be obtained. Subjects might include unusual vehicles, heavy traffic flows, or extraordinary traffic mixes in which a variety of vehicles, and even pedestrians and animals, compete for space and movement.

Unless specifically intent upon pictures of traffic-jams, it is important to create a sense of movement. Commonly, panning is a useful technique to employ with moving subjects but with traffic in a street there can be problems unless the aim is to concentrate on a single subject. The difficulty is that traffic movements are composed of numerous vehicles travelling at a variety of speeds and even in opposite directions.

If it is desirable to give specific attention to one vehicle it is best to choose a time when the field angle is free of other traffic unless, of course, one is photographing a very fast moving vehicle, for example, a police car, in otherwise slow moving traffic. For best effect the vehicle should be well lit

compared with its background and brightly coloured.

Panning in still photography is not easy and, it must be admitted, good results are often the product of luck. All the same, there are some simple rules which will help. The photographer should stand on the opposite side of the street to the subject vehicle and pre-focus the camera lens on traffic using the same lane as the intended subject (X in fig. 2). Although a pan-head tripod should really be used, this is often inconvenient or impossible, so it is important that the photographer's body movement is as smooth as possible. In fact, the photographer should turn only his head and shoulders in following the subject through the pan as any movement of the feet will cause the camera to pan through a plane which is not truly horizontal. In practice, the camera will probably be swung through an angle of about 60 to 120° but the shutter will be open for only about fifty percent or so of the swing.

The moving subject should be picked up (i.e. captured and held in the same position in the viewfinder) as it approaches, the shutter smoothly released at a pre-selected point, and the camera then moved to follow the vehicle through the remaining sector of the angle of swing.

Figure 2 shows the three component sectors of the camera swing. In Sector 1 the shutter is closed

Shutter opens

Shutter closes

Path of vehicle

A B X C D

1 2 3

a b c d

Camera swing

Fig. 2

as the vehicle moves from A (the point at which it comes into the viewfinder) to B (the pre-selected point at which photography begins). The film is exposed in Sector 2 but the camera continues to pan through Sector 3 (the follow-through) as the vehicle moves from C to D and out of camera vision. The follow-through sector is important to the smoothness of the pan.

An SLR camera is not ideal for panning in that there will be no image in the viewfinder during exposure (Sector 2), so emphasising the importance of Sectors 1 and 3. However, it has the advantage over a TLR in that, held to the eye, the movement will probably be smoother.

In panning, it is important to use a slow shutter speed but one which is consistent with the speed of the vehicle. Although it may not be convenient specifically to select a slow film, an alternative is to use a neutral density filter. This will have the effect of allowing a longer exposure. Shutter speeds faster than 1/100 cause problems but speeds slower than 1/15 will mean that the camera is unlikely to remain in a horizontal plane during the enlarged angle of swing. For a moving vehicle in a

street, a shutter speed between 1/15 and 1/30 should be adequate, but it must be remembered that, as subject to camera distances are not constant, some consideration must be given to depth of field. Because a standard lens is best for panning, the aperture should be small rather than large.

Incidentally, it is *not* necessary for the subject vehicle to produce a perfectly sharp image. A little blurring of the subject can give an even better impression of speed than would be so with a vehicle in perfect focus.

Many other traffic pictures can be shot without the need for panning. The most obvious alternative is to photograph traffic approaching or receding from the viewpoint. In this case the best place to stand is in the middle of the road – seeking the refuge of a traffic island or central reservation, of course! In this position it may be best to wait for vehicles to fill the street and, preferably, be fairly close to or actually passing the photographer. Using a wide-angle lens and a shutter speed of 1/60 a sense of movement can be created as a long vehicle, a tram or bus, passes alongside. The image

distortion which results from the perspective of a wide-angle lens close to its subject provides the dynamic effect. A wide-angle lens has the added advantage of maximizing the depth of field. In such a shot, it is advisable for the vehicle passing close to the camera to fill not more than one-third of the frame so as to heighten the feeling of movement through contrast with other traffic which will appear to be near-static.

From the same vantage point, a long focus lens will provide shots along considerable lengths of the highway but, at the same time, compress the view to give an impression of a much more crowded street than actually is the case. Telephoto lenses of 200mm to 400mm are ideal for this sort of picture. The same sort of crowding can be achieved when taking shots of pedestrians along a sidewalk. If using a zoom telephoto, interesting results can be achieved by zooming actually *during* exposure. The effect is to suggest movement but the camera must be held very steadily so that the long axis of the lens barrel is static. Such a photograph is best attempted using colour film and with colourful subjects.

Shots of crowded streets, especially of pedestrians taken from ground level, may be almost impossible unless an isolated vantage point can be found. Shooting from eye level while standing in the middle of a crowd will produce little more than a good close-up of the back of the nearest person's head! A simple way of getting over the problem, and, at the same time, producing a photograph from a somewhat unusual angle, is to hold the camera above the head. The camera should be held with the arms fully extended above the head and turned to lock the elbows. This should prevent camera shake. Should it happen that the camera being used is a TLR or roll-film SLR with a waist-level viewfinder, it can be inverted and the picture composed by looking upward into the screen. With most SLRs having eye-level viewfinders, this is impossible and the angle at which the camera is held will have to be a matter of personal judgement.

A common mistake, if the viewfinder cannot be seen, is to tilt the camera too far from the vertical plane. With a standard lens being used, a tilt of just a few degrees downwards will allow an extended view of the street without including people close to the photographer. A small aperture will also help to overcome the difficulty of focusing and shutter speeds may have to be estimated unless an independent light meter is used.

Traffic incidents (not necessarily accidents!) make good pictures: arguments between drivers or

between drivers and pedestrians, traffic-jams and breakdowns. In many instances traffic will generate clouds of dust, yet photographs to illustrate these conditions do not always successfully do so. A low viewpoint and back lighting may help or a fog filter could be used.

Working in a town with hilly streets or lanes gives a photographer the opportunity to obtain pictures with interesting perspectives. Camera position can vary from a view downhill at climbing traffic to viewpoints at the foot of the hill with, perhaps, a street framed by buildings. Long focus lenses are often useful for these types of shot.

In all shots involving traffic in streets it is worth waiting for times when brake lights and automatic traffic signals can provide vivid spots of red for colour photography. Using black and white film, the amber lights of traffic signals show up best.

Away from the traffic there is still much of interest to photograph in a town's streets: lines of lamp standards (using a telephoto lens), or perhaps strange street 'furniture'. Close-up shots of street names and traffic signs again suggest a telephoto lens but it may be wise to include just a little background in the frame, perhaps subdued, out of focus.

SIGNS AND ADVERTISEMENTS

Two, easily missed, subjects for pictures which really do add to the sense of place, are street advertisements and shop signs. As with traffic notices, it is advisable to include some background but ensure that any wording or picture is sharply in focus. Lenses of focal length 70mm to 150mm are ideal for this sort of work.

The travel photographer should look out, too, for graffiti and wall slogans. These may well reflect political or social attitudes or circumstances far more tellingly than almost any other piece of photographic evidence.

MARKETS

Some of the most rewarding photography in a town will be in its markets. Remarkably, even the most sophisticated of western cities is likely to boast at least one open market and in some parts of the world, for example, West Africa, towns seem to be dominated by their markets.

It will usually be necessary to check days and times of markets and to arrive early and be prepared to stay late. If photography is confined to times when the market is in full swing, then opportunities will have been lost to shoot at those most interesting of times, when stalls are being

A little Cockney humour. Street signs like this capture the *sense of place* as well as any photograph of a famous landmark.

I couldn't resist this street poster in a Kumasi street. It might be entitled *Western Culture Comes to Africa.*

erected and when traders are packing up at the end of the day.

Flower markets, like that held on the quayside at Bergen in Norway, may provide the most colourful pictures but the real photographic interest of markets lies in their activity and their range of produce. I must admit to being fascinated by markets and will shoot roll after roll of film in an attempt to capture their very human interest.

Markets are usually cramped places with little room to manoeuvre and the constant threat of an uninvited shopper stepping into view just as one presses the shutter button. I find the easiest way out of this particular difficulty is to use a 28mm lens and to get in close to the subject. A standard lens is less useful but telephoto shots between lines of stalls, preferably from a slightly raised view-

point, emphasises the crowding that characterises most markets.

Particular incidents which contribute to the interest value of market pictures might be moments of transaction and bargaining between customer and trader, or stall holders' attempts to attract custom. Often the reaction of traders to photographers is worth filming, too!

Market produce will often include locally grown foods or fish caught in off-shore waters. A portfolio of market pictures should include pictures of the production of the goods: fruit being picked, flowers gathered, fish caught. An enquiry in the market will usually provide the necessary information regarding the origin of produce and these complementary shots can be taken on travels outside the town.

Markets are exciting places in which to photograph: a rich source of human interest pictures. Here, in Tamale, northern Ghana, men are making and selling sandals cut from old car tyres.

In many Third World countries, the markets show a remarkable degree of grouping of like stalls which is referred to as complementarity. Thus all the fruit will be sold in one part of the market, cloth in another, shoes in a third. In these cases some of the interest lies in recording on film the similarity of goods being sold on adjacent stalls.

When the market shuts for the night, the resultant litter is exposed as the crowd dwindles away. Photographs of boxes, paper blowing in the wind, rotting produce, are best taken from a low viewpoint, almost from ground level, to emphasise and exaggerate the amount of debris. Look out, too, for scavenging birds and dogs.

Although security of cameras has already been discussed in Chapter 2, it is worth pointing out that market crowds make an ideal haunt for the petty thief and that cameras and equipment must be safeguarded while working there.

PARKS

Parks, whether they be formal gardens or simply patches of open ground used for recreation, provide a contrast to photography in crowded streets and markets. It is not so easy, though, to capture that elusive sense of place. Unless the plants themselves are sufficiently exotic to distinguish the location, it will be necessary to include in most shots, people, buildings, monuments or some other place-defining subject. Of course, people, whether relaxing, playing, or even sleeping in a park are in themselves richly rewarding subjects but unless the objective is *specifically* people, they should play a subordinate role in the content of the photograph.

The use of a split-field filter enables the photographer to include a close-up of, say, a single flower bloom in a general shot of a park but it is not easy to achieve a satisfactory balance in picture

Formal shrubs in the town square of Silva Porto, Angola, complement the geometry of the building.

composition with such filters. My personal preference is to use a wide-angle lens, say, 35mm, or a small aperture on a standard lens, in order to include objects close to the camera in general views. It is preferable that the close-up subject matter should not distract but blend with the rest of the photograph.

Framing, for example the use of overhanging branches from trees, will be referred to in Chapter 6 and some of the techniques applicable to landscapes are equally relevant in parklands.

Parks which border the central business districts of towns can be used to create pictures which point up the contrast between the congestion of the city and the spaciousness of its open areas. For such shots, a variety of techniques may be used depending on the style of picture required. Silhouettes of skyscrapers adjacent to the park can be obtained by exploiting a low sun behind the buildings while the park in the foreground remains sufficiently well lit to show detail. Alternatively, effective shots may be had by *pulling-in* the buildings using a telephoto lens and compressing the view with its flattened perspective. Another approach to the same scene may be to photograph the backdrop of the city along an avenue of park trees or simply framed by trees.

Many formal parks have regulations limiting photography and most will prohibit the use of a tripod. Although park rules are often honoured more in the breach than in the observance, it is wise to be aware of any restrictions.

MONUMENTS AND STATUES

Larger towns all over the world have their special statues and monuments. Indeed, a single photograph that incorporates some unique piece of

sculpture may immediately identify the town. Such is it with the Statue of Liberty outside New York or Rio de Janeiro's figure of Christ.

Access to statues is usually unimpeded but their setting on raised plinths can make them awkward to photograph. If the subject of the statue is described by carvings, or otherwise, on the plinth, it can make for a more interesting picture to include this information in the photograph's frame. However, the inscription will have to be in sharp focus and the figure itself may easily become almost a secondary object. An obvious solution might seem to be to use a lens with a good depth of field but, unfortunately, this may spoil the perspective of the shot. This is especially so if the photographer stands at ground level and points the camera upwards at the rising statue. Of course, this can give an interesting photograph in which the statue gains in dominance as it rises high above the plinth. Nevertheless, a more natural perspective is had by using a standard lens.

When a standard lens is used it is important to control the depth of field by using a small aperture (f/16). It is almost certain that, to include the whole of the subject in the frame, it will be necessary to stand well back from it, thus maximizing the range of sharpness, but a check should be made on the lens barrel scale to be sure of the best results if optimum depth is wanted. If it is possible to find a raised viewpoint, so that the camera does not have to be pointed upward to include the whole of the subject, so much the better.

If it is desirable to isolate the subject from its background then the depth of field should be reduced and a telephoto lens may be best for this purpose.

Using a small aperture will demand good lighting unless a very fast film is loaded. Light should be falling on any inscription so that it gives the most legible results. If the inscription is carved into the plinth or raised from it, it will be best for light to strike the plane of the inscription at an angle a little way from normal, so giving a slight shadow to the lettering and making it easier to read.

As with so many subjects, it is best not to assume that the whole of the subject matter *must* be included in the frame. If more intent upon effect than upon recording the subject, interesting shots may be taken of small details of any statue or monument. A photograph of the statue of some solemn looking dignitary may be much improved if just the head is framed, perhaps with a pigeon perched on his hat. Likewise, the juxstaposition of a statue and a passer-by may produce an amusing picture.

MUSEUMS

Just as statues are common in many quite moderately sized towns, it is likely that some sort of museum or art gallery will be found, at least in countries outside the Third World. Photography in museums provides the travel photographer not only with a record of the exhibits actually on display but, through them, also with a collection which may supply a wonderful insight into that town or country's cultural heritage.

Although photography in some museums may be forbidden, still pictures taken without the use of a tripod will be allowed in many museums if a permit is obtained or verbal permission is sought. Flash equipment may also require a permit or be totally forbidden. If both flash and tripods are forbidden, the photographer is faced with the double problem of using available light, requiring slow shutter speeds, and, at the same time, hand-holding the camera but trying to avoid camera shake.

In these circumstances it may be advisable to look for some special means of support such as described in earlier chapters. If full sized tripods are not allowed, it is sometimes possible to use a miniature model without earning a rebuke from the curator or attendant. In this case, the mini-tripod can be rested on or against a solid object, even a vertical wall, and turned into the correct plane on its ball and socket head. If all supports are banned, then it may be possible to rest the camera against some solid structure, or even on a companion's shoulder, to improve stability.

Using available light, rather than flash, may mean that fast film will be needed, especially if a good depth of field is required and large apertures are to be avoided. If the museum is lit by artificial light, or a mixture of artificial and natural, it is important when using colour stock to make sure that a correctly balanced film is loaded or to attach compensating filters to the lens. This could be especially the case when photographing subjects where reproduction of the correct colour is critical to the quality of the photograph.

In most large buildings, whether they be museums, churches or other public buildings, the best natural light will probably be between 10 am and 11 am, or between 1 pm and 2 pm. This is particularly so in the tropics and sub-tropics but, at higher latitudes, the best time may be around noon. It will be at these times that the maximum

Paintings, mosaics and sculptures are favourite camera subjects in towns, but I photographed these famous frescoes on the fortress rock of Sigiriya.

illumination is available from sunlight through the windows.

If lighting conditions are especially poor, then the only solution is to set the camera for time-exposures and take two or three shots per subject, using slightly varying times. It is on these occasions, when even a separate exposure meter will be of little use, that the absence of a tripod will be most keenly felt and some ingenuity must be employed to keep the camera absolutely still.

Lenses of the whole range that a travel photographer is likely to be carrying will have their uses, although those of more limited speed will be less useful if flash cannot be used. It is worth experimenting in museums and art galleries with a variety of compositions from full length pictures of sculptures to details taken from a painting or fresco. If a complete painting or drawing is to be photographed, it is unlikely that its dimensions will be proportional to the film frame size, so it is best to include the whole of the painting and crop the photograph after processing if need be. What is

particularly important is to centre the camera in a vertical plane facing the picture. The long axis of the lens is then normal to the plane of the picture being photographed.

In many museums, the exhibits will be protected behind glass, either paintings framed and glass fronted, or objects shown in glass cases. A polarizing filter should be used but unwanted reflections can also be eliminated by varying the camera plane so it is at a slight angle to the plane of the glass. (Obviously this technique is not appropriate to pictures but works well with display cabinets.) If flash is permitted, it should always be held away from the camera at an angle to the glass and it should not, therefore, be mounted on the camera's hot shoe. The flash unit should be placed near to the glass.

Because of the relatively poor lighting to be expected in many museums and the usual ban on tripods, it is not possible to use neutral density filters to increase exposure time and so overcome the problem of people passing between the camera and its subject when the shutter is open. The only practical advice that can be given is to visit the building at a slack time. A word with an attendant will usually provide accurate information as to the least popular times for visitors.

CHURCHES AND TEMPLES

Much of what has been said above, about museums and art galleries, applies also to churches and temples, at least as far as interior shots are concerned. Over and above the difficulties already mentioned are further restrictions to photography in sacred places. It is always best to assume that some sort of permission is needed even if it is only verbal and obtained from the most junior of officials. Regulations regarding dress must be strictly observed in order not to antagonise local people and create even more problems.

It might be expected that the photographer will start work on exterior shots and what is said below, about the photography of buildings, will apply equally to churches and temples. However, the great size, and especially the height, of cathedrals and some temples, gives its own difficulties. It is fortunate if the church is on open ground or has its own piazza. If it is located in a crowded part of the town a photographer will be hard pressed to find a suitable viewpoint and perhaps will have to resort to concentrating on detail rather than on the whole structure.

This is not a bad plan anyway. One or two shots of the whole of the building may be all that is necessary for record purposes and much of the interest in churches and temples is in the complexity of their architecture, whether it be a gargoyle on a European cathedral or the gopuram of a Hindu temple. For detailed shots such as these (remembering that a lot of the features will be high up on the building), a telephoto lens is a must. I find that it is in this sort of work that I really value a zoom lens. It makes composition so much more challenging and allows one to do a great deal of work without constantly having to change one's viewpoint.

Church and temple exteriors offer a bewildering range of photographic opportunities and, if time allows, a whole day may be needed to make the best use of light. Unlike so many other buildings, particularly modern ones, there are points of interest on all sides, not simply on the street frontage. If the east elevation is seen best in morning light, it may be late afternoon before the opposite side receives its most flattering rays of the sun. After inspecting the outside of the building, it may be best to divide the time available so that interior and exterior are photographed alternately rather than complete all photography outside before entering the building.

Inside temples and churches, the greatest photographic problems are usually those of insufficient or awkward light and of scale. Dark

The Omar Ali Saifuddin Mosque in Brunei. Diffuse light shows the mosque and its *boat* at their best.

areas are best dealt with by resorting to time exposure, experimentation and bracketing exposures. Even if flash is permitted, it will probably be of little use in general shots because of the scale of the building. If it is used, then a flash gun that

68

can cope with the needs of a wide-angle lens (28–35mm) will be required because there is no doubt that this sort of focal length lens is the most versatile for interior photography.

Assuming that available light is being used, it is better to increase exposure time than to open up the lens and thereby reduce the depth of field. In so doing, if the exposure is long enough, it is possible to remove from the final image unwanted people who are crossing the field angle during exposure. Of course, if they are stationary, they will be recorded anyway. If necessary, to increase the exposure time, a neutral density filter can be used. This device is recommended here, but not, earlier, for museum work, because it is often much easier to find a rigid support for a camera in a church where the viewpoint is probably less critical. Hand-holding the camera will, therefore, be less necessary.

It is not desirable to remove all people from interior architectural photographs, in fact some figures will serve to emphasise the vast scale of

Detail is as important as shots of the whole of a building. The work on these Meenakshi gopurams in my favourite Indian city, Madurai, illustrates the point.

these buildings or worshippers may contribute to the colour and atmosphere. But, if scores of tourists are present, it may well detract from the final picture. Western tourists in an Asian temple add little to the sense of place.

An especially difficult problem occurs if the photographer is not dealing with a general low level of light but with contrasting shafts of bright sunlight and dark shadow areas in the same shot. This frequently happens and, in the case of some cathedrals, for example, may have been planned so by the architect. Intense light entering the building from windows or doorways may call for a diffusion filter. This will diffuse the light, giving a soft-focus effect. Although it is possible to achieve the same results without this filter, by such methods as smearing petroleum jelly on a UV filter or stretching fine chiffon across the lens, most travel photographers will find a special filter less fussy and requiring less experimentation. It must be realised, though, that using a diffusion filter will not give the best results if the surface texture of the fabric of the building is to be emphasised.

An alternative way of dealing with shafts of bright light is to accept and exploit them by using special-effect engraved filters.

The beauty of fine buildings like churches and temples may well be seen at its most magnificent by looking upwards. It may be in the proportions of fan vaulting or in the artistry of a painted ceiling. Although something of the roof can be photographed by including it in general shots of the building's interior, it is often possible to shoot with the camera pointed directly at the ceiling, that is to say, with the long axis of the lens normal to the plane of the ceiling. The photographer can focus the lens from a crouching position, as near to the floor as possible, before placing the camera on its back on the floor. Using a cable release, the shutter can be operated without difficulty. This type of shot is not possible if the back of the camera body is not absolutely flat and any case should be removed before shooting. The most effective and pleasing results come from compositions which stress the symmetry of the ceiling or roof. If this is wanted, then the camera must be very carefully positioned,

for example, immediately below the centre of a dome.

Looking downwards may reveal interesting floors, tomb covers or mosaics, for example. It is less easy to get satisfactory shots of the floor than of the ceiling because a travel photographer is unlikely to fall back on the usual expedient of a camera held over the floor with a boom. If the church has a gallery, then a near-vertical viewing angle may be possible, but otherwise the photographer may have to be content with an oblique shot. This may emphasise any irregularity in a mosaic pavement or give an unsatisfactory perspective to a photograph of any floor carving, so it is worth trying a number of viewing angles and positions before shooting. If the floor is a mosaic, the colours can be brightened if the floor is wetted. A sympathetic attendant may be obliging if approached diplomatically.

Stained glass windows are another feature of many churches and cathedrals which invites photography, especially if the camera is loaded with colour film. It is arguable as to whether it is worth attempting shots of the whole of a large stained glass window, especially if the shape is long rather than round, or to concentrate on a small portion using a long focus lens. I believe it *is* worth trying for both sorts of picture but, if photographing the whole window, let a third of the frame be occupied by the walls surrounding the window and experiment with viewing angles.

It is advisable to avoid photographing stained glass when direct sunlight is falling on the window. By far the best results will be obtained when the sky is covered with thin cloud, allowing for plenty of light penetration but avoiding colour falsification resulting from a blue sky background to the glass. As with all interior shots including windows, there may be halation problems in the shadow areas around the window.

Turning to photography of details within the church or temple suggests pictures of architectural or human interest. Worshippers at prayer or making offerings, priests or temple monks, people illuminated by the light of votive candles: all make interesting subjects.

BUILDINGS

It is not possible or appropriate to cover the complex subject of architectural photography in a book concerned specifically with travel photographs. But, equally, the travel photographer will doubtless spend a great deal of his time in towns recording the buildings he sees. The techniques described below will concentrate on those most relevant to the work of the travel photographer. Again, the elusive sense of place will figure largely in his thinking and buildings do reflect this just as much as do landscapes.

It can be assumed that a travel photographer is unlikely to want to carry with him special lenses such as a perspective control lens or an anamorphic lens. Of course there will be perspective problems of converging verticals and leaning buildings, but these difficulties can be looked upon as creative opportunities.

All three of the basic lenses which a photographer can be expected to have with him (wide-angle, standard and telephoto) will come into use. When working in crowded towns or where large tall buildings are normal, a 35mm lens is probably going to be the one most often used, switching to a 50mm when a truer perspective is wanted and to telephoto for close-ups.

Having planned his own town work in the manner described at the beginning of this chapter, the photographer will have prepared a list of buildings or groups of buildings he wishes to shoot and noted the optimum time of day for each subject. If shots of the whole building are required and space around it is restricted, it may be possible to use a viewpoint in a building on the other side of the street. Apart from roof-top sites, already described, an ideal viewpoint which reduces perspective problems is from a position midway between street level and roof. If access to a building opposite to the one to be photographed is possible, then such a viewpoint can be chosen and the camera set up to shoot out of a window and across the street. As has been said above, it often requires only a little audacity to gain access to buildings, especially in the centre of town.

Even if photography is from street level, it is important to look upwards for points of interest. Most of us are so used to walking along streets scarcely looking above head height that we fail to notice that much of the interest of buildings is towards the top.

It is not possible to generalize in suggesting on what buildings a travel photographer should concentrate his attention, but it is probable that it is in the vernacular architecture that he will find his most satisfactory shots. While one modern skyscraper may look very much like another, whether it be in Singapore, São Paulo or Sydney, a Chinese Shophouse in Kuala Lumpur or a row of traditional round and square mud-brick buildings as in the towns of northern Nigeria, will more

Problems in perspective can become studies in perspective as with this view of the Connaught Building in Hong Kong. Note the window cleaner's cradle which makes a point of interest and emphasises scale.

immediately evoke the feeling of a place, a particular location.

Architectural contrasts often demonstrate something of the history of a town. Colonial style buildings in the old European colonies, German style buildings in western Poland, French style architecture in the province of Quebec, are examples. Look for evidence of change in function as when a private residence becomes an office building, or for a change in fortune shown in boarded-up shop fronts, to show something of the social structure of a town. It is important, I think, for a travel photographer to select his buildings in a way that he records, not only the architectural masterpieces, but also the city's character.

Framing buildings is important and viewpoints at street level should be chosen with this in mind. A building at a road junction, for example, can be photographed framed by others at the opposite corners. As always, foliage of nearby trees can also act as a frame as well as helping to balance the scale and provide a contrast with the sharp lines of the building.

A challenging problem in photographing buildings, as has already been suggested, is that of perspective. This is particularly so in towns where buildings crowd together and choice of viewpoint is restricted. It is a challenging problem because creative opportunities can be exploited in a variety of ways.

The vertical perspective is controlled largely by camera tilt. Using a wide-angle lens will allow a tall building to be photographed at close quarters but will exaggerate the difficulty of keeping the vertical parallel. As the camera is tilted upwards, perhaps to include the top of the building in the frame, the verticals will tend to converge. Only when the plane of the film is parallel to a specific plane of the building will the perspective be such that parallel lines of that face of the building appear as parallels. Clearly this condition is not usually possible if the viewpoint has to be close to the buildings and the building is tall.

However, a travel photographer, usually short of time, should not necessarily see this as anything but a test of his ingenuity. Assuming the viewpoint

This simple street scene in Nepal contrasts the old with the new and allows a little human interest to intrude. Street photographs should invite the viewer's scrutiny. The pig in the cage is as important as the vernacular architecture of the building on the right in telling us something about life in Kathmandu.

cannot be changed significantly, it is wise first to experiment with two or three different lenses and to choose the one of longest focal length which fills the frame and includes all the photographer wishes to include. If the verticals cannot be made parallel, or nearly so, then a more interesting shot may be produced by *emphasising* the keystoning. This can give pleasing results but care should be taken to control the camera tilt to get the best effect. Sometimes this will be obtained by keeping just one line truly vertical, say, the corner of the building nearest the camera. On other occasions it

might be wiser to tilt the camera so that the whole building appears to rise towards a corner of the frame. Such deliberate distortion of true perspective must be used with discretion and will be most effective with very tall buildings, especially modern ones. Such photographs can help to convey size and dominance in a way in which a shot with true perspective may not.

When photographing more than one side of a building at a time, the horizontal perspective is of greater importance and the camera's plane should be rotated to obtain the desired effect. Often this

will be a compromise because, if the camera plane is parallel to one face only, the perspective distortion of any other side steepens.

Perhaps the greatest care is needed in considering the the perspective of adjacent buildings which are unavoidably or deliberately included in the frame. If using black and white film, then unwanted buildings can be cropped out at the printing stage. With colour transparencies, this is less convenient. One option may be to give the subject building a near-true perspective, centred in the frame, and allow framing buildings to tilt inwards towards it. This can give acceptable, even pleasing, photographs but it is less suitable if the framing buildings are either of different heights or much lower than the subject.

If it proves impossible to obtain a satisfactory perspective close to a building, the only alternative is to seek a viewpoint, perhaps on rising ground, distant from the site and use a telephoto lens. This can introduce another distortion as the view is compressed in depth. But this, too, can be used with effect, especially as the subject, in focus, contrasts with its slightly blurred surroundings and draws attention to itself. A wider aperture will enhance this effect.

Always bearing in mind that time is a vital factor in a travel photographer's planning, it is worth looking out for suitable distant viewpoints of buildings when working in other parts of the town.

It is not necessary or advisable to photograph buildings in a way that might be required by the real estate salesman – a picture which deliberately sets out to give a true likeness. If it is *not* important to emphasise texture, a soft-focus filter can give very pleasing results, particularly with buildings of a distinctive or light colour. If texture is important, then focus must be very sharp, depth of field carefully calculated, and the lighting must be right. Just what is the right lighting depends not only on what sort of picture is required but also whether a single elevation or more than one side of the building is to appear in the frame.

Very bright sunlight, as experienced in the tropics and sub-tropics, tends to give too great a

Such a rich façade as this, at Honfleur, France, had to include as much of the variety as possible. A street level view was unavoidable and the deck of a cabin cruiser gave sufficient distance for the subject.

Framed by two nearby buildings and using a high window viewpoint, I photographed the skyscrapers of Hong Kong's island to show them rising to compete with the mountain backdrop.

contrast between light and shade and a correction filter should be used, especially if shooting with colour film. Ideally it is better to photograph when there is some thin cloud to shield the sun. It may be worthwhile to keep one's attention on the sun's position during shooting. If the sky has broken cloud, using a colour filter to shield the eyes from direct sunlight, watch for the sun as it is about to reappear from behind cloud and shoot just before it does so.

For photography of buildings that are richly textured, the angle at which light is striking the face is important. For best effect, it should be at a very acute angle to the plane of the building. In any event, lighting should be from a fairly low angle and photography within an hour or so of noon should be avoided.

With all these points in mind, it is clear that photography of buildings in towns takes time and must be planned. I find it most convenient to work in relatively small areas at a time, especially if I am on foot. In this way I can mix my photography, switching from buildings to street scenes and traffic, to people, and back again to buildings through the day. This allows a more selective use of light without having to waste time or visit the same buildings on different days, with consequent increase in travelling.

Time spent on photographing whole or substantial sections of building exteriors will possibly be greater than that spent on shots of detail. However, I find that I am likely to expose three or four times the number of frames on architectural detail as on the buildings themselves. Of course, it will depend somewhat on the buildings but it is surprising what you see if you look.

It is detail that is often the most revealing of a building's style or age. It may reflect the style of the architect, or the craftsmanship of the builder. Or even the character of the occupier. I use my zoom telephoto (80–210mm) as a spyglass to scan the building, and compose the shot by adjusting the focal length. Most often, at least something of the building itself will be included in the frame: the surrounds of a window or door, the background of a carving. With some details, though, a door knocker, an elaborate doorway pediment or, perhaps, just a pattern of bricks, it may be better to zoom in towards the subject, hold it sharply in focus and exclude all surroundings.

Photography of architectural details often requires different lighting from that needed for the whole building and exposure adjustments (reducing exposure time for close-ups of distant subjects shot through a telephoto lens, for example), are much easier. If working in colour, it is worth

recalling that reducing exposure up to one stop may enrich the colour quality of a picture of slightly faded subjects in this sort of work than would be the case if intent upon capturing the whole of the building in the viewfinder. Conversely, a detail in a shaded part of a building will show up better with a half stop increase in exposure.

SHOPS AND SHOP WINDOWS
Almost as effectively as markets, shops mirror much of the character of a city. Small shops and stores have a special charm of their own and large shops in affluent towns provide imaginative window displays. Stores in some of the poorer parts of the world will have simple shuttered fronts, but, elsewhere, polarizing filters are likely to be needed to cut out reflections from glass windows.

FACTORIES
Urban areas and industry are inseparable. Photographing the exteriors of factories is little different from work on any other large building or group of buildings, unless the factory is surrounded by a high wall. In such instances, access may be difficult and a photographer may have to be content with shots through open gates. Permission to enter factories is often hard to get. There seems to be some sort of law which states that the larger the enterprise the more inaccessible it will be. I remember trying to obtain permission to photograph a large opencast iron mine in Swaziland which is owned by a multinational company. It took two days and telex messages to and from London before my permit was issued – and that was a relatively simple case. It is not so much that industrial espionage is suspected as a problem of bureaucracy.

Photographs of one or two typical manufacturing industries nicely complement other shots taken in a town, but most travel photographers will find the time and patience only for exteriors. Even these photographs should include something of the factory's products, perhaps being loaded in the factory yard or on leaving the factory. At least the name and description of the factory might be included in the shots, from an advertising display or a nameplate at the gates.

Inside a factory, if permission to photograph can be obtained, it may be better to concentrate on processes and people at work rather than to take

The dentist and opticians in Delhi make their own comments on the social scene.

general views of substantial sections of vast interiors. Lighting is often very difficult inside factories with great contrasts between well lit and shadowy areas. Flash should be used but will be more effective for relatively close subjects.

BAD WEATHER

It is not that unusual to find travel photographers who could be described as fair weather workers, and this is especially the case in towns. Although it is true that it is not particularly pleasant walking the pavements of a city in a downpour, there are some inviting subjects in bad weather. Storm clouds approaching a town are best photographed from a commanding viewpoint on the top of a high building. With black and white film, a yellow filter will improve the sky contrasts but a red and orange filter may be better if a more dramatic effect is wanted. If the cloud cover is already reducing the available light, then the high factor of a red filter may disqualify it. Timing is important and the most effective shots, especially in colour, will be obtained when the town is still bathed in sunlight and the storm clouds are only on the horizon.

To photograph rain drops is exceptionally difficult, requiring conditions of lighting that are not easy to find. Ideally, the droplets should be well lit but the background should be dark, say the wall of a building in shadow, Exposure times are, therefore, a problem because fast shutter speeds (probably 1/125 or faster) will be needed to freeze the raindrops but exposure times must be reduced to cope with the generally dark background.

Much more effectively and creatively, rain storms in towns can be *suggested* by the reaction of people, huddled in a doorway or battling through the rain with raised umbrellas. Alternatively, photographs of rain falling in puddles or ornamental pools, spray thrown up by traffic, leave no doubt about the conditions. Working in India in the monsoon season, I found that shots of raindrops bouncing on the pavements and roadways showed up well and emphasised the severity of a storm.

One method of photographing rain which commends itself to the dry weather travel photographer is to shoot the scene through a window from inside a building. Large plate glass windows, as perhaps in a restaurant or store, are ideal because they give an uninterrupted view, uncluttered by window frames. Two different situations can be used: when rain first starts and the glass is simply spotted with individual drops, or, later, when the window is streaming with water. In the latter case, a wide-angle lens will help

increase the depth of field and allow the water on the window to show clearly but not at the expense of the scene outside. Distant objects seen through wet glass will appear blurred but this only heightens the evocative quality of the picture. A polarizing filter ought to be used for these photographs.

Photographs of falling snow in towns can be especially attractive, giving a diffused, almost ghostly, character to the scene. Snow in the streets is better shot just after a heavy fall, before it has become dirtied by traffic. Early morning, after a night snowfall, is the best time of all.

Towns in fog may not seem attractive subjects, but if it is just thick enough to cause traffic to use headlamps and the lights of buildings to be switched on, then yet another *mood* of the town can be recorded on film. The temptation to cheat, by using two fog filters, is best avoided because the resulting picture, in towns at least, is obviously bogus.

One side of Cape Town's Heerengracht reflected in the glass wall of a building on the other side. At street level the reflection is lost.

REFLECTIONS

The large number of reflective surfaces encountered in a town offer wonderful opportunities for photographs of subjects seen as in a looking glass. In cities with many modern buildings, it is probable that at least one will have glass walls, or have such a large expanse of window, that it acts as a giant mirror. Intriguing shots are possible with these surfaces, enabling the photographer to capture both sides of the street at the same time. The glass fronted building should be well lit, but preferably without the sun's own image in reflection. For the most dramatic effect, fill the frame with the mirror wall so that it forms the whole background and choose a viewpoint in which reflected images appear in at least half the frame. Because the glass surfaces will not lie in exactly the same planes, the reflected image may look as much as if rippling water were the reflecting medium.

A straight forward adaptation of the sort of shot described above is to photograph street scenes in shop or other windows, choosing one which has a dark background and reflects well. Alternatively, reflected images can be photographed in the polished paintwork of vehicles, in wing mirrors, or even in hub caps. If the reflecting surface is curved, the resultant distortion only adds to the interest.

For small mirrored surfaces, I find it useful to work with a telephoto lens, most often a zoom operating at about 135mm. Remembering that the angle of incidence equals the angle of reflection, it is easy to eliminate one's own image from the frame by a careful choice of viewpoint. When using a large window or glass wall as reflector, and standing well back from it, there is less need to

bother about the angle of view. If the photographer appears in the frame it may even add to the interest and there is no reason why a standard or wide-angle lens should not be used.

Two further points might be made about photographing reflected images. Focusing is not a real problem unless using a camera without a focusing screen or rangefinder. Then it is important to recall that the image is as far behind the reflecting surface as the subject is in front of it (see fig. 3). If it is important to have both the reflecting surface and the reflected image in focus, then attention will have to be paid to depth of field. This suggests the use of a wide-angle lens and working at small aperture. Lastly, the intensity of reflected light received from a reflecting surface, that is, the reflectivity of the surface, is partly a function of the angle of reflection. Thus, it may be possible to increase the intensity simply by altering the viewpoint.

NIGHT SCENES

Cape Town at night, as seen from Signal Hill, or the lights of the Hong Kong waterfront seen across Victoria Harbour, could be dismissed as just two of the clichés of travel photography. But such is the attraction of the town night scene that few travel photographers will pass over the chance of getting these kinds of shot no matter how many times it has been done before.

Night photography in towns is really much easier than some might suppose. It is not even essential to reload the camera with high speed film or to use a tripod. Both these aids will improve the definition of a picture but that may not be a major consideration. If it is, then black and white stock rated at ASA 400 is quite adequate, and for colour, ASA 200. If the light source is artificial (street lamps, neon signs, lights from windows) and colour photographs are wanted, tungsten film may be preferred. It should be remembered that conversion/correction filters can be used when shooting by artificial light with daylight film, and vice versa. So there is no need to reload a camera simply because a whole roll of film is not being used under any one condition.

If long exposures are necessary and sharpness desired, a tripod ought to be used, but most travel photographers will find this inconvenient or even impossible. Instead, assuming the camera to be hand-held, the photographer can brace himself against the side of a building, a lamp standard or some other piece of street furniture. In some

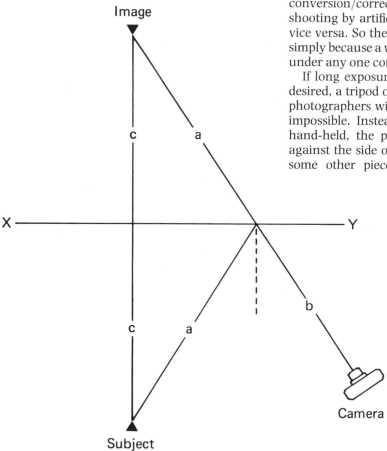

Fig. 3 **With XY as reflecting surface, the focusing distance equals a + b**

circumstances, the camera may deliberately be moved, even swung or rotated in a vertical plane, during a long exposure to give intricate abstract patterns of light. This, like most other night photographs in towns, is most effective with colour film if there is a variety of different coloured light sources.

The most commonly used type of special effects filter for night work in towns is the starburst. This gives each light source a star-like appearance, the number of points to the star being decided by the etched pattern of the filter. Because the light from each source is spread by this means, the filter is especially useful in small towns or in the Third World where the amount of street lighting and other sources may be limited. Alternatively, if it is not easy satisfactorily to fill the frame with artificial light sources, some sort of multivision filter can be used.

The most colourful scenes at night will probably be found in the entertainment quarter, with lights from traffic, advertisements, cinema and theatre signs, shop fronts, and so on. In like manner, public buildings may be floodlit, or subjects might be a night market as in Singapore, or an open-air Chinese opera in Penang, or a religious festival like the Esala Perahera in Kandy. Enquiry on the spot and a good guide book will usually provide sufficient information regarding the best locations but, as always, ground reconnaissance is advisable.

Shots of many moving lights, as with traffic, give a choice according to the sort of effect required. If sharpness is wanted, the traffic will need to be near stationary. The photographer will have to choose a viewpoint near a road junction where traffic is controlled by light signals or a policeman. The moment to shoot in these circumstances is as the traffic flow is about to change. That is, as one group of vehicles comes to a halt and the other has not yet moved off. (With the sort of traffic movement one finds in some towns, this requires very careful timing!) It is at these times that pedestrians are also likely to be relatively still at the kerbside, waiting to cross the road.

On the other hand, if the photographer chooses to shoot with the traffic in motion, allowing the vehicles' lights to appear as coloured lines then the best viewpoint will be above the traffic from, say, a window or pedestrian bridge over the roadway. A time exposure will give fascinating patterns of red and white lights, enhanced if the viewpoint is near a junction and the lines cross. Heavily trafficked streets give the best results, especially when vehicle speeds do not vary too greatly.

In all night scenes which are well lit, there is something to be said for including silhouettes of recognisable shapes in the foreground of the picture. These can range from trees to people, lamp standards to monuments. The purpose is twofold: to heighten contrast and to give an impression of depth in the photograph. In some cases, such silhouettes may also give additional interest to the picture as, for example, when pedestrians are seen looking into brightly lit shop windows.

As with floodlit buildings, shop windows present little difficulty to the photographer because all the lights will be pointing away from the camera. If window shoppers are to be included as more than silhouettes, the viewpoint will have to be from the side where their faces will be seen lit by reflected lights from the window. Exposure problems now occur because the faces will be considerably less well illuminated than the goods in the window. A compromise is the only answer, but it may be necessary to be content with less than perfection as far as the images of the window shoppers are concerned. Otherwise the interior of the window will be over-exposed and its contents unrecognisable.

In many Third World countries, small open workshops and retail shops remain active until late hours in the evening and, with the early sunset of the tropics, scenes like these make particularly attractive subjects. However, long exposure times may be needed with interiors dimly lit by oil lamps.

Timing of photography for special effects is always critical and this is no less so at night in towns. General views of towns at night, from distant vewpoints, are often best taken as the sun sets. Twilight will not compete with artificial lighting but add more detail to the resultant picture, reducing contrasts. In the tropics (or in winter in more temperate latitudes) it is also likely that lights in the central districts of a city will be more numerous at this time in the evening. Not only will street lamps and neon signs be switched on, but office buildings will still be functioning and their lights burning. Traffic scenes may be best shot at the same time as the rush-hour gets underway. For shots of city centres, it may be wiser to wait for the night life to begin.

One of the few occasions that a travel photographer might actually welcome rain is when he is working in town at night. Reflections from wet pavements and roadways not only provide more creative opportunities but also allow exposure times to be reduced by between a third and a half. Reflected lights in fountain pools or along waterfronts are another bonus in night photography.

SUBURBS

If time is short, there may be some excuse for a travel photographer working exclusively in the central districts of a town. But there can be no other excuse. City centres may be interesting, certainly they are exciting, but they are not typical. The true essence of a town is in its suburbs. Obviously there must be an element of sampling but, with the sort of preparations described in Chapter 3, the photographer should already be aware of the general morphology of the town before he arrives.

Although his choice of suburbs will depend on the sort of objectives he has for his photography, for general purposes, a variety of suburbs or districts should be chosen as representative. Each town will be different in the scope it offers. In some towns it may be possible to select two or three districts which provide contrasts in the population's social structure. These may be illustrated by a garden suburb, a public housing estate or a run-down district of slum dwellings. Districts favoured by particular ethnic minorities are often especially photogenic. San Francisco's China Town or New York's Harlem are examples, but there are few big towns without their equivalent. In suburbs like these a whole, alien, culture is encapsulated. China Towns, wherever they are, are somehow more Chinese than any town in China!

The basic principles of urban photography do not differ from centre to suburb but the accent may change in choice of subject. Residential areas are, after all, where people live and something of the people and their attitude to life should emerge from the photographs taken there.

I photographed this breakfast time scene in an Indian street. It is a more telling portrait of town life than shots of architecture.

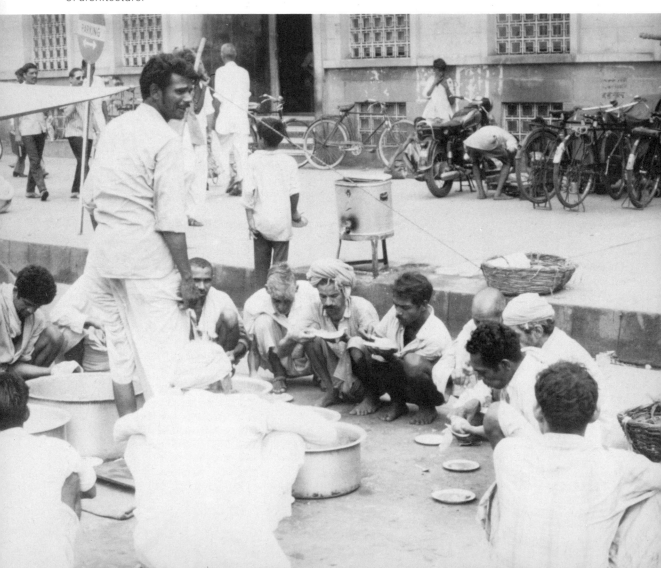

6 In the Country

I hope it is correct to assume that the travel photographer is also a traveller, that he will not be content until he is on the move again. Towns are places of confinement, claustrophobic, limiting. In the countryside it is different.

For the travel photographer the greatest challenge comes when he leaves the town and takes to the wide open spaces: plains and mountains, empty deserts and rich forests. Not all the problems he encounters will be photographic. If towns are restricting, they also offer greater security. If they are limiting, they also suggest limits. In the countryside, the traveller must draw his own boundaries, decide his own frontiers.

While the traveller journeys to experience the world away from home, it is the additional aim of the travel photographer to record these experiences on film. The images he produces must evoke faithfully *his* recollections of the peoples, places and things he sees on his journey. What *he* sees is unique and the pictures he produces must also be unique. Just as a landscape painting is the impression of the artist, so too is the traveller's photograph. Only the medium is different. The photographer is painting with light.

So varied are the locations, opportunities and objectives, it is difficult to generalize about planning work away from towns. Much can be done before leaving home, on the lines suggested in Chapter 2. On arrival, but before beginning work, some further organisational tasks should be completed. All routes should be checked to ensure that the data collected at home are still accurate. Roads clearly marked on a map may no longer exist or they may temporarily be closed by floods or snow. On the other hand, new roads may have been built and access improved. Information may be difficult to come by in some parts of the world. If there is a national motoring organisation, their help can be sought. Alternatively, the local highways authority can be approached. During a journey it may be advisable to check route conditions daily at petrol stations.

With journeys on foot, or where fixed-line communications do not exist (a camel trek across a desert, for example), it is even more important to obtain confirmation and reassurance that one's armchair planning can safely be put into effect on the ground.

Political unrest or conflict may cause a travel photographer to modify his plans. An outbreak of cholera or a drought will, likewise, deter all but the brave or the foolhardy.

Arrangements for the export of film, such as discussed in Chapter 2, may need to be made and the services of a guide or driver engaged. I firmly believe in the wisdom of employing local guides unless I know the country well. In areas where the going is tough – politically, socially or physically – they may mean the difference between life and death. Even if one has a travelling companion or assistant, the local knowledge of a guide is indispensable.

I am often asked how guides may be found. Circumstances vary and general rules are hard to lay down but it is usually unwise to accept the services of the individual volunteering help. Guides should be *chosen*. Two likely sources are travel agents in the country you are travelling in, or students. Many travel agents will either provide transport and a driver or suggest a reliable freelance guide. Universities can be approached, perhaps through the geography or English language departments, for help from a student, particularly if one's own tour coincides with a university vacation. Students often make very good guides; they are, one hopes, intelligent and their standard of spoken English is often far better than is the case with most other sections of the indigenous population.

Another possible source of information and help is the British or American Embassy or local consul. In this case it is better to write well in advance of arrival. As with any other approach, it is important to give some idea of the level of payment that is being offered.

Having recruited a local guide it is important to spend a little time explaining the photographic

objectives of the journey. He should understand that photography is the purpose of the trip and not just an unimportant distraction. Something too should be said about equipment so that the guide is aware of its value and of the problems associated with storage and its vulnerability to damage. A good guide will quickly appreciate the travel photographer's task, share in his work and even begin to make valuable suggestions as the journey proceeds. I find this process of conversion, from a guide to an assistant, is accelerated rapidly if I explain what I am doing in my work.

The techniques of travel photography away from towns depend largely upon three variables: geographical location, terrain and objectives. The first of these has been touched on in Chapter 3 and will be dealt with incidentally below. The latter two variables can be taken together as dependent, in that the terrain may suggest the objectives, or vice versa. It generally can be supposed that a travel photographer will have in mind a wide variety of camera subjects in order to produce a composite record of the region in which he is travelling. Naturally, emphasis will change and travel photography may well take on the guise of expedition photography when the aims are very specific.

Below are discussed some of the terrains and objectives which might be the travel photographer's goal.

LANDSCAPES

For a very thorough review of landscape photography, the reader may be referred to another book in this series: *Creative Techniques in Landscape Photography*. Here the accent will be especially on the approach of a travel photographer to landscape subjects.

If a general collection of landscape pictures is wanted then route planning will be of critical importance. No matter how short the journey, it should be planned to exploit the variations in scene that are one of the primary attractions of travel itself. Working from a map and from local knowledge or advice, the route should attempt to cross, or expose to view, as great a variety of scenery as possible. Sometimes this may be done by the use of transects across country, at others it will be more economical to choose a series of bases from which to produce sample studies of a region.

Perhaps even more than with any other photographic subjects, timing of work has a dominant part to play in the *quality* of landscape photographs. It is not only the technical quality

which will be affected but the whole mood of the picture. This fact can be demonstrated in sequence photography, a series of pictures shot through the day or in different seasons. There is no such time as an ideal moment of the day to photograph landscapes. It all depends upon what you want. However, the effects of different lighting conditions ought to be considered.

In the tropics, or in summer in more temperate latitudes, a flat landscape may show up badly in the light of the noonday sun. Shadows will be short and the resultant photograph will lack depth and scale. Although this is less serious with colour film, there remains a problem caused by the high contrast between shadow areas and those in light. If the landscape is one of rugged terrain then it may be preferable to wait until the sun is high and the landscape can tell its own story without the emphasis of long shadows.

For many general purpose landscape photographs, mid-morning or mid-afternoon are preferable times to work, not least because the temperatures of mid-morning may be more tolerable than later in the day. At these times, shadows cast by natural light will be long, emphasising relief features and contrast will be less as more reflected light seeps into the shadow regions. Early morning and late evening conditions are special cases and are dealt with below.

Not only should a travel photographer consider the time of day but also the cloud conditions as they affect the illumination of whole areas of natural landscape. As previously described, a filter can be used to look at the sky and anticipate changes in light as clouds move across the sun. Patience is rewarded when strong shafts of sunlight suddenly illuminate a part of the distant scene, or thin cloud diffuses the light making for a softer landscape.

Because of the importance of light, planning should allow for variations that occur during the day and landscape photography may well have to alternate with other subjects in order not to waste valuable time.

Viewpoints for landscape photography may well depend upon access and the time available. Obviously a change of lens, using a different focal length, may be a short cut, but this has its drawbacks in giving, at the same time, a change in perspective. To encompass a larger view of the landscape, a wide-angle lens can be used but this will have the effect of pushing back the distant parts of the scene. In fact, wide-angle lenses are of limited value in landscape work unless the foreground and middle distance is full of interest.

Lighting is critical to the effective photography of any landscape. Gordale Scar, in the English Pennines, is seen here with just sufficient shadow to suggest the presence of the gorge.

Conversely, using a telephoto lens may so compress the view that its majesty is diminished. There is much to be said for using standard lenses for landscapes if intent upon recording the view in something like its natural perspective.

However, there will be times when the foreground is of little interest and cannot be eliminated by choosing a high viewpoint. Then the telephoto lens comes into its own and a zoom lens gives the added advantage of some freedom of composition. For landscape photographs in which the aim is to give emphasis to the foreground, it is better to take a low level viewpoint and use a wide-angle lens, but not an ultra wide-angle. This will put the background into a subordinate position but allow it to set the scene for the foreground subject.

It is very important to consider the whole field of view in photographing landscapes. Too easily,

unwanted subjects appear in the frame but go unnoticed. It is a sensible rule to think in terms of foreground, middle distance and background, every time one looks into the viewfinder. The biggest problems can occur with foreground objects which distract attention away from the more distant landscape. To eliminate such distractions, the photographer has a number of options. He can alter his viewpoint, moving back or away from the offending object. He can alter his viewing direction or the focal length of his lens. He can put the foreground out of focus by adjusting aperture and/or focal length of lens to alter the depth of field.

In some instances, a subject in the foreground may deliberately be chosen by a photographer to improve perspective and emphasise scale. Such subjects should not draw attention away from the main subject: the landscape, or they will defeat the

I composed this shot of the Lyngen Alps to divide into two blending parts: the foreground a peaceful rural landscape of farms and drying hay; the background, a mountain scene enhanced by shadows.

purpose of their inclusion. Objects like trees or a nearby rock outcrop blend naturally into landscape photographs, but if the object is man-made or a human figure then it may be more distracting unless chosen with care. People in the foreground of landscape pictures are better facing away from the camera and, in colour photography, not wearing especially bright clothing in colours contrasting with the natural hues. However, in circumstances where the landscape is predominantly shades of a single colour, for example, green or brown or white, a subject in contrasting colours, say, red or orange or yellow, may relieve the monotony of an otherwise monochromatic effect. As with all photographs, the photographer's intention is a deciding factor.

Most landscape photographs will include the sky. The skyline may well be an important feature of the landscape and add to the interest of the picture as well as conveying a feeling of depth as the horizon is seen. The sky, its light and shade, cloud and clear patches, may contribute greatly to

This photograph allows the mountains to dominate while giving the viewer two other points of interest and scale, the bridge and the pipe sections.

the attractiveness of the photograph. It is important to recognise this and to take the sky into account when framing and composing the photograph, adding it to the considerations of foreground, middle distance and background, mentioned above. What proportion of the frame to give to the sky can only depend upon the photographer's sense of composition and objectives.

Any photograph with over fifty percent of sky in the frame might be classed as a skyscape rather than a landscape and, therefore, signify a change in the photographer's intentions. On the other hand, it is usually unwise to reduce the proportion of sky in the frame to a very low percentage, say, less than twenty percent, if it is to be included at all. There is something very unsatisfactory about a landscape photograph in which the sky appears simply as a thin streak across the top of the picture. There will be exceptions, of course, to any general rule like this, for example, in the case of a landscape shot from a particularly high viewpoint.

It is essential not to *freeze* movement in photographing a waterfall. Here the water appears to be spilling out of the picture. I had to climb out along the branch of an overhanging tree to take this shot of the top of the falls.

Certain subjects, incidental to the general open landscape, will certainly attract the travel photographer's camera. Landscape details, a coppice, a windmill, the pattern of hedgerows, a tumbledown farm, all have an important role in the travel photographer's quest for a sense of place. The details of the landscape, natural or man-made, are even more important to record than archi-

tectural details in towns. They will often establish more clearly and quickly a location's uniqueness. I find that I will most likely expose ten frames on landscape detail for every one general shot I take. Even a single tree, a baobab in Africa, perhaps, a dwarf birch in Lapland, a wind bent palm in the tropics, can be singled out as a subject.

Of all the landscape elements that travel photographers find irresistible as subjects, water, and especially waterfalls, come high on the list. Even falls of a quite modest drop qualify. Probably the most difficult problem in photographing a waterfall is the decision as to shutter speeds. If there is to be an impression of movement, it is not necessary to use the sort of speed (perhaps 1/500 or faster) which will *freeze* the water. Speeds of 1/250 or even 1/100 can be used depending upon the effect required. Streamer effects can be produced with slow speeds and, as a general rule, the shutter speed should be increased the closer the viewpoint and the greater the proportion of the frame to be filled by the fall.

Most falls of any significant size and drop will give off clouds of spray, especially near the base. This can be exploited to give pictures with diffused light transmitted through the water droplets and it is often possible to move to a viewpoint from which a rainbow can be seen in the spray if there is bright sunlight.

Rivers and lakes, too, are attractive: turbulent streams photographed to emphasise their power and speed, and still rivers and lakes giving opportunities to make use of reflected light and reflections.

For all landscape photography, a tripod is advisable but may not be available to a travel photographer. If so, improvisation is the answer on the lines suggested in earlier chapters. With some form of support, slow shutter speeds will allow small apertures to be used, thus improving sharpness of focus and depth of field. However, if there is a strong wind disturbing the leaves and branches of trees, it may be necessary to increase shutter speeds to 1/100 or more, especially if the movement is in subjects near to the viewpoint.

Filters will almost certainly prove useful and there is no excuse for not including them in the gadget bag. UV or skylight filters are a must for colour work and black and white. A light yellow filter will be useful when the camera is loaded with black and white film, especially if the sky is to form a significant part of the picture. A common fault with black and white photographs of landscape is weakening the picture's visual impact by a totally washed-out sky, lacking in interest.

SKYSCAPES

Photographs of the sky can be taken for their own sake or to complement landscapes. If some of the ground is to be included, then it should occupy not less than twenty percent of the frame. The most attractive skies, photographically speaking, are usually those with distinctive cloud patterns and are often seen at their best when there is a balance between cloud and clear sky.

In locations where the weather conditions are rapidly changing, there will be opportunities for sequence photography. Where weather conditions are fairly predictable, as may be the case in some equatorial regions, a travel photographer can time his work with reasonable certainty. Almost any condition may be attractive except for those times when the sky is uniformly overcast or totally free of cloud. However, two sorts of cloud are especially worth looking for: cirrus and cumulus. Cirrus clouds, composed of ice crystals, form at high altitude and have a feathery appearance. They are best photographed when the sun is high and they cover a relatively small proportion of the sky. If the sun is visible through the cloud it may have a halo of light. Associated with a variety of weather conditions, cirrus clouds often herald an advancing depression and are also especially characteristic of colder climates.

Cumulus clouds, the cotton wool clouds of childhood drawings, form in an unstable atmosphere and may tower to great heights. They will be characteristic of stormy conditions in any part of the world. A third class of cloud, stratus, is found in a more stable atmosphere and may give rather unattractive skies with a thin layer of grey-white medium height cloud.

Travel photography should include skyscapes. The sky is very much a part of the traveller's visual experience and, as an indicator of the weather, it is as basic to the ambience of a place as are the hills and the valleys. It *is* the atmosphere, and frequently *provides* the atmosphere. Any problem the traveller has is less likely to be one of photographic techniques rather than one of habit. As was said earlier, in the chapter on photography in towns, we spend so much of our lives looking down or straight ahead, that we fail to look upwards.

Light, and therefore exposure, can cause some difficulties in skyscapes. The difficulties will be exacerbated if landscape is included in the frame. There are two reasons for this. Firstly, the sky will be well lit compared with the ground, and, secondly, the sky itself will vary in brightness from the horizon upwards. Unclouded sections of the

Patience is usually rewarded, as when a junk on Wuxi Lake in China sailed into view to create a point of interest within the symmetry of the picture.

sky may be light near the horizon and much darker at higher elevations. Cloud shades vary from almost black to bright white, some clouds blocking out the sun, others translucent. The sun behind small black storm clouds will give wonderful silver lining effects.

Calculating exposures for skyscapes calls for care and decision. Assuming part of the landscape is to be included, readings may vary by anything from two to four f-stops between ground and sky. Unless one resorts to the use of a graduated filter (and probably loses some control over composition), it will usually be better to allow the sky to set the exposure and accept an underexposed landscape. With an interesting skyline of, say, rugged mountains or tree shapes, this can give an acceptable, even pleasing silhouette at the bottom of the frame. For a rather flat horizon, it may be preferable to strike a compromise although overexposure of the sky will give uninteresting results.

Side lighting usually shows up cloud forms best and is especially helpful in modelling cumulus. Haze problems, especially in the tropics and in temperate areas, are least in the early morning and late afternoon but greatest at the horizon. Areas near deserts may present a different hazard: blown dust. Winds such as the Harmattan, for example, can block out the sun and produce a near fog on the southern margins of the Sahara. A travel photographer who has skyscapes as a major objective of his tour would do well to study the seasonal climatic conditions of an area before he fixes the dates of his departure to it.

Skyscapes do not call for much by way of special equipment. A tripod is less necessary than with landscapes, but some support should be used if shooting at slow shutter speeds which might be demanded at the beginning and end of the day. Incidentally, it is important to remember that clouds are moving subjects and shutter speeds below 1/15 should not be used with very fast moving clouds. Although I prefer a standard lens for landscape work, I use a wide-angle or ultra wide-angle lens for most skyscapes. A wide-angle lens conveys better the sense of an all-enveloping sky. For colour, polarizing, UV or skylight filters are all that are needed and although these can be used with black and white film, so too can various coloured filters. Commonly, yellow or green filters are used to heighten contrasts between cloud and clear sky and, for natural tones, these are best. But to produce more dramatic sky pictures, red or orange filters can be attached and these are particularly useful with rather pale skies.

THE SUN

The sun can, of course, play a dominant role in skyscapes but it can also be a subject in its own right or totally transform a skyscape or landscape as, for example, at sunrise or sunset.

Travellers in the tropics will know that there is very little twilight at low latitudes. The sun rises and sets very quickly and a minute or two can be all that separates a dramatic sunset from a badly lit landscape. In addition to quick reactions and preparedness, the photographer needs a polarizing filter when working with colour film, and because exposures are difficult to calculate with accuracy, there is some excuse for bracketing. In measuring exposures, either through the lens or with a separate light meter, the sun should be held off-centre by about thirty degrees. The greatest danger is of underexposure and it is often better to let the sun burn out a little. Away from the tropics, sunsets and sunrises will generally be less brilliant but longer lived.

For special effects, the sun can be shielded behind some object such as a tree or even a person, or a starburst filter can be used. Alternatively, the red glow of a rising or setting sun can produce warmly attractive pictures with the sun itself out of shot. If the sun is to be included in the frame, its size can be magnified by using a telephoto lens.

BAD WEATHER AND SEASONS

Our impressions of places we visit are very much coloured by the weather and the season. A journey across Canada in January and another in July will be the equivalent of visiting two different places. Bright sunshine may turn the most unattractive location into a demi-paradise.

No travel photographer can afford to be a fair weather operator. It is not surprising that picture postcards are so often produced by a local photographer who can pick the day to show a location bathed in sunlight although such a view may be atypical to the point of being unique. Travelling with a camera does not permit the luxury of choice of conditions enjoyed by the resident photographer. If it is foggy, then the scene must be photographed in fog. If it rains, then this too must be recorded. Something has already been said of bad weather conditions in Chapter 5 and reference will be made to other particular conditions in the sections which follow. However, one atmospheric phenomenon has not been mentioned at all, so far. This is the electric storm.

Taking elementary precautions, the open countryside is the ideal background to photography of thunderstorms. Along with coastal locations, here there is a much better chance than in towns that lightning will be more easily seen and recorded. The severity of thunderstorms tends to increase towards the equator in sympathy with increases in atmospheric instability. Many electric storms will occur during daylight hours, particularly in the late afternoon, but some will be at night and this will be the best time to photograph.

The existence of a storm probably supposes an overcast sky and the camera can be pointed in a direction towards the storm and away from any light sources. With the shutter held open, it will be possible to record several lightning flashes and the countryside illuminated by them. With so-called fork lightning, a number of flashes can be recorded on the same frame, but with sheet lightning it will be better to shoot only one flash at a time. The landscape, silhouetted against the sky by the light of the electrical discharge, should be chosen with care to give the most dramatic effect, Buildings, trees and other clear shapes can be included in the frame. The camera must be held absolutely still on a tripod, a window sill or other rigid support.

In daylight, photography of lightning is less simple and will need exceptionally quick reactions, a small aperture setting and slow shutter speeds. A neutral density filter is a useful aid.

It may not always be possible to choose the time of year that one visits a location, but when choice is possible, it should be considered carefully because the season may well determine the *mood* of the place. New England in autumn is more attractive than in mid-winter and, like people, all places have more or less attractive moods. If the same place can be visited more than once, it will add to the interest of the photographer's collection should the visits be made in contrasting seasons. In temperate and sub-polar regions the greatest contrasts may be between winter and summer, although spring and autumn may be more alluring. Towards the tropics, greater contrasts may be between wet and dry seasons. A parched landscape can undergo a transformation when the rains come.

Storm clouds dominate but there is sufficient light to reveal the landscape across the fjord. The tree in the foreground is included so that its bending branches should combine with the rippled water surface to create an impression of wind.

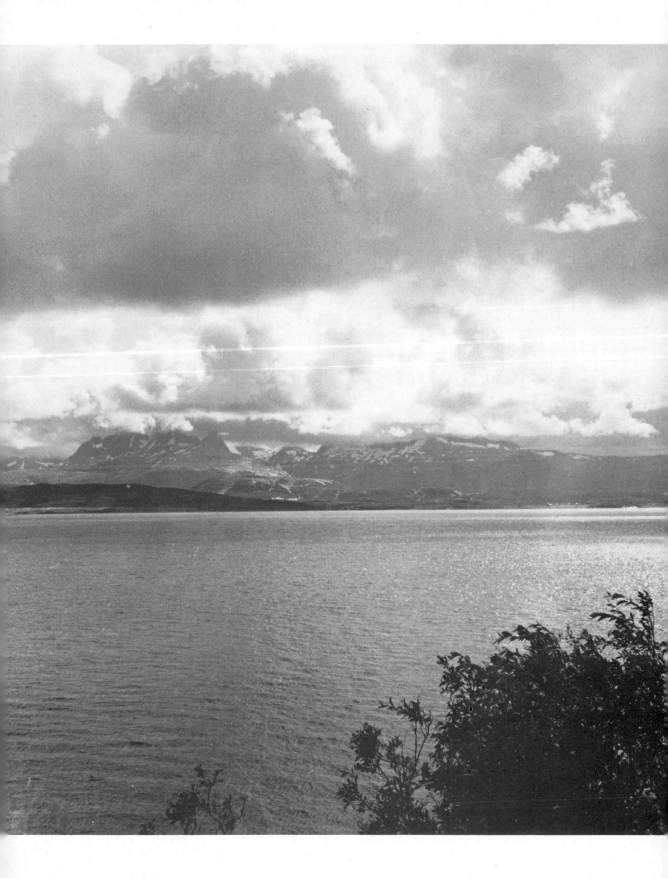

MOUNTAINS

Mountain photography techniques (see also Chapter 3) tend to concentrate on the capturing of the awesome nature of the landscape, its majesty and scale. Properly to do so, will mean appreciable physical effort on the part of the photographer. Whereas in a town or well settled plain, the scene is constantly changing, on a mountain trek it may be necessary to climb and walk over considerable distances in order to find satisfactory viewpoints and obtain a variety of shots. In many parts of the world, this will only be achieved by engaging the services of a guide and being prepared to spend ten to fourteen days on location, camping overnight. In developed regions, an easier journey may be planned using mountain roads or tracks and using a four-wheel-drive vehicle. In any event there is certain to be a lot of walking involved and the points made about equipment in Chapter 3 should be borne in mind.

It is sometimes said that mountain photography is a lesson in perspective and certainly it is a major determinant of success or failure in reproducing the grandeur of mountains. Two controlling variables are within the power of the photographer: viewpoint and lens choice.

The optimum viewpoint is often halfway up a mountain for much the same reason as explained in Chapter 5 in the section dealing with the photography of buildings. Viewpoints at the foot of a mountain mass tend to be unsatisfactory. On a standard lens, too little of the mountain will be seen unless the viewpoint is a long distance from the subject with a consequent diminution in the size of the peaks. A closer viewpoint is possible to include more of the subject using a shorter focal length lens, but again the effect will be to diminish the mountains' scale. With a telephoto lens, it may be impossible to fill the frame satisfactorily. All low viewpoints tend to exaggerate the heights of the nearest range or the foothills at the expense of more distant peaks, which may well be higher. In some cases, the more remote ranges may be completely invisible due to being masked by the nearest hills.

Even if it is possible to reach the summit levels, viewpoints from the top do not always convey a good impression of the *bulk* of the massif. This time the foreground loses at the expense of the background relief. From a position between summit and mountain foot, the camera will more accurately register both the depth of the valleys and the heights of the peaks.

Assuming a viewpoint at altitude, but below the summit, two lenses are useful. A wide-angle (24 to 35mm) will be able to take in a significant part of the landscape, and a telephoto lens (150 to 200mm) will enable the photographer to pick out detail, *pull in* the furthest ranges, or isolate a distant peak.

A common device to suggest distance is to use foreground objects such as trees, or their overhanging branches, to frame the picture. Because the scale of a nearby object will immediately be apparent to the viewer, he can better appreciate the depth of the view. This is particularly useful in mountain photography and, even if the slopes are unvegetated, some other natural object such as a boulder can be used.

If there is an opportunity to photograph climbers, again the best viewpoint is on a facing slope at approximately the same altitude as the subjects. Two sorts of shot are possible, those which emphasise the small size of the climbing figures against the massive scale of the slopes, or close-ups using a long focal length lens. In both cases, climbers dressed in colours at the red end of the spectrum will show up best. If it is possible to find a suitable viewpoint on the same slope as a climber, it may be possible to photograph him from the side so that the sky forms a background to his silhouetted figure.

Rapid changes in weather conditions are characteristic of mountain areas and these can be the subject of a sequence of mood pictures from a single viewpoint. Lighting variations through the day also change the scene so dramatically that a photograph taken in the morning may appear totally different from one taken in the afternoon even when the weather is unchanged.

If it is possible to make a choice of lighting, then it may be thought best to restrict much of the photography to the early morning or late afternoon, especially when working at low latitudes. As so often, lighting from the side gives the best three dimensional effects although the sun behind the camera can give pleasing results if there is sufficient variation in tone between the foreground and background.

Strong ultra-violet rays, which increase as higher altitudes are reached, make a UV filter a necessity rather than a luxury, but atmospheric haze is least at high levels. From a relatively low viewpoint, haze can be used to give an impression of depth in the picture. This is especially so when using colour film on which the range of hues from foreground to background will distinguish mountain ranges receding into the distance.

If working in black and white, it may be better to use a UV filter rather than a yellow filter once

Mountains are subjects for studies in mood. The mountain above, in storm and snow covered, appear forbidding. Below, depth is suggested by tonal contrasts and the valley makes its own invitation to explore.

heights of 7000 feet (2000 metres) or so are reached. In bright sunlight, at high altitudes, a yellow filter tends to make the sky tones too dark.

Snow and ice at very high altitudes may add to the attractiveness of mountain photographs but will give the same problems as those associated with polar and sub-polar regions, and these will be dealt with later in this chapter.

CAVES

Caving has been described as 'mountaineering upside down', but for the photographer the two environments are very different. For the travel photographer, most cave work will be only incidental. It is unlikely that a great deal of time will be spent underground or that the hazards of a cave expedition will be encountered. The same sort of caution should be exercised as in those two other specialist fields: mountain and underwater photography. Local guides should be used even when the photographer has some experience of caving.

Most large caves will be found in areas of limestone and a quick look at a geological map may be the first clue as to their possible presence. Further enquiry can be made on location and arrangements to photograph can be negotiated. Two different circumstances are likely to be met, with some cave systems open for visits as part of a commercial operation and others to which there is free access. While the former present the least difficulty to the inexperienced caver, they will not necessarily be the easiest to photograph. Some owners specifically forbid photography, others may insist upon payment and all will allow the photographer less freedom to choose his viewpoints and control his lighting.

In the case of caves which are illuminated, the question arises as to whether to use only the light provided or whether to supplement it with fill-in lighting from flash equipment. On the whole it may be better to do without the addition of flash because this only exacerbates the problems of eliminating colour casts from light sources of colour temperatures which are not matched to the film stock being used. A colour correction filter, used to allow daylight film to be exposed in artificial light, will not give totally satisfactory results with a variety of lights. Of course, if black and white film is loaded, this problem is not encountered.

Photography in unilluminated caves will again mostly be by artificial light rather than by available light. If the caves are off the tourist beat, they will probably be in their natural state and, with a guide, a travel photographer may be able to move

freely about the system with only the physical problems of access with which to contend. Some form of flash will be used and it is worth repeating here that there is much to be said for the greater reliability of flash bulbs compared with electronic flash guns. In damp conditions, as will be experienced in caves, electronic flash has a nasty habit of malfunctioning just when it is most needed. If a flashgun is used, it should be fully computerized and have remote facilities.

Two problems arise if the caves are very large. The first is that of providing sufficient light and, without several flash sources and a slave unit, that is difficult. Only if cave photography is a major objective will the average travel photographer be carrying a lot of flash equipment. An alternative is to use a tripod and multiple exposures. The single light source can then be moved about the cave and the multiple exposures of the same frame will give a well lit single photograph. Care has to be taken to avoid overlapping flashes. Exposure difficulties suggest bracketing as a safeguard. On the whole, there is often a tendency to underexpose in cave photography but exposure times really depend upon the effect required.

The other problem of size is that of giving an impression of scale to the photograph. It may be important to include a close-up of something or someone against which size can be judged. As always, the object or person should fit naturally into the picture and not distract the viewer's attention.

In photography near the entrance of caves it is easier to work from the outside. Photography from inside a cave, looking towards the entrance, can cause burn-outs – the result of too much contrast. Alternatives are to use fill-in flash at the entrance or to work in the late evening, or even after nightfall, when the contrasts will be least and flash can be used in the normal way.

Because of the very wet conditions found in many caves, care must be taken to keep the cameras dry. Doing a lot of work in caves might make it advisable to have an underwater housing or to use an all-weather camera. But these are unlikely courses of action for a travel photographer. As with mountain photography, a lightweight camera is an advantage, but, in caves a wide-angle or wide-angle zoom lens may be all that is necessary. Although the atmospheric conditions are stable inside caves, away from entrances, there may be considerable differences of temperature and humidity between the air outside the cave and the cave's interior. Especially if working in a cold country, or where the caves are

at altitude, it is important to check lenses for condensation before beginning work inside the cave system.

Apart from the very vastness of the caves themselves, other attractive cave subjects are found in the variety of dripstone formations that may occur at certain levels in the system. Stalagmites, stalactites, limestone curtains and pillars, rimstone pools and the like are worth looking for and photographing for their beauty and intricacy. Side lighting will give good modelling and also exploit their reflecting surfaces.

DESERTS

Opportunities to photograph in the arid tropics used to be limited to the true expedition photographer. Sorties into the Egyptian desert or from the security of a North African town, perhaps a limited view of the Great Australian Desert or a crossing of more temperate deserts in North America, were some of the rare occasions that a travel photographer took to the world's great dry areas. Today, even with the political difficulties which beset the Middle East desert countries, more travellers, and photographers, are taking to the sand and stone on cross-desert safaris by truck or camel.

The major problems have already been discussed in Chapter 3 and it is important to recall that hot deserts are not the ideal place for a camera. All the same, some spectacular pictures can be had from these wastelands. Many of the techniques to be adopted are those described above in the sections on mountain photography and general landscapes. The remarks made below will, therefore, concentrate very specifically on those peculiar to deserts.

In planning a desert journey it is unlikely that a

Deserts are harsh landscapes. This oasis settlement in the Iranian desert emphasises man's struggle against the arid environment.

photographer will be thinking of travelling solo. A number of travel firms cater for the more ambitious traveller and it might be advisable to join a group. The greatest disadvantages of so doing are the loss of control the photographer will have over his itinerary and the fact that groups such as these may not be particularly understanding of his needs. Although costs are higher, a more attractive proposition may be to hire a guide and vehicle, or other form of transport, locally. In this case, a great deal more planning will be necessary and such a journey may be better left to a second visit when the travel photographer already has some familiarity with the area.

Choice of location may take into account the fact that the arid tropics do vary greatly. For instance, not all deserts in these latitudes are sandy. In fact, only about a third provide the sort of scenery we associate with films about the Foreign Legion. Not all deserts are flat. In some, like areas of the Atlas mountains, a mountain environment merges with an arid one. The degree of aridity varies, too. Some may be totally devoid of vegetation while in others thorn scrub or cacti may grow. Seasonal variations are greatest at the desert margins. Research before setting out on a photographic assignment is essential.

Deserts, by definition, are dry, and in the tropics that will mean cloudless skies. This causes problems photographically because landscapes may be somewhat monotonous and, together with a sky lacking in interest, provide a rather flat, dull picture. If using colour stock, skies may be too blue, too dark, and a filter will be needed. A skylight filter can be used to reduce bluishness and this is a better plan than trying to adjust the exposure to burn-out the sky. The landscape is likely to be too well lit and light coloured to do this effectively. For black and white photography this problem is less troublesome, but, should there be any cloud at all, a pale yellow or, better, a green filter will make the most of the contrast.

Dust haze often varies with the time of day and arid landscapes are often at their best (i.e. most clear) early in the morning. Other variations do occur, most related to changes in pressure and, therefore, wind conditions. It is worth making the most of those occasions that haze is at a minimum.

Features which provide suitable subjects in deserts include almost all the typical landscape characteristics. In many rocky deserts, the rock structures assume almost bizarre shapes as their variations in geology are exaggerated by the agencies of erosion. Isolated hills (inselbergs) are typical of some deserts, with a variety of shapes, many flat-topped and others pinnacle-like. The buttes and mesas of the North American deserts are well known from cowboy films.

In a sand desert, dunes may provide the only large scale features. Most impressive, and photogenic, are the giant crescentic dunes called barchans. It is often best to photograph dune formations from a relatively high viewpoint and also when the sun is low enough in the sky for shadows to emphasise the shapes of the dunes.

Large expanses of smooth sand (or even lightly coloured rock) can cause exposure difficulties similar to those of a snow surface (see below). Uncompensated meter readings may lead to underexposure.

Scale may be difficult to judge in photographs of the desert environment and some thought should be given to close-up foreground subjects. Two of the essential characteristics of arid regions are their vastness and their uniformity. The latter should not be destroyed by using some alien feature as the foreground subject. Far better to try to find some natural object which appears totally *in place*. With such a close-up subject included in the frame, it may prove fruitful to experiment with a variety of apertures or lenses, changing the depth of field to put the object in or out of focus. To emphasise vastness, lower the horizon in the frame and use a short focal length lens.

FOREST AREAS

Forests are not peculiar to any one environment and are usually associated with all regions that are well watered throughout the year. Some of the problems and techniques of photography are common to all forests whether they be the great orderly stands of conifers as in Scandinavia or Canada, or the jungles of rain forest in the tropics. On the other hand, there are differences, not just in the species of tree but in the photographic techniques that are appropriate. It is convenient to deal separately with tropical and temperate forests.

In the tropics, the term jungle should not be taken as synonymous with forest. In many countries, the primary forest has been removed by fire and cutting to give space for agriculture and the secondary growth which replaces it may still be termed jungle when there is hardly a large tree to be seen. Large areas of rain forest are limited mostly to those areas of the world which are still undeveloped such as great tracts of Borneo and parts of the Amazon Basin. Elsewhere, thick forest is somewhat patchy. It is my own view that the true tropical forest environment is very difficult to capture effectively on film but that makes it all the

more satisfying when a successful shot is achieved.

By their nature, dense tropical forests are difficult to penetrate and a travel photographer without a guide is advised not to attempt to do so. With a guide, the best plan may be to approach by river because a river view, particularly where the banks and valley sides rise steeply, may give unique opportunities to see the forest at its best. From any other direction, there will be no edge, no beginning, to the forest. You will be in it before you can really see it. Arrangements to take a trip up river by boat are easily made locally and the meandering of most rivers gives a welcome variety of viewpoints and lighting conditions.

On foot or in a vehicle, assuming there to be a road or track through the forest, it really is a case of not being able to see the wood for the trees. Photography may have to concentrate on detail rather than forest landscape. It is none the worse for that and a mixture of shots is advisable in any case. One of the special attractions of tropical forests is the great variety of vegetation they contain and this may provide much of the interest in the picture. The real problems come, not with finding subjects, but with finding the right light conditions.

So many forest pictures suffer from over-contrast: the trees underexposed and the shafts of light which break through burning out the picture. There can be no golden rules about lighting. There is no optimal time of day or angle of incidence. It is all a matter of moving about the forest until the lighting available provides the effect required. Lighting at the edge of the forest may be better early in the morning or late afternoon, but the deeper parts of the forest may be better lit when the sun is high. All rain forests have some patches where nature or man has thinned the trees and the sun's rays can filter through the leaf canopy. On hilly ground the higher levels may provide the most favourable viewpoints.

Rain forests are just that, forests in rainy areas. It is often worth waiting until after a rainstorm to photograph when the leaf surfaces will be wet and shiny and reflective. Rapid evapotranspiration can, however, give an excessively humid atmosphere and all that means, not only to equipment, but to visibility. Steamy is a not inapt description of these forests soon after the rain stops and the sun gets to work.

The photographer's creativity can be tested in shooting into the light, upwards through the trees with the sun itself hidden perhaps behind the trunk of a tree or in thick leafy branches. Individual shafts of light alternating with the shadowy shapes

of trees and other vegetation also make effective shots.

If working from a boat along a jungle margin, intricate root patterns of mangroves may provide subjects for close-ups especially if the river is low. Similarly, various forms of lianes and epiphytes may merit a close-up or semi-close-up shot.

The reader is referred to the section on the humid tropics in Chapter 3 for suggestions about care of equipment but it might be mentioned here that cameras or other equipment should never be put down on the bare ground inside a tropical forest. If it is necessary to place equipment on the forest floor, some waterproof sheeting must be used.

If walking through really thick jungle, camera straps can very easily be caught up in overhanging branches and on the countless vines and creepers which block the path. It may be found advisable to wear a light shirt over the top of any equipment carried on the photographer's person.

All the usual focal length lenses will have their place in rain forest photography but a fast lens, with its greater light tolerance may be preferred to a slow one. Filters for black and white photography could include a light green to lighten foliage in very strong sunlight. Fast film should be loaded prior to working in forest conditions.

The travel photographer working in regions of temperate forest may need to modify the suggestions made above and even adopt quite different techniques. All things considered, the problems will be less. There should be little problem of access and the climatic hazards of the tropics will be absent.

Forests of deciduous trees will provide the photographer with totally different opportunities according to season and any chance to work in autumn's russet months should never be turned down if colour film is the medium. With black and white film, winter may be a better choice when shapes are more important than colours. Blossom time or branches heavy with hoar frost, rime or snow, make obvious mood and time subjects. The interior of a deciduous forest, dark in summer, may be more easily photographed in autumn or winter when the foliage is thin or absent. Photographing woodland from the outside in summer and using a soft focus filter, will give very pleasing effects. A travel photographer may well consider seasonal attractions of temperate forests and woodland when planning a trip. If the time of year cannot be chosen, then advantage should be taken of particular seasonal attributes.

In the cooler temperate forest areas, conifers

may replace deciduous species and there may be large areas of commercial timber. The regularity of man-made forests can form the subject of photographic studies of shape and line. Fire-breaks and roads may provide viewpoints into such forests. Front lighting, used with care, may show the tree patterns most favourably. In forests that are alongside lakes or rivers, an alternative viewpoint may be from within the forest. Photographing tree shapes against reflected light off the water can give exciting results, just as back lit deciduous woodland is especially attractive in the early days of spring, before the leaf cover thickens.

Areas devoted to commercial forest also provide interesting subjects of human activity: tree felling and small timber mills are examples. Where logs are still sent down to the mills by water, shots of the floatways, with their seemingly tangled masses of trunks, make good pictures, particularly if the composition can include something of the forest and the river.

ICE AND SNOW

It is not necessary to join the penguins or the polar bears to find snow and ice. Vast tracts of the world's more temperate regions are blanketed by snow in winter and the snow-line is not always so hard to reach in mountains at any latitude. The differences between photography in polar and sub-polar zones and anywhere else where there is snow and ice are largely those of subject matter, of light and, of course, in the intensity of the weather conditions. Temperate or mountain regions are more likely to be visited in winter, but most travel photographers, unless working with expeditions, will restrict their polar journeys to the summer months. As already suggested, there is little difficulty in arranging trips to Greenland or Alaska, and these arctic locations should be considered seriously if the photographer wants to record the largely unspoilt snowy wastelands that recall the scenery of the Ice Age. In fact, it could be argued that only in such environments will snow and ice landscapes be *central* to the photographer's objective. Elsewhere, mountains or the hand of man may well put the cover of ice and snow into a subordinate, decorative role.

In planning a photographic trip to polar areas some air travel should be included because of the unique opportunity it gives to film broad landscapes and so emphasise the vastness of the ice caps and snow fields. Because much local travel in these areas is, in any case, by light plane or helicopter, there should be no problem in making the arrangements while actually on location. If the journey, or part of it, is to be overland then the services of guides will be essential. However, as with deserts, the off-beat travel firms which abound in Europe and in the United States of America do organise very worth while trips although my own preference is for keeping control of my own itinerary.

Photography of snow landscapes presents major problems in exposure times. Snow's high albedo, or reflective power, is well known and, especially in bright light, demands some compensation. Most camera meters or separate photo-electric light meters do not sufficiently compensate for the lack of shadow. Unlike other landscapes, snow surfaces will actually be brighter than the sky.

If shooting general scenes to the horizon or working with subjects some distance from the camera, settings should be one step less than in normal conditions, although this will not be necessary for back lit middle distance subjects. But if photographing subjects close to the camera, where shadows are competing with brightly lit surroundings, back lighting will demand one stop more and side lighting, half a stop. Increasing exposure is especially important if the sun is very low in the sky, as it will be at higher latitudes. Direct meter readings of light reflected from snow surfaces will often be only a half or less of the exposure time needed.

To complicate matters still further, very cold temperatures can affect film emulsions and effectively reduce film speeds. This will not usually bother the average travel photographer because he is unlikely to be working in temperatures below minus twenty degrees Celsius at which temperature exposures *may* need to be adjusted to counter the loss of film speed. If such low ambient temperatures are to be met, it is best to get advice from the manufacturers of the stock being used as there is no uniformity of reaction using the variety of film available to the photographer.

Viewpoints are best chosen to allow back lighting or side lighting. This light shows up the granular characteristics of snow best. Front lighting tends to give rather flat, uninteresting pictures. If it is necessary to shoot when the sky is overcast, it is better to concentrate on close-up subjects rather than on scenic views.

Paradoxically, perhaps, colour film produces far more striking and pleasing pictures of snow scenes than does black and white film.

Filters for snow work are advisable with colour if excessive bluishness is to be avoided. A skylight filter will be adequate but some photographers prefer a UV filter and consider the blue tint reflected

There is no need to go to polar regions for snowscapes. Here at 18,640 feet, and almost on the equator, is the edge of Kibo crater, Mount Kilimanjaro, Tanzania, with plenty of snow and ice—and bright sunlight. The rock outcrops and background of crevasses and ice ridges help to off-set the monotony of a smooth snow surface.

from the sky to be actually desirable. It can be interesting to experiment with light colour filters for special effects. The sun will create its own colour tone at the beginning and end of the day, and snow may then appear a warm yellow, orange or red. A polarizing filter can be used to control sky tints but it should be noted that the darkening effect which this filter has on the sky will vary according to the direction the camera is pointing. It is best used when the camera is directed polar-wards, or, with less effect, away from the pole. If the camera is facing east or west, an uneven darkening will result. Neutral density filters may be employed if very bright light is limiting the aperture settings at normal shutter speeds and the photographer wishes to have greater control over depths of field.

If working with black and white film, a medium yellow filter can be recommended for its effect of darkening the sky tones. It has the added advantage of increasing contrast as it will also darken shadowy areas. A greater contrast will be achieved with a red filter which will exaggerate the reflective qualities of snow.

With light being reflected off the snow as well as coming from the sun, a good lens hood must be used. To make certain that no unwanted stray light enters the lens it may be helpful to get an assistant to hold some shielding object, perhaps the record book, in such a way as to cast a shadow over

the lens. This is a common practice with *contre jour* (or front lighting) photography but it must be done with care to ensure that the object used does not appear in the frame.

Fast film is necessary only if natural light conditions are likely to be poor, as, say, in the winter months. If sky photography is an objective at high latitudes, it will probably be the Aurora phenomena that are especially attractive. Shots of the northern lights are not easy and their low actinic intensity make long exposures necessary.

Subjects for the travel photographer's camera in a sub-polar location are as varied as in any other environment and may range from close-ups of icicles to general landscapes. Glacial features provide attractive subjects such as seracs (pinnacle-like ice found most often at an ice-fall), moulins (circular holes in the surface of glaciers), or deeply crevassed ice and snow surfaces. It is worth looking out for places where the snow and *firn* ice has cleared to show higher density blue-ice below. Coastal regions may provide those most photographed of all ice features: icebergs. Travelling in Greenland, for example, a photographer would have no difficulty in getting hired transport down that country's immense fjords which are, in summer, littered with icebergs floating slowly down to the open sea.

There is no reason why a snowfall should halt photography provided the lens and camera can be kept dry. A cloth placed over the camera will usually be sufficient precaution unless the fall is very heavy. As far as is possible, the camera must be pointed so that snow does not blow on to the lens. A *white-out*, or blizzard conditions, can make for dramatic shots especially if a close-up subject, a person or perhaps a sledge, is seen silhouetted against the background of falling snow. To shoot pictures of the snow itself, as it falls, is not so easy although the problems are less than with rain. Because of the difficulty of focusing sharply it may be wise to photograph from under cover so that no snow is actually falling just in front of the lens.

VILLAGES

By no means will a travel photographer's work away from towns be confined to landscapes and natural features. If his journey takes him through areas which are inhabited it can be assumed that some time would be spent in rural settlements,

Rural architecture is often very regional in character, as here in Normandy, France—as timeless a scene as one is likely to see anywhere in Europe today.

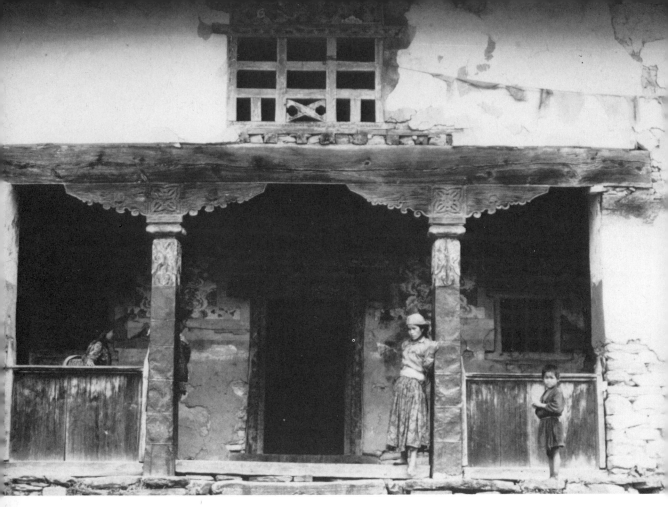

A simple temple in a Sherpa village at 10,000 feet in the Himalayas. Despite the obvious poverty, I was given a royal welcome by the villagers.

villages of all shapes, sizes and characters. The people of the village will be major subjects for the camera but this aspect of the photographer's work is dealt with in Chapter 8. In addition, village buildings and industries will provide valuable record photography as well as evocative pictures.

Villages, on the whole, are small places although I hesitate to generalize when I recall the size of some West African villages, for example. Their small size suggests attention to detail and this can be very rewarding. In many parts of the world, ancient cultures and ways of life are to be found in the villages in contrast to urban settlements which have succumbed to the ubiquitous Coca Cola culture. For this reason the photographer's quest for a sense of place, a unique picture which identifies a location and distinguishes it from any other, may be more successful in village photography than in towns.

Some of the techniques suggested in Chapter 5,

dealing with towns, may also be appropriate to villages. Often it is a matter of scale. The roof-top viewpoints suggested for town photography may be replaced by balconies or windows, but in many parts of the tropics, flat topped village houses are common and these can be used once permission has been granted. Permission seeking is *very* important. Villages are much more *private* places than towns and people will take unkindly to the travel photographer who does not respect this privacy.

Ideally, village photography should be preceded by reconnaissance, not, as in towns, so that the photographer may become familiar with the surroundings. No, this time it is a case of the surroundings, or rather, its people, becoming familiar with the presence of the photographer. This may take time but it is time well spent. A local guide may be helpful in this respect and some distinction can be made between villages. There

The unique is worth seeking. Above, human skulls in the Head House of a Land Dyak village in Borneo. Below, without a second look, these models in the rock graves at Londo, Tana Toraja, south Sulawesi, appear human.

Using a 200mm telephoto lens I took this shot in north India.

are regions in the world where it may even not be advisable to enter a village without a guide, but more will be said about this in Chapter 8.

Building styles, the longhouses of east Malaysia, chalets in Switzerland, mud huts in West Africa, have a tale to tell because so often they reflect the people's economy and adaptation to the environment. Photographs of small details, decorations, window shapes, doorways, may not only be fascinating camera studies, but also important recorded evidence of cultural and economic variety within a region.

The construction of buildings may be interesting to photograph. Subjects might include close-ups of materials used in building as well as workmen actually erecting a house. Wattle and daub huts, thatched roofs, laterite-block houses, are examples of particular building forms which have regional significance.

Interiors of buildings may be difficult to shoot because of the need to obtain permission to enter. All the same efforts should be made to gain access because the interiors will be even more revealing of the villagers' way of life. If entry can be made, flash may be necessary to supplement available light and I can think of many instances when light from windows or doorways has been so poor that flash has provided almost the only illumination. In much of the developing part of the world, interior walls of village buildings may be very poor reflectors and there will be no chance to bounce the flash off walls or ceilings. This can lead to rather flat pictures unless the flash is held away from the camera, slightly above and to one side, in which position modelling (a three dimensional effect) will greatly be improved. Few travel photographers will be carrying more than one flash so that multiple flash, so useful for interior shots, will probably not be possible.

Many villages will have some form of industry or

The yam mounds' regular pattern is emphasised by the late afternoon sun.

craft. This sort of activity photograph is easy if the work takes place in the open, but if it is in dimly lit workshops, flash will be needed. Without flash, it may still be possible to get detailed shots if craftsmen can be persuaded to leave their workshops and come out into the sunlight. If interest is shown in the work, many a craftsman will be quite happy to concede to a photographer's request. Once out in the open, it will probably be best to photograph from a close viewpoint, concentrating on the worker and his craft. Using a wide-angle lens, a fast shutter speed and a wide aperture will capture the subject's movements and, at the same time, put the background out of focus if it would otherwise distract the viewer's attention or appear incongrous. Because the subject is out of his normal setting, a blurring of the background may help to provide a false authenticity. Detailed shots of hands working on a carving or fingers skilfully using a needle may be excellent camera studies.

FARMING

Photography of village crafts and working life should be complemented by shots of agricultural activities in the open country between villages. Unless the photographer is prepared to spend a great deal of time and energy on gaining such shots, two necessary requirements are a guide and a telephoto lens, preferably a zoom, with a focal length of, say, 200mm as minimum. A local guide will be useful in obtaining access, identifying crops and farming tools and, at the daily planning stage, in suggesting the best time of day for particular activities. In many hot countries there will be little activity after noon and it may be necessary to get up very early if there is any distance to travel before photography starts.

Many farming activities are natural subjects for sequence photography: a series of shots showing the general scene, workers in the fields and close-ups of the workers and of the plants and animals.

Women planting rice conform to the geometry of the scene.

To take an example, tea plantations in the Sri Lankan Hill Country are relatively easy to photograph successfully from a road or from plantation paths. Access is almost unrestricted. A sequence might include: (1) A general shot of the rolling hills carpeted by orderly rows of tea bushes. (2) Shots of the tea pluckers at work, their bright clothing contrasting with the verdant bushes. (3) Close-ups of a plucker at work, selecting the new leaves and tossing them into a basket slung behind her from head-straps. (4) Macro shots of the leaves, possibly in the plucker's hands. (5) The pluckers on their way down to the weighing rooms. (6) Shots at the weighing room as the baskets are weighed and the pluckers go back home. These shots can be still further complemented by photographs of the tea factory on the plantation, of the workers' homes, and of other work on the plantation. In this example, there is no need to take all the shots on one occasion or from the one plantation. Light, time of day and access may make it wiser to spread the photography over a number of plantations.

Some tea factories, for instance, are more welcoming to visitors than others and shots may be taken of the work inside a factory.

This sort of example can be multiplied by as many times as there are types of agriculture and farming scenes. Obviously some times of the year are more productive, agriculturally and photographically, than others and labour-intensive farming regions or those with fairly primitive methods, sometimes provide the greatest opportunities. All the same, there need be nothing dull about farming photographs if a little ingenuity and imagination is used.

The importance of a zoom telephoto lens for shots of farming is that it allows the photographer to choose a viewpoint from which to work, some distance from the subject. Less embarrassment may be caused and the farm worker will continue his task and give a much more natural and interesting shot.

Certain types of agriculture may call for particular techniques. Workers in flooded paddy

A break in the clouds focuses attention on this Indian boy guarding the family's cows.

fields can be photographed either in reflection or, at least, with reflections filling a part of the frame. Workers tapping rubber trees are more easily photographed when they are cutting and tapping trees on the edge of a plantation where light will be less of a problem. A woman winnowing grain should be photographed with the flying seed and husks clearly visible against a light background – possibly with back lighting. It is very important, not only to catch the right moment, but also to ensure there is a dynamic quality to the shot. Because many farming tasks are repetitive, the photographer can spend a little time over composition and in judging the moment to shoot.

PLANTS

One of the joys of travel is to see what would be described at home as exotic plants, in their natural surroundings and it is unlikely that a photographer will be put off including them in his collection just because he does not know their names or because he rarely photographs flora at home. There is no need for special equipment although a close-up attachment for standard and telephoto lenses can be useful. (For a full discussion of this subject the reader is advised to make reference to another book in this series: *Creative Techniques in Nature Photography*.)

In the context of travel photography, it may be important to ensure that any shots taken of flowers and other plants are seen against a background of their surroundings. This is perhaps more likely the case with non-flowering plants than with flower blooms. For this purpose a wide-angle lens is helpful with its greater depth of field, but it is less satisfactory if the texture of the plant is to be emphasised. For flower blooms or bunches of fruit, a narrower depth of field is advisable to throw the background out of focus and concentrate attention on the main subject. This will require a very close viewpoint but the lens at small aperture. Alternatively, a telephoto lens, and a more remote viewpoint, can be used but there will be problems of shutter speeds if the conditions are windy.

For this shot of breadfruit, I allowed just enough depth of field to show the detail of fruit and leaves.

Unless a blurred image is wanted for special effect, a breezy day can make it difficult to choose a shutter speed which is appropriate to the aperture setting, yet fast enough to counteract movement in the plant caused by the wind. For close-ups, it may be possible to get a companion to shield the subject by standing nearby and holding his coat open. But this is rarely very effective and may create an additional problem if sunlight and wind are coming from the same quarter. It is usually better to increase the shutter speed at the expense of the aperture although in good light this should not be necessary.

Side lighting is best for close-up photography of plants because it helps with modelling, but I prefer partial backlighting when taking pictures of crops in fields or of bush plants without flower or fruit. Back lighting creates a much less harsh effect than front, or even side, lighting for such general shots. The background of shots of plants is often important. Nine times out of ten, the sky is an ideal and natural backcloth but, if a darker background is needed, a higher viewpoint will usually provide this. Dark green foliage or blue flowers are not always seen at their best against a bright sky and some alternative light background may be sought, for example, a sandy coloured soil or rock. A distinction must be drawn between the *background* to a particular plant or flower and the *setting* of photographs of plants referred to earlier.

For colour work it should be possible to dispense with filters except perhaps a polarizing or UV filter, but with black and white film loaded in the camera, a light green or yellow filter can helpfully improve the tonal contrasts.

Some degree of *cheating* might be permissible to raise the pictorial quality of photographs of plants. A well known trick is to sprinkle flower heads with water to simulate dew or raindrops. A nearby stream or puddle can provide the source but, failing that, the photographer's ingenuity is tested. In close-up work, flower blooms or bunches of fruit can be held against a natural background to be photographed if lighting conditions in situ are unfavourable. Alternatively, poor lighting can be supplemented by flash.

Choice of subjects depends largely upon the area in which the photographer is travelling and, of course, on the season. All manner of vegetation can be thought of as a potential subject, from brightly coloured lichens or cotton grass in an arctic clime, to wild orchids and bougainvillaea in the tropics. It is little use relying on a local guide to identify plant species. Probably he will either not know or he will give you some regional name which will be meaningless back home. If there are problems of identification, it is often better to leave the task until later when colour transparencies can be sent to an expert for naming. This is, however, an important matter when cataloguing is being done.

WILDLIFE

Photography of animals in the wild can be the *raison d'être* of a travel photographer's journey or it may be incidental to his other work. The essential difference between approaches to the subject will be that the former will give more scope for planning and organisation while the latter will be very much a matter of chance opportunity. The actual photographic techniques employed should be the same although they may have to be modified if time is short and an encounter with game cannot be forecast.

Wildlife safari holidays organised by travel agents often offer as good an opportunity to photographers as a privately arranged journey. Certainly they are cheaper, especially when one takes into account the services of a guide or game warden which can be considered a prerequisite of a successful trip. For a little extra cost, it is possible to ensure that a window seat and roof vent place are guaranteed in the vehicle being used. If the photographer has freedom of choice, it is important to select a time of year when the game will be at

their best and, most in evidence. This, together with the time of day, are two of the major controlling factors in successful wildlife photography.

It probably goes without saying that the photographer's equipment will include telephoto lenses or zoom telephoto. Obviously there are advantages in a zoom in that there will be more latitude for composition in the viewfinder from a single viewpoint, but if only one zoom is used then work is restricted to the range of focal lengths at which the lens is built to operate. If a lot of wildlife photography is planned, it may be far better to work with two or three camera bodies fitted with, say, lenses of focal length 100mm, 200mm and 500mm. It may be important also to keep a standard lens at the ready for those times when animals such as monkeys come very close to the vehicle.

Lenses should be fast rather than slow and it is worth remembering that many large photo stores will hire out equipment so it is not necessary to go to the expense of buying really good long focal length lenses which may have little use outside a wildlife trip. The use of tele-extenders (extension tubes) or tele-converters will increase the focal length of a lens making, for example, a 200mm lens into a 400mm or even a 600mm. However, they have the disadvantage of effectively reducing lens speed. For this reason they cannot be recommended for wildlife photography, much of which may be in poor light.

Together with fast lenses should go fast film with high ASA ratings and, if possible, an auto-winder or motor-drive and bulk-film camera back. However, while these latter items are very useful, they should not be considered essential.

Working from a vehicle has its drawbacks as well as its advantages. Moving game can be tracked and a vehicle acts as a sort of mobile hide in game parks where the animals are so familiar with trucks. All the same, there is little point in attempting to photograph while the vehicle is in motion because, running over rough ground, the vibrations will be too great for all but exceptionally fast shutter speeds. Much better to wait until the vehicle is stationary and stand to photograph through the sunshine roof which any good safari truck should have. Try to persuade the driver to turn off the engine everytime he stops so that the barrel of the lens can be rested on the roof or window frame without fear of vibration. If there are dangerous animals nearby, this may not be possible and the photographer should hand-hold the camera as steadily as he can, remembering

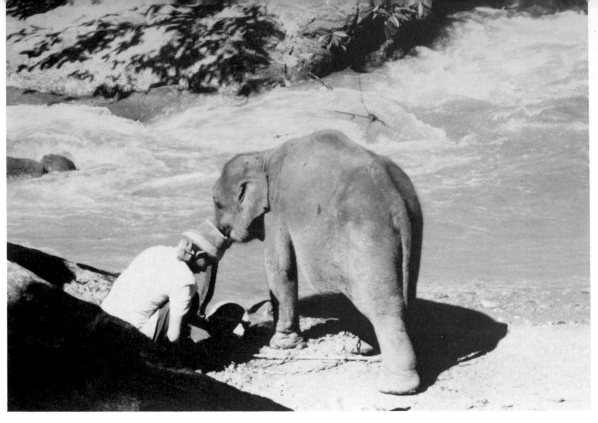

I came across this young elephant on the Burma-Thailand border. The *mahout* was about to give the animal its morning wash in the muddy stream.

that any movement will be exaggerated by the long focal length lens he will be using.

Because many animals, leopards are an example, will be seen only in late evening or early morning, light is often a problem and the need for fast film and lens is never more keenly felt. Unless the animal is absolutely still, for example while sleeping or resting, shutter speeds will need to be not less than 1/100 and, in poor light, the difficulty is in selecting apertures commensurate with this speed but not too large to give problems with depth of field. Animals at close quarters, moving but not running, will need shutter speeds of between 1/100 and 1/250 and the lens should be set at apertures no larger than f/8. If game is on the run then the shutter speed will need to be increased but if they are some distance from the photographer, say, 300 feet (100 metres), or more, the aperture can safely be increased.

With colour film loaded no special filters are needed although those recommended for landscape work can be left on the lenses. For black and white film, broad shots including the sky may need a yellow filter and this can be retained for other shots.

A reliable and experienced guide is indispensable. He will know where and when to find game, will spot them when their natural camouflage makes them almost invisible against their surroundings, and identify the various species. Many animals are difficult to photograph simply because they blend so well with the background against which they are seen. Highly selective focusing can help to distinguish the animal from its surroundings and the short depth of field of a long focus lens usually does the trick.

A great deal of patience should be exercised and this may be rewarded as the quarry emerges from behind cover into the open. A wise practice is to expose one or two frames immediately the subject animal is in view, in case it should take fright and run away into the bush, and then to wait in the hope that the animal may move into a better position. I recall one occasion in the Kruger National Park photographing two giraffes and then sitting in my truck to watch them. Quite suddenly I realised that they were not standing passively alongside one another as it first seemed, but were, instead, engaged in a ritual battle. In turn, each swung his long neck to strike the other in a sort of slow-motion action replay. Had I moved on after the first few exposures I would have seen none of this.

In many game parks it is an offence to leave a

vehicle and fines are imposed on those foolish enough to do so. Most game will not attack a truck unless provoked but elephants are unpredictable and rhino and buffalo can be dangerous at any time. The big cats are rarely troublesome unless hungry but it is always best to assume that all wild animals are a potential danger. Even a bite from a monkey can be very painful. If spending some time in a game park, a photographer should be particularly cautious. Because he is anxious to get the best possible shots he can be tempted, unwillingly, to put himself in danger and no more so than after a few days of travel when he is less on his guard. It may be necessary to keep reminding oneself that the hyena which comes up to the vehicle and lies down alongside is best not stroked like the family's pet dog.

It has been assumed so far that the photographer is using a vehicle. If it is safe and convenient to work on foot, it should be remembered that even more patience may be needed. The least sound will disturb most wildlife. Even if the photographer is not moving, the sound of a camera being operated can be enough to send the subject fleeing for cover. It is often helpful to wrap the camera in a dark cloth to reduce noise and to cover up any bright parts. This should be done with care so that the lens is free and the camera can still be operated quickly.

Generally speaking few travel photographers will have enough time to spare to build hides or track their prey for hours at a time. This is a pity because a lot of fun can be had if time is not pressing. Working in Lapland some years ago I remember the fun as well as the frustration in trying to obtain shots of reindeer in their summer habitat, open birch woodland. Everytime I and my assistant spotted the deer, they spotted us and were off at a speed we could not pretend to match. Even when we had a Lapp guide, we fared little better though I did become quite proficient at imitating the buck's mating call in an attempt to lure deer towards us!

Photographing birds in flight requires quick reactions. The lens must be focused accurately while it is following the bird's path and adjustments to aperture may be needed as the light quality changes. If a flight of birds suddenly appears there may be little time for preparation but if it can be anticipated, aperture settings and shutter speeds can be pre-set for the existing conditions and only focusing will be necessary.

Shutter speeds will depend chiefly on the distance of the bird or birds from the viewpoint and whether the flight path is across the field angle or

Never keep your subjects waiting!
This baboon, in the Kruger National Game Park, yawned just as I was about to take the photograph.

towards or away from the camera. If the subjects are close to the camera, say 10 metres or so, shutter speeds of 1/1000 will be needed for subjects crossing the field angle. But if they are 300 feet (100 metres) away, the speed can be halved. At such high shutter speeds light must be good unless apertures are to be so large as to cause problems with depth of field and critical focusing. Small birds are more difficult to photograph than large ones not just because of the size but because their wings beat faster and need faster shutter speeds.

Fortunately it often is possible to photograph with the sky as background but choice of lighting direction is really for the birds to decide! If back lighting is unavoidable, good silhouette shots can still be obtained and these are most effective with either a large flock of birds or a single bird with a large wing-span. If the background is dark, for example, forest trees, lighting may be so poor that it may not be worth trying to shoot at subjects moving across the field angle without panning (see Chapter 5). Panning can also be used in bright light if a neutral density filter is attached to the lens. Against a clear sky this can be very effective.

Locations for wildlife photography can be found in many parts of the world, but there is no doubt that for the travel photographer there is a lot to be said for East Africa, Kenya in particular, or South Africa. Here the variety and quantity of game are the major attractions. For more specialist photography, the birds of western Norway, for example, or the tigers of Nepal's Terai could be quarry for the camera.

7 At the Coast

For more than one reason, travel photography will often include areas of coastland. Whether the photography be of tourist resorts, ports or coastal landscapes, this is a special environment, the triple boundary of skyscapes, landscapes and seascapes, worthy of a short chapter of its own. Of course, much that has been said in the preceding chapters will apply equally, or with modification, to coastal areas but there are some special points that ought to be considered.

Natural light at the coast may be thought to be to the photographer's advantage. There is a large reflective surface, the sea, and often there is an abundance of shadow from natural or man-made features. In fact the problems are legion and there is a common tendency to overexposure. More highly actinic sunlight and strong tonal contrasts add to the difficulties. There is much to be said for trying to confine seascape photography to days when there is some cloud to diffuse the sun's light. Unfortunately, the tight schedule to which many travel photographers will be working may make this impossible.

Filters will perform a dual function. Their compensating and correcting role is vitally important but they also protect the lens from salt water spray. If a filter is damaged by sea water it will cost only a fraction of the replacement price of a lens.

For colour photography, and this is the obvious medium for coastal work, the standard filter should be a skylight. Its absorption of ultra-violet radiation combines with its reduction in the bluishness of natural light to give a far more natural colour balance than its more generally used alternative, the UV. The bluishness of the sky and sea is not always as evident to the photographer's eye as it will be recorded on colour film. That it also makes the sunbathers on the beach look slightly less tanned may or may not be considered important! If reflected light needs to be reduced, for example when shots are taken out to sea on a bright day, a polarizing filter may be a suitable replacement for the skylight.

Some travel photographers are insistent upon trying to reproduce natural colours faithfully. Others like to experiment. The sea, with its reflective qualities and great expanse is an ideal subject for experimentation with colour filters. These, including half- and dual-colour, can be used with colour film loaded in the camera. Combined polarizing colour filters also are very effective with seascapes. Some dramatic pictures are possible especially at sunrise or sunset when the sun's rays strike across the water surface.

The photographer working with black and white film will probably use a pale yellow or green as standard filter with a light orange or red for special effects. A yellow or green filter will overcome problems of tone, mentioned above, and give a more natural rendition of tone variation. An orange filter should be used with caution but may be employed to effect with shots of rocky outcrops and headlands, making them stand out against the sea. A red filter will prove useful only if its qualities can properly be exploited. It tends to produce a rather static picture, a photograph without subtlety. It can, however, give pleasing results if mood shots are wanted.

Although it ought to be taken for granted that lens hoods will be fitted for all general work it may be as well to emphasise their value at the sea. Like the filter, they will give some protection from unwanted spray but they are really necessary for their primary function, to eliminate light from outside the field angle. Stray reflected light from water surfaces is always a problem and the sea is no exception. Hoods should be as deep as possible and a cheap hood with a smooth inner surface should be exchanged for one with a matt milled or ridged interior.

The coast's bright light will often demand fast shutter speeds and it may be advisable to carry a x2 neutral density filter if photographing breaking waves or a rough sea. As explained in Chapter 6, when dealing with waterfalls, it is a mistake to think that water movements should be frozen by a high shutter speed. All the dynamic qualities are lost when this is done. A speed of $1/125$ is probably

all that is needed and with shots of spray rising as a wave strikes a pier or a breakwater, an even slower speed may be better. Even the fastest speed-boat should not pose too many problems when shot from a beach viewpoint. Only when photographing *from* a boat will it be *necessary* to use fast shutter speeds to eliminate the effects of vibration and movement.

When photographing from a small boat, it is a wise rule to work at shutter speeds of not less than 1/300 unless light conditions make this impossible. A high shutter speed is even more important if photographing one moving boat from another, unless the two craft are moving in the same direction on parallel courses.

It is likely that a travel photographer will find uses for lenses of a variety of focal lengths and, because of the hazards described in Chapter 3, he should have with him an adequate supply of waterproof and dustproof bags for storage.

Film stock can be slow rated rather than fast unless very cloudy weather can be expected. Loading and unloading film on a beach combines the problems experienced in a desert and on a mountain. A changing bag can be used to minimise the difficulties.

Subject matter for coastal photography should be decided at the planning stage and the plans modified when on location. It is usually not difficult to find out in advance of a trip sections of coast that offer particularly attractive scenery. Guide and travel books will detail fishing beaches and harbours, and holiday resorts can be selected from tourist firms' brochures. Part of the planning exercise should be an investigation into the availability of small craft for hire or of boat trips along the coast.

On arrival, the question of access to beaches should be asked and places where there could be difficulties at high tide should be noted. It can be useful to be able to forecast the times of high and low tides and these may be obtained by enquiry or observation.

SEASCAPES

Seascapes offer opportunities to try out techniques already tested in landscape photography. General shots combining the coastlands, sea and sky challenge the photographer's sense of composition. From a low viewpoint the sea can play a subordinate role vis-à-vis the land and sky (A in fig.

A balanced seascape. It is important to consider the proportions allotted to sea, coastland and sky. In this shot of Table Bay, I decided on equality.

Fig. 4

For this tropical beach scene, I wanted to include most of the palm tree and composed the shot to include three wedge shapes: the beach, the sea and the patch of clear sky.

4). As the viewpoint rises it becomes easier to balance the three elements of the picture to more pleasing proportions (e. g. B in fig. 4). Unless the landscape, the coastland, is of such interest that the sea and sky can be deemed unimportant, it is usually less satisfactory to compose the shot with the sort of imbalance shown in C of fig. 4.

The sea is such a vast and largely uniform surface that some *point* of interest should be included to arrest the attention of the eye.

117

Something out at sea, a ship or an island, for example, not only breaks the uniformity but gives that scale reference so vital to landscapes and seascapes. If the sea is empty, an alternative ploy is to include an object on the beach in close-up. It is best if this projects across the sea, as seen in the viewfinder. As said before, the close-up subject must not be alien to the scene or be too distracting.

The very clear and uncluttered horizon afforded by shots out to sea is a hazard in itself. Any deviation from the strictly horizontal is very obvious in the developed photograph. As a rule, this problem is least with eye-level (direct) viewfinders and with black and white photography. With eye-level viewfinders it *ought* to be a simple matter of reminding oneself to check the horizon before shooting. With black and white photography, it is possible to correct irregularities at the printing stage in a way that is far less easy when producing colour transparencies.

High cliffs present something like the same problems of perspective as high buildings and a distant, mid-height viewpoint is best if the shot is to be taken from the land rather than from the sea. Straight coasts are especially difficult to photograph but indented coastlines, such as fjords or rias, make the task easier when it comes to choosing viewpoints.

ON THE BEACH

Beach details should not be neglected and any number of pattern and texture shots suggest themselves to the photographer who really looks around. Sand ripples, beach pebbles, seaweeds, jetsam, barnacles and limpets are just some of the possible subjects. With most of these it is essential that lighting be across the subject at low angle in order to preserve and emphasise the texture and pattern. Some beach subjects look far better wet than dry if their surfaces are potentially reflective. A dry piece of seaweed comes to life when wetted and the same is true of pebbles.

It is worth looking out for subjects of geological interest where the sea has exposed them to view. They do not have to be as dramatic as the basaltic columns of the Giant's Causeway. Flint nodules or fossils, for example, embedded in a cliff face can make attractive close-up shots.

Particularly fascinating photographic subjects are rocky pools where something of the wildlife of the beach may be lurking. A polarizing filter should be used for these photographs and some of the techniques suggested for photographing subjects in shop windows (see Chapter 5) are relevant.

At holiday resorts, a travel photographer may well give much of his attention to shots of people on the beaches, in the sea and on the promenades. Even away from resorts, the human presence will not be ignored. The next chapter deals more thoroughly with this side of a photographer's work but some points unique to a coastal location can be covered here.

A crowded, active beach will provide a wealth of subjects: people in the sea, swimming and splashing, floating on air-cushions and surfing. On the beach itself they usually divide into two sorts of subject, the passive sunbather and the active beach-game player. The bright colours of swimwear, towels, sun umbrellas and deck chairs make wonderful contrasts with the all-over yellows, browns and blues of beach and sea.

If the shore shelves gently, and assuming a calm sea, it is possible to photograph the beach and its background of hotels or natural features from some short distance into the water simply by wading. This viewpoint, a sort of swimmer's view, is best if the camera can be held close to the water surface. A wide-angle lens gives the necessary depth of field and front lighting improves the contrast between sea and shore. The same viewpoint can be used to photograph people swimming or playing in the sea near the beach. This time the shots are best taken with the camera pointing out to sea and with the sky as backcloth. Whereas the shots to the beach can probably be taken at quite slow shutter speeds, a speed of not less than 1/125 will be needed if there is a lot of movement from swimmers near the camera.

At all times that shots are being taken by the photographer standing in the sea, the twin hazards of spray and reflected light must be guarded against.

For pictures of people on the beach, some thought should be given to choice of lens. A telephoto lens is particularly appropriate for the intimate shots like those of a sunbather asleep in a deckchair or a child playing on the sands. It can also be used to give an impression of a beach more crowded than is actually the case as it compresses the perspective. A further use for the telephoto on the beach is in picking out a single person from the crowd. In this case the single subject should be held in sharp focus against an out-of-focus background of fellow sunbathers. Especially when working on topless or nude beaches, the photographer is well advised to be aware of the sensitivity of his subjects. Indeed, on some beaches photography may be forbidden.

For more general views of activity on the beach, a high viewpoint is preferred. Most resorts will

Conversation piece. Beach resorts are rich in such subjects.

provide this by way of a promenade or raised footpath or road. From a position above the beach, a standard or wide-angle lens may be used but it should be remembered that people on the beach generally face the sea. Thus some sort of compromise viewpoint may need to be chosen.

THE SEA

The sea itself rarely provides the sole subject matter for a photograph except in the case of breaking waves. Waves of high amplitude and short length make excellent subjects in all phases of their development, maturity and final demise. Shutter speeds should be fast enough to prevent too much blurring but not so fast as to give a frozen appearance. This will usually mean adopting speeds of about 1/125; slower or faster according to the state of the wave. Large waves that are plunging forward after breaking may need speeds up to 1/200 but pools of receding backwash can be shot at 1/100.

Waves can be made to look higher by choosing a low position from which to photograph and a side

viewpoint will enable shots to be taken as the line of the wave breaks at an angle to the shore. Photographs of backwash, as the foaming wave runs back down the beach, are best taken at times when the wave frequency is high and the backwash is held against the incoming swash. Waves can also be the subject of sequence photography.

In choosing to photograph waves and spray, it is important to see that the lighting is good and exploits the reflective qualities of the white water (a mixture of air and water), produced when the wave breaks. Strong sunlight coming from the side usually shows waves to advantage.

If the waves are pounding against the coast, a pierhead or rock outcrop, timing is important in order to make the shot at the climactic moment when the spray is at its highest point. It may be necessary to stand for a while observing the wave action in order better to judge, not only the moment of climax, but also which waves are likely to give the most dramatic results. Successive sea waves do not all have the same amplitude and this,

together with slight changes in frequency, means that some waves are distinctly better than others from the point of view of the photographer.

Sunrise and sunset pictures, taken with the sun at the horizon or a little above it, and with the sun's rays reflecting across the sea surface, are some of the clichés of travel photography. All the same, it is difficult not to be tempted by the beauty of such scenes. Bad weather photographs at the coast can be equally appealing. Particularly interesting are shots of an approaching storm as it builds up off shore. Pictures like these are often more effective as sea and skyscapes without any of the coast or beach being seen in the viewfinder.

OUT AT SEA

If it is possible to hire a boat or to put to sea with local fishermen – or in some other way distance oneself from the beach and shoreline – a whole new prospect is obtained. Photography from ships was dealt with in Chapter 4 but in a small boat the difficulties are far greater. Even on a calm day there will be some movement of the boat. If it is rough or the boat is moving at speed, the only advice one can give is to use as fast a shutter speed as possible and consider a ten percent success rate as good.

If it is possible for the photographer to direct the path of the boat, it is advisable to shoot only when the boat is lying parallel to the shore and the

Retreat from advancing waves. The movement of these Indian boys accentuates the onrush of the sea.

To compress the perspective of this shot of Reykjavik, Iceland, I used a telephoto lens. The volcanic cliffs, the quayside and the ship, form the three subject elements.

photographer can stand with shoulders in line with its long axis. Standing feet apart, preferably anchored under some rigid structure on the floor of the boat, the photographer should avoid leaning against anything, such as a mast, and maintain his balance as best he can. Even then the chance of getting a really good shot is not high but it *is* worth the effort.

A better proposition is to use a larger vessel, perhaps a local coastal ferry or even a pleasure boat such as one finds at holiday resorts. Once at sea the distance from the shore will never be so great as to preclude coastal landscape shots; the ship itself, or its ports of call, may also provide subjects. To give an example, some years ago I was working in north Norway, writing an article for the colour supplement of a Sunday newspaper. I took the intra-coastal ferry out of Hammerfest, the world's most northerly town, and travelled round the islands dotted about the arctic waters. Not only was it possible to obtain photographs of the island landscapes, but also shots of the small fishing

communities whose homes these are. As a bonus, the ship's captain offered to stop the ferry for me to enjoy a little fishing in the rich waters! This sport provided me with more subjects as giant cod, and even a catfish, were landed on deck.

FISHING
Not all fishing photography need be out at sea. Particularly in the developing world, but also along many other coasts, fishing will be a major part of the economy of those who have settled the shore. There are few more picturesque subjects for the camera than fishing fleets and fishermen, but it is desirable to capture something of the energy, effort and activity that characterizes their work.

These qualitites will be most in evidence as the fishing boats return or the catch is landed on the beach. It may be necessary to get up early or to wait almost until dusk to see the best of the fishermen's work. Many small fleets move in and out on daily changes in land and sea breezes and

the middle of the day may see the fishing harbours and beaches deserted. Knowledge of local practice is essential but should not be difficult to obtain.

A sequence of shots helps to build up a record of fishermen's work. The boats returning, boats being dragged up the beach or anchored in the harbour, the catch being unloaded, fish being gutted and prepared for market – these are just some of the shots that should be possible. They can be complemented by photographs, taken at other times in the day, of nets and boats being repaired and of fish being sold in local markets.

Where fishing takes place from the beach itself, there is less urgency for the photographer. At his leisure he can select his viewpoints and photograph all stages of the work.

If light is poor, as it may be if fish are being landed in the late evening, dramatic silhouette shots of men and boats against a background of sky may be possible. Viewpoints will need to be low, almost at beach level. In better light, shots can be taken through nets. Using a long focal length lens and experimenting with varying depths of field by changing the aperture or the viewpoint, it is possible to focus sharply on subjects beyond the net while the mesh has a shadowy, out of focus, appearance, With a wide-angle lens and working at f/11 or f/16, on the other hand, it may be possible to take general shots but also include some interesting detail in the foreground, lobster pots, baskets, or harpoons, for example.

As with all shots of people engaged in their daily work, it is important not to become an unwelcome intruder, holding up the serious business of earning a day's wage. No travel photographer has learnt his profession until he can fade into the background at the right moment.

Such is the variety and potential of photography of fishing scenes that it would be possible to spend many years of travel working at this subject alone. In planning trips, it is certainly worth considering what might be available if some slight detour is made to a fishing coast. Information needed to locate the best sites may be gained from specialist travel books or from relevant geographical literature. Without some research, it is just too easy to motor up a coastal road and be unaware of what fishing might be taking place from the beaches alongside one's route. I nearly made this sort of mistake when staying a few days at Kuala Dungun on the east Malaya coast. Only the night before I was due to leave did I learn that I was just a few miles from the beach on which giant turtles lay their eggs. Just in time I was able to get shots of this wonder of the animal world.

The windswept palm compensates for the lack of sail on these dhows in the Old Harbour at Mombasa in Kenya.

Not fishing, this time, but a unique photographic opportunity almost missed.

PORTS AND HARBOURS

Perhaps the most active of all places along a coast are its ports and harbours. Some distinction should be made between these two. *Sensu stricto*, a harbour is simply a shelter while a port is a point of contact (trade) between land and sea. As far as a

photographer is concerned, the two offer quite different opportunities. A harbour will generally be accessible without difficulty and the subject matter will largely be small craft and their crews.

Some of the most exciting work can be in harbours sheltering boats still operating under sail; a yacht marina or a primitive fishing harbour are examples. If the boats are at anchor and there is little movement in and out of harbour, photography can concentrate upon scenes of activity on the boats themselves. Shots of painting, repairing and cleaning, against a background of

other craft, can help to paint a picture of activity. If the boats are also their owners' homes, scenes of domestic activity, say, the return of one of the family from a land shopping expedition, can be used to express this function. The nature of the harbour, a haven from the more stormy waters of the open sea, can be emphasised by shots of boats and their reflections in the relatively still waters. For these photographs, some slight rippling of the surface, perhaps by a passing boat, puts the right sort of accent on the water, drawing particular attention to it. In framing these photographs, it is

I waited for a slight ripple to disturb the reflective waters in this shot of small boats in harbour.

important to ensure that all the boat and its reflection is included. It is generally not satisfactory to cut off even the tip of the mast or its mirror image.

Overcrowded harbours make wonderful shots. Parked side by side, with scarcely any water to be seen, the harbour is like a forest of masts. This situation is just as likely in a European or American marina as it is commonplace in Hong Kong's typhoon harbours. Shots should emphasise patterns and, from ground level viewpoints, the clutter of masts can be exaggerated with a telephoto lens. If more is to be seen of the craft, a higher viewpoint will be needed. From the landward side of the harbour, the roof of a building or a window may make an ideal position from which to photograph the harbour from above and also include in the frame something of the open sea beyond.

Lighting for harbour shots is best from the side but, if there is a significant number of sails in view, back lighting can be very effective. Shots of the harbour and its boats at sunset and sunrise are also worth considering. This is especially so on an east or west coast from which the sun can be seen to rise or set over the sea outside the harbour.

Access to ports can be very difficult. For reasons of security, port areas are usually enclosed and obtaining permission to enter can be a lengthy and frustrating task. The most obvious course of action is to try to obtain permits in advance of the trip. If this is not possible, a travel photographer should at

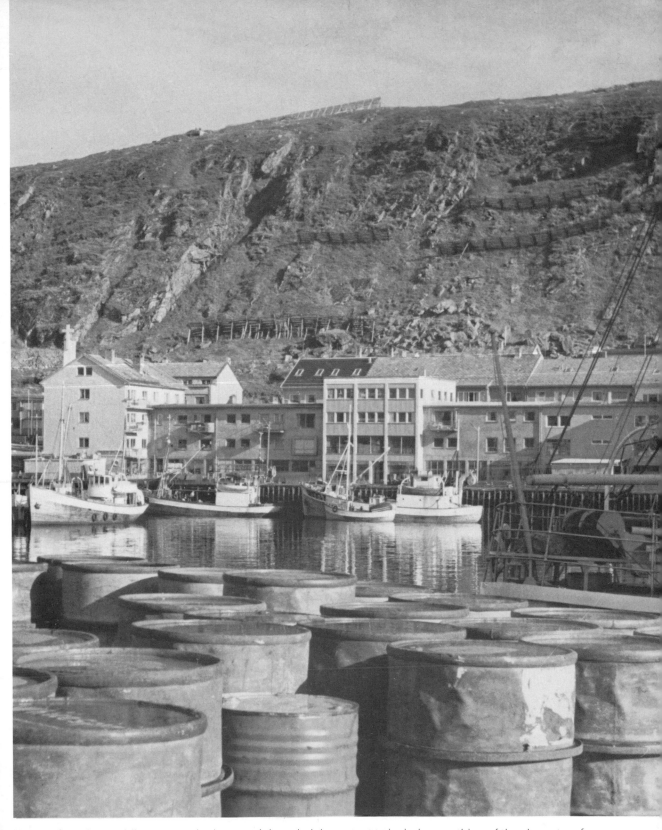

Hammerfest, the world's most northerly town. I thought it important to include something of the character of the island with its bare hillside punctuated by snow fences.

For this bird's-eye view of ships and quayside, at Port Kelang on the Malacca Straits, I used the gantry of a crane as my perch.

least have made enquiries about the controlling authorities before he leaves home. I do not generally recommend a trick I used some years ago in Lourenco Marques (Maputo) in Mozambique. Finding I needed some shots of iron ore carriers to complete some work I had been doing in neighbouring Swaziland, I gained entry to the port by showing my business card to the armed sentry at the gates. The fact that he was almost certainly illiterate (he *read* the card upside down) probably helped.

Large ports can be confusing places even once one is inside the gates and it is helpful to have obtained, or at least looked at, a plan of the dock layout before starting work. This is less difficult than gaining an entry permit. Many guide books include maps of large ports. If possible a guide should be asked for and he will make access to warehouses and even ships easier than if the photographer is working on his own.

Most of the techniques that will be relevant to photography in ports are discussed in Chapter 10 but it may be necessary to repeat here the

warnings given in Chapter 2. If the port functions as a naval base as well as a commercial port, caution should be exercised. Even if a permit to photograph has been issued, it would be unwise to pay too much obvious attention to naval vessels.

SUB-AQUA

Photography under water is a very specialist activity, just as is sub-aqua diving. It is not proposed to deal in detail with the techniques or equipment but it is recognised that some travel photographers will wish to explore the undersea world with, perhaps, just a day or so given up to this work. Now that underwater camera equipment is relatively cheap and easy to obtain, a photographer planning a trip which will include a suitable location may be tempted to pack an additional camera or housing with the rest of his impedimenta. One of the least expensive and simplest solutions might be to take a 110 underwater camera complete with built-in flash. Diving equipment can usually be hired on location.

For the non-specialist underwater photo-

An engineering still life. Deck machinery aboard ship.

grapher, it can probably be assumed that work will not be at depths below 15–20 feet (say, 6 metres), and it is important to check the camera housing manufacturer's instructions regarding the depths to which waterproofing is guaranteed. Even at these shallow depths, sub-aqua photography for the inexperienced can be a very chancy matter.

To be certain that one is working in optimum light conditions, it is best to choose a bright sunny day when the sea is calm and to dive between the hours of 11 am and 1 pm. At depths of up to a dozen or so feet (3.5 metres), a choppy sea will greatly decrease the intensity of light penetration. Below that depth, surface conditions will be less important.

A fast film ought to be used because light under water will be less bright than at the surface, but if flash is used this will not matter quite so much. It is unlikely that photography will be in black and white, but, if it is, fast film can cause problems. The undersea world lacks tonal contrast and a slow film will get the best out of what little is present. Filters for black and white work might be yellow or orange, but if using colour film, then a pink or light red would be better.

The greatest difficulty is in judging exposures. Unless very well experienced in this field (and these remarks are not addressed to the regular underwater photographer) it is best to bracket exposures and also vary the viewpoint.

This is not the place to deal with the hazards of underwater work but it should be stressed that sub-aqua diving needs expert tuition and assistance. A travel photographer spending just a day or so of his trip shooting below the surface of the sea must go to the local sub-aqua club and use their expertise. They will not only find him the best locations, but also advise him in the all-important matter of safety.

8 People

In these chapters on particular subjects and locations, I have left until last my favourite subjects: people. If there is one delight above all others in travelling, it is in making new friends. Travel photography without people is a very barren occupation.

A travel photographer's approach to people as subjects in his work will vary. There will be those shots in which people are simply incidental to the main subject. At other times their contribution will be greater, providing a point of interest or in-filling. Lastly, there will be those occasions when people form the main subject of the photograph and all else is subordinate. (In this latter category I include shots of people engaged in activities when the activity itself may be central to the photographic theme.) It is this final class with which this chapter is concerned.

It could be argued that true portraiture has no place in travel photography, in which *place* must always be a distinguishing characteristic. But if one is concerned with recording the essence of a particular location then its people are an essential element. Their physical characteristics, their style of dress and style of life must faithfully be put on record. This is as a legitimate part of travel photography as is the photography of landscapes and buildings.

For some photographers, shots of people will be a sufficient single justification for an overseas trip. This is often the case with a visit to a community in some remote part of the world whose lifestyle is unique. This more specialist work should not be undertaken lightly. A considerable amount of preparation will be needed and the relevant authorities should be approached. There is little point in a professional or amateur photographer walking into a village in, say, central Borneo or the Amazon Basin, without a guide, knowing little about the people he will be meeting and expecting to make a success of his work.

Although most photographers will, doubtless, work on portraits from time to time at home, it may be worth while to recall some general points regarding equipment and technique before turning to the particular subjects, opportunities and problems which a travel photographer will encounter.

EQUIPMENT

It would be comforting to be able to say that only one lens need be used for portraits. If only one were to be used it would be a 135mm fast telephoto lens, or, even better, a 80–210mm zoom. In many circumstances this lens is ideal. It allows the photographer to stand well back from his subject and gives good modelling of the subject's features. A standard lens requires the photographer to stand intimidatingly close and the subject's features will appear flat. Use a wide-angle lens and either the viewpoint is so close that physical shape will be distorted, or stand back and include too much in-focus background. But if we consider the circumstances in which a travel photographer is operating, and also his objectives, a telephoto lens may sometimes limit the depth of field *too* much for any background to be clear and the setting (perhaps of special importance) may be lost.

In the end, the choice of lens may be a difficult one, even for head and shoulder shots of individuals. For groups, or when backgrounds must be seen in focus, a standard or 35mm wide-angle lens may be unavoidable. If these lenses are to be used, it is worth remembering that distortions will be exaggerated by a poor choice of viewpoint but modelling can be improved by careful use of shadows.

Filters for portraits are a matter for debate among photographers. The photographer working in a variety of conditions has the additional problem of varying skin tones, from the shiny black to the pallid white. I find it most satisfactory to use a skylight filter with an amber or even a pink tint for all portraiture. For shots where background is important and in focus, it may be necessary to let that dictate the filter to be used. Diffusion filters produce a softer image and something of an other-

worldly portrait can be obtained by using a special effects filter with a clear centre and a diffused outer ring.

A tripod ought to be used for portraiture but a travel photographer is not always able to carry one. If one is available, it can be used with a long cable release or a pneumatic shutter release. An electronic flash gun can be used to supplement natural light or provide the only illumination indoors or at night.

LIGHTING

Before dealing with choice of lighting, it should be said that, together with viewpoint, this may be the travel photographer's greatest problem in shots of people. It really all depends upon how much command he has over his subjects. If he is able to move them, even if only to ask them to turn to face another way, then he can consider himself lucky and he can begin to control the light. More often than not, however, shots will have to be taken without any communication whatsoever between subject and photographer.

Assuming that the photographer is able to position his subject, the ideal lighting is almost always from the side, but slightly behind the camera. An angle of forty-five degrees with a line drawn between camera and subject is usually considered as optimum. Light is best, at its most flattering, when directed downwards, making an angle of about thirty or forty degrees with the ground. All this emphasises, yet again, the importance of timing work, especially in the tropics, because the light in most cases is, of course, the sun. Some correction for vertical angle can be made by a slight tilt of the subject's head and back lighting can be used to best effect out of doors when the sun is high. It then gives an attractive halo effect, especially if the subject has a good head of hair. Should the face be in too much shadow, or the subject's skin is very dark, flash can be used to supplement sunlight. In such cases, the light reading should be taken from the subject's face and an exposure calculated as for flash.

Only when unavoidable, or for special effect, should strong front lighting be used. It tends to show up imperfections in the skin and the subject will probably be ill at ease looking into the sun. Exceptions might be made if it is wished, say, to emphasise a wrinkled or scarred face, or if side lighting is casting shadows which exaggerate facial features.

For many shots, using colour or mono film, it is better to wait until the sun is hidden behind light cloud or to ask the subject to move into open shade.

This cannot be overemphasised and yet it is a point often overlooked. On a day when the sun is overcast and there seems little chance of the sun putting in an appearance, flash may be the only answer. Flash can be used quite satisfactorily if the subject's background is the sky, but if this is not the case, the subject should be close to his background so that it too can be illuminated by the light of the flash gun. In the latter instance, the proportion of background in the frame should be reduced to a minimum and not be too highly textured.

At night, or indoors, the conditions a travel photographer experiences are rarely ideal. Working with only one light source, or perhaps a mixture of different sources in an illuminated building, really good results cannot be expected. The normal practice of using bounce flash may be impossible but, as outdoors, the flash should be held away from the camera, not using any hot shoe fitting, and the common problem of red spots in the subject's eyes will be eliminated. A single flash for portraiture is tricky. Usually the light is too harsh. If the output can be adjusted or if a diffuser can be attached to the flash, then some of the worst faults may be avoided.

It might be worth recalling at this point the remarks made in Chapter 3 about the use of flash in extremes of climate. It is most unwise to become reliant on electronic flash in either the tropics or very cold climates.

VIEWPOINT

As has been said, the choice of viewpoint may be outside the photographer's control, so the remarks that will be made below are something of a counsel of perfection. Using a standard (normal) or wide-angle lens, the level of the camera vis-à-vis the subject's head is far more critical than if standing back and using a long-focal length lens. If there is to be a minimum of distortion of the subject's features, the lens should be in approximately the same horizontal plane as the subject's head. If the camera is pointing downwards the forehead and nose will be exaggerated at the expense of a reduction in the lower part of the face. Point the camera upwards and again the nose is emphasised but the brow is made shallow. The shorter the focal length of the lens, the greater the distortion.

For full-length portraits the same rules apply but the camera can now be held at mid-torso level. For reasons of effect, a lower or higher viewpoint can be chosen. If high, the head will appear too big for the body, but from a low viewpoint a standing figure can be made to look more imposing or

dominant. A photographer must, as on other occasions, be prepared to crouch, kneel or even lie on the ground in order to obtain the optimum angle for his lens.

FOCUSING AND BACKGROUND
A very simple rule for focusing for individual portraits is to focus on the eyes. In photographs of people, the matter of focusing should be considered of vital importance. The aim will be very sharp focusing unless, quite deliberately, a decision is made to produce an out of focus image or effect. This is particularly important when a very narrow depth of field is being used as will often be the case with portraits. Backgrounds to shots of people can be of special significance in the context of travel photography. The usual rules concerned with avoidance of distracting surroundings (trees apparently growing out of the subject's head, and so on) will still apply. In addition, a travel photographer should be sensitive to background for another reason, recognising its contribution to the sense of place he is looking for. This is part of the art of composition and may include the framing of a shot to eliminate distractions, to focus attention on the subject or to add to the ambience.

In portraiture there is a decision to be made regarding how much of a person is to appear in the photograph. The choice is usually from one of five possibles: The picture can be full-length, from the waist upwards, head and shoulders, head only or even just a part of the head so long as it includes the eyes. As a rule, there is something unsatisfactory about a photograph in which the subject is cut off at the knees or whose feet have disappeared. With black and white film, judicious cropping can correct these faults but with colour reversal film this is less easily accomplished.

A common fault with amateur portraits is that the subject does not fill enough of the frame. If using a standard focal length lens, the photographer may have to get in very close to his subject. With a telephoto lens there is no such problem. In travel photography, costume or dress may be very important to record in detail and a general portrait may need to be complemented by a close-up of some items of dress: a belt or hat, or a pair of sandals, for example.

EXPOSURES
Shutter speeds ought to be fast and this will allow wide apertures which, in turn, help to reduce the depth of field. It is important to set exposures consistent with the subject rather than with the scene in general. Even with high shutter speeds it is not easy to capture in $1/250$ of a second an expression which somehow *reveals* the character of a subject. An answer might be to expose a large number of frames and hope to get it right just once in twenty shots. Indeed, a large number of photographers are turning to motor drive units and exposing a whole roll of film to obtain one satisfactory print or transparency. This seems to me deplorable. Whereas half a dozen or ten shots may be considered legitimate practice, firing off three dozen seems to rely more on luck than on skill.

Turning now specifically to the field of travel photography, it is possible to examine some of the situations that will be met and the techniques that may be adopted.

THE APPROACH
I never cease to be amazed at the tolerance of the people I meet in my travels when it comes to being subjects before my cameras. I am equally amazed, but also horrified, at the insensibility of a few travel photographers (including well-known and experienced practitioners) to people they wish to photograph. Too readily, those who travel abroad with a camera come to assume that everyone and everything is fair game to be recorded on film. It is little wonder that they, and those who follow them, can run into trouble when the cry goes up 'enough is enough'.

There is only one rule to be applied. As a photographer you must put yourself in the position of your subject. How would you react if some strangely dressed person, speaking gibberish, accosted you? How would you feel if you were asked to move into the sunlight or the shade, hold a particular pose, wait for the sun to shine or go behind a cloud? I know what I would want to do and I cannot expect others to react differently.

The answer: make friends first and leave the photography until later. This is not as difficult as it sounds, even if there is a language problem. A smile, a wave of the hand, these are universal gestures. If out of western society, learn the local form of greeting – and use it. Point to the camera and, with gestures, indicate that you wish to take a shot. If the reaction is unfavourable, either look for another subject or use one of the techniques suggested below for sensitive subjects.

Making a positive approach, asking your subject's permission, is even more important if using a telephoto lens. The more elaborate the equipment being used, the more potentially intimidating it is.

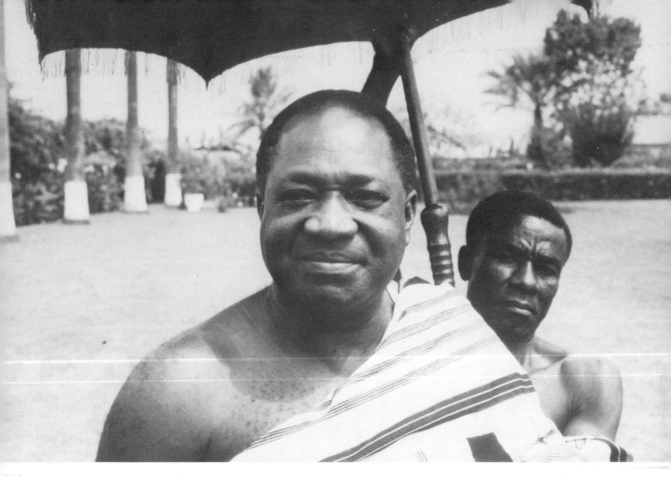

The Asantehene, King of the Ashanti, photographed at his Kumasi palace.

With people to whom the camera is not a familiar sight, the importance of approach is even greater. It may be necessary simply to become a familiar sight yourself before you ever start work. This can vary from standing at a street corner for fifteen minutes or so, to being in a village for a couple of days before you are seen with a camera. Only when it is impossible to spend such time in preparation should a more direct and immediate approach be made.

In communities where the camera is not just rarely seen but perhaps even unknown, a softly-softly approach may not be enough. There are still many parts of the world where the camera is regarded as something of an evil-eye. To point one at a woman may, in her view, affect her fertility. To point one at a baby may put a curse on the infant. In these circumstances, patience, tact and in-genuity are called for.

One method I adopt is to allow the more courageous and inquisitive to look through the viewfinder of a camera starting with a standard lens and then using a telephoto. They rapidly begin to see the camera, not as a weapon, but as something to look through and they appreciate its magnifying properties. This method has its draw-backs if there are too many inquisitive souls about! In next to no time there is a long queue of eager viewers. But it does establish a friendly relationship.

Another ploy I use in small villages (see also Chapter 10) is to start by asking the headman (language need be no barrier even without a guide) if he would consent to have his photograph taken. If he agrees – and I have not had a failure yet – then that is the signal for everyone else to want to be photographed. Of course one is selective and there is every excuse for pretending to press the shutter button.

A polaroid-type camera, producing instant pictures, can be a great help in winning over a hesitant subject. I can never make up my own mind as to whether it is really worth carrying such a camera on a long trip, but, when I have used one for this purpose, it has always proved valuable. Two points should be borne in mind, however. There can be technical problems with these cameras and their film in extremes of hot or cold

and one looks very silly if no recognisable print is produced. Secondly, it is always better to take a group rather than an individual photograph. More people are pleased and one avoids a crowd calling 'me next!', or whatever is the local equivalent.

If women are reluctant subjects, I find it worth trying to persuade a mother with a young child to let me photograph the baby. Then I hand the baby back to the mother and photograph the pair. Soon there is a queue of mothers and babies. An alternative approach is to photograph some older women first and the younger ones usually capitulate. It is rarely a successful approach to start with the young women who always suspect the worst of intentions! Children rarely pose any problems.

The importance of approach is never greater than when seeking permission to photograph a local, regional or state dignitary. It is not likely that the Head of State will immediately acquiesce to a photo session, but, if the photographer's reputation warrants it, an approach through official channels before leaving home may get an introduction. Alternatively, one's Embassy abroad may help. As a writer as well as a photographer, I find it

Mrs Indira Ghandi. The most powerful woman in the world allowed me a half smile. I crouched to take this shot in order to lighten the background.

The unexpected is always interesting. Two men, one with a red flag, lead a flock of ostriches in the Karoo.

Right, this prize winning photograph, Toda man and boy, was shot when I was working in the Nilgiri Hills. At the time, the Toda people had suffered almost complete extinction.

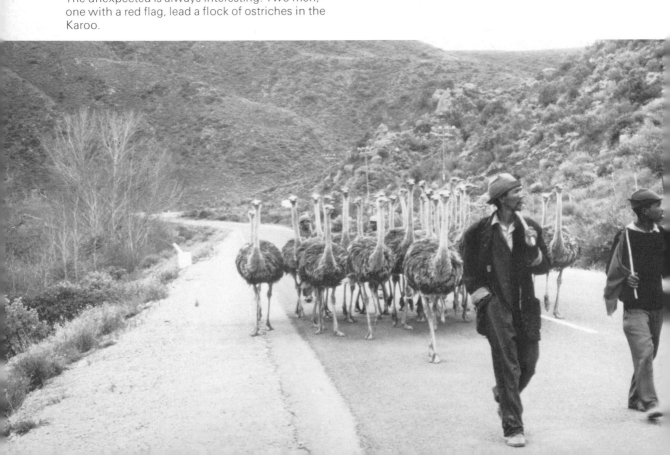

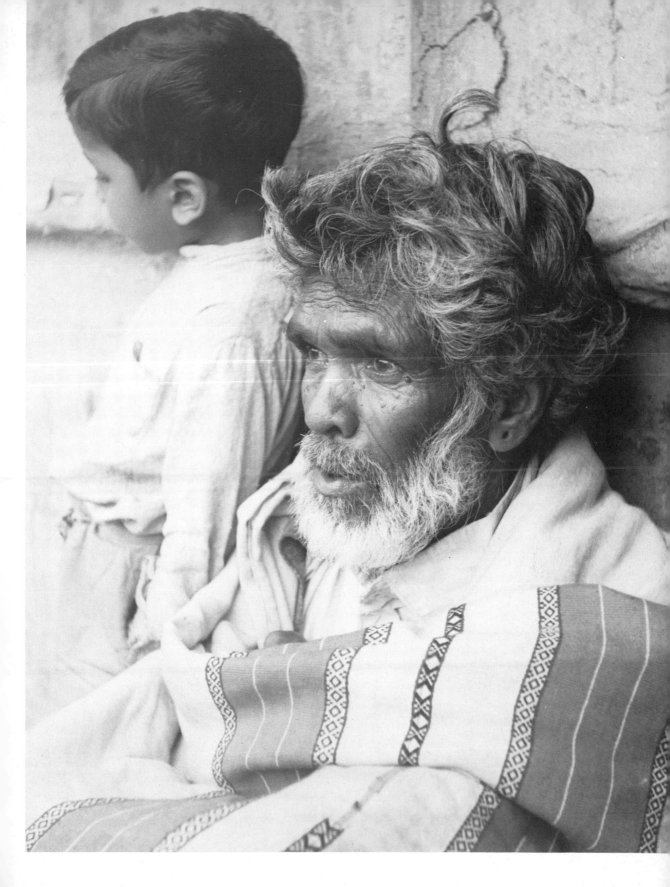

easier to ask for 'a few photographs' after an interview.

With the right approach, a photographer will be looking at friends through his lenses and that is how it should be. The greatest respect should be paid to people's customs, religious beliefs and sensitivities. A travel photographer is dependent upon his subjects, not they upon him. If circumstances suggest it, some gift can be made *after* the photography is finished. This can often be done with the least embarrassment through children.

Bribery is quite another matter. If money is asked for before shots are taken, it is best to move on unless the particular subject is of special significance or the photographer feels he can cope with the situation. Even more awkward are demands for money when photography is completed because, at that stage, the photographer is, to an extent, in the debt of his subject. Without a local guide he may well find it necessary to concede to demands although any money paid may make it impossible to continue in the same area without the problem being met with other subjects. After years of experience, one develops a sixth sense and can anticipate difficulties of this sort, skirting round them before they become nasty.

SENSITIVE SUBJECTS

Notwithstanding what has been said above, there will be times when a travel photographer will, justifiably, not wish his subjects to know they are being photographed. A political demonstration, people who do not wish to have attention drawn to themselves, a child, perhaps, who would be frightened or cease to act naturally if aware of the camera: these are the sorts of situation in which a photographer may need to exercise some ingenuity in order to get the picture he wants.

The most obvious hidden-eye is a telephoto lens. Focal lengths above about 100mm can so distance the photographer from his subject that the latter may be unaware he is being photographed. As the focal length increases, so a more distant viewpoint can be chosen. It is worth having a long focal length lens always attached to one camera body so that a shot can be taken immediately the subject comes within its range and before the photographer reveals himself. Coupled with a hidden viewpoint, for instance the corner of a building, a tree or a window, a telephoto lens is invaluable for work in sensitive situations.

A rather different method can be used if a twin-lens reflex or roll film SLR camera is available. For a number of years I used a TLR for much of my black and white photography. Into the tripod socket I screwed a simple rubber hand-grip which I pushed into my waist belt. This held the camera tightly against my body. A long shutter-release cable lead into the pocket of my trousers. Finally I wore a loose jacket or shirt open at the front to leave the lenses and viewfinder uncovered but partly concealing the camera. Now I was able to focus and compose in the large ground-glass screen of

A long focal length lens enabled me to photograph this child on an African beach without attracting his attention.

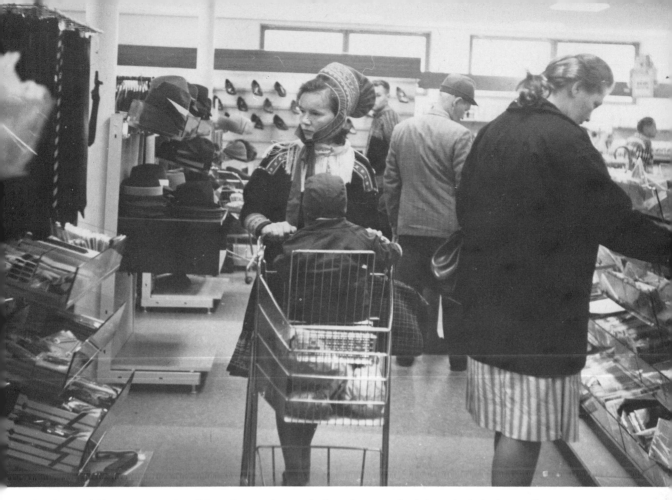

This Lapp girl in a supermarket did not know she was being photographed. I used a twin-lens reflex camera for this shot in the manner described in the text.

the camera without difficulty and release the shutter by using the cable in my pocket. The fact that the camera was never held up near the eye and that I hardly needed to handle or touch the body of the camera allowed me to shoot without it being obvious to my subjects.

When a tripod or other support can be used, then it is possible to employ all manner of devices which allow the photographer to operate his camera by remote control. Generally, such devices will be for a single shot which can be taken with the photographer completely out of view. Although this method is only appropriate in somewhat limited circumstances, some simple device such as a remote release air cable may be worth carrying. This pneumatically operates the shutter button and is an inexpensive piece of equipment. More expensive and sophisticated are ultrasonic and electronic devices but few travel photographers will have a use for these.

Photography from the safety and obscurity of a car is effective in cities unless it over restricts the choice of viewpoint. With the window lowered and occupying a rear seat, the photographer can often go unnoticed, especially if he sits back to shoot rather than putting the camera or lens out of the window. Shots of people in a street can be taken without the photographer being seen if a first floor window is used. It is surprising how few people look up above eye level. In the street itself, it may be possible to pretend to be photographing traffic and buildings when actually focusing on a person on the opposite side of the road. Inside a building, where there is sufficient light not to require the use of flash, a camera can be rested on a table or ledge and operated by cable release. Although a wide-angle lens may be best for this work, a telephoto lens will be most appropriate in almost every other circumstance.

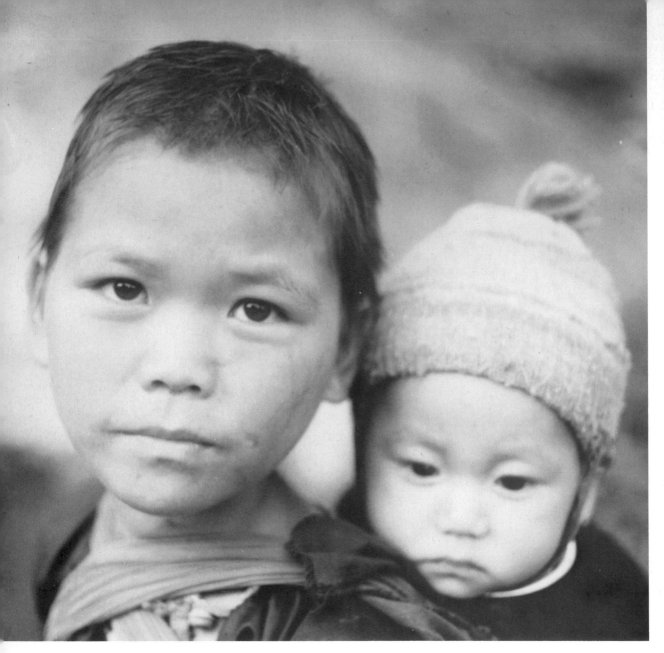

Two boys of the Meo Tribe of Indo-China. I found them very willing subjects despite the somewhat pained look of younger brother.

CHILDREN

For me, children as photographic subjects, come in three classes: the self-conscious, the over enthusiastic and the naturally perfect. In the first category are North American, Australian and European children, in the second, African, and in the third, Asian. Of course, I generalize, and I cannot speak for South American children. What I like most about Asian children (at least, the non-urban variety!) is their ability to be perfectly composed before the camera.

Children, it will generally be agreed, are the easiest of subjects for the travel photographer because, in most parts of the world, they will be most welcoming to the stranger in their midst. They also make delightful subjects.

Photographing children often entails getting down to their level, quite literally. This means that, for small children, at least, the photographer will be working from a crouching position for much of the time. Children are also active and cannot be

No need for stealth to take this photograph. This girl in a Bangkok street had fallen asleep while waiting for customers to buy her caged birds.

expected to hold a pose for long. Not only must the shutter speed be fast but the photographer will need to be working quickly.

Children will often crowd together around the photographer, eager to see what he is doing, interested in his equipment. This situation can sometimes take on the worst features of a nightmare. One of my best remembered experiences was when shooting on a West African beach. For about five minutes, perched on some rocks, I was unnoticed as I took some general shots of boys bathing and playing. Suddenly one saw me and in a matter of seconds I was surrounded by almost one hundred waving, grinning, shouting children. If I raised my camera all I could see in the viewfinder was a forest of outstretched hands. It took nearly half an hour before I could start work again. I tried the usual trick of pointing the camera in a direction one hundred and eighty degrees from the one I wanted to use in the hope that my

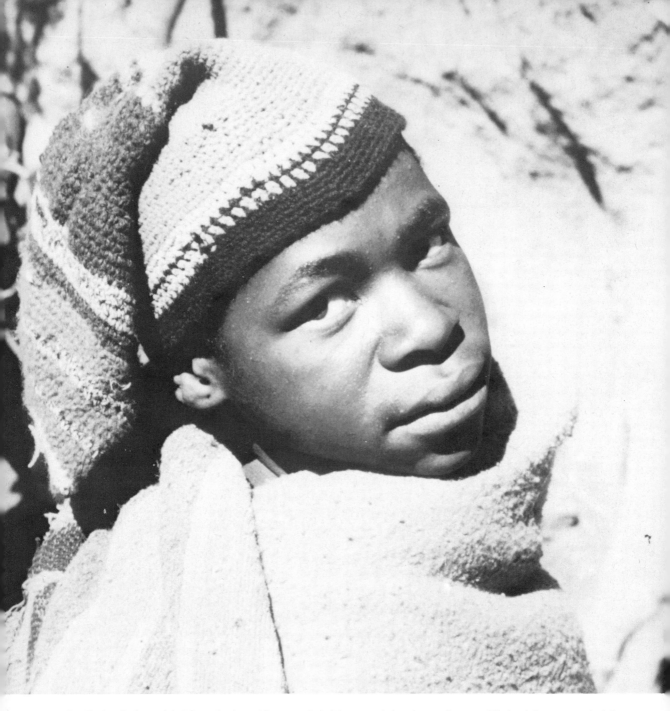

I called quietly to this Mesotho boy. He turned and I pressed the shutter button. His look is not startled, just inquisitive.

spectators would rush round to face the lens and leave my field angle free. It is a ploy that usually works and one can swing back to take the shot in freedom. With one hundred excited youngsters it was too much to ask. Whichever way I turned, there they were!

Often I want to photograph just one child from a group and I adopt the technique of pretending to photograph everyone, from every angle, until they all get tired of the game. Then I ask my selected child for just one more shot. At that stage the others largely have lost interest and will not be jealous. But the selected child will still be flattered and is usually willing for me to choose a suitable

I used back lighting for this Malaysian beauty. I later discovered my own image was reflected in the irises and pupils of her eyes.

place for the shot and to be dictated to regarding such important matters as the direction he or she is to face. If parents or other adults are present, it is wise to get their co-operation.

Most children much prefer to look at the camera so that full face shots are easier to obtain than profiles. In fact, in places where cameras are something of a novelty, they will often be fascinated on seeing their own reflections in the lens. This interest can be exploited for really close-up shots. It is also a way of overcoming any apprehension the child may have of the camera. It is seen to be no more than a mirror. As with adults, it may be helpful to let them look through the

No excuse was needed to photograph this beautiful young Chinese girl. Like most Asian children, she was completely at her ease.

viewfinder and gain their confidence through your recognition of their natural inquisitiveness.

No one likes looking into strong light and this is especially so in the case of children. Lighting should be chosen with special care, not only to avoid the child pulling a face, but also because it may be desirable to emphasise his delicate skin texture.

Photography over, the child must be thanked and, perhaps, rewarded.

GROUPS

So far the emphasis has been on photography of individuals. In many instances, however, groups of people will form the subject. Most of the techniques applicable to portraits or shots of a single person apply equally to groups but there are some additional points to bear in mind.

A group may be anything from two to a score or more of people and, in the context of travel photography, it is very unlikely that the photo-

Conversation piece in Kathmandu. Another example of a telephoto lens being employed to leave the subjects undisturbed—but I believe the boy on the right had just caught sight of me.

Washing in the street in Bhadgaon, Nepal.

Young man and two boys make the best of the puddles—all that's left of the River Vaijai in south India's dry season.

Sometimes people will be only part of the subject for the camera. I concentrated here on the sacrificial lamb which had just been slaughtered outside a temple in Kirtipur. The little boy on the right shows interest but three other boys are unconcerned.

grapher will be able to control the positions of those making up the group. Lighting, then, is a particular problem. Ideally, each person in the group should be more or less equally well lit but often a compromise exposure is necessary. If the lighting of just one or two people is especially sub-optimum and they are on the edge of the group, the best plan is to recompose the shot and omit them. Alternatively, a different viewpoint may improve the overall lighting effect or diffused sunlight can be used to reduce contrasts.

Lenses with focal lengths of 28mm or 35mm are very useful for group work allowing, as they do, a fairly close viewpoint and giving a good depth of field. There is a danger, however, in using short focal length lenses with groups of people spread out away from the photographer. Perspective is *stretched* by a short focal length lens and this will make people close to the camera appear relatively much taller than those standing some distance away. Of course, if the group is spread out *across* the field angle this difficulty does not arise.

Composition follows from the field angle of the lens in use and from the choice of viewpoint. A point of interest in the photograph can improve the composition. Whatever it is, a lampost, a street pump, a tree, it should fit naturally into the picture and not dominate. If circumstances permit, it is a wise practice to move round a group trying alternative viewpoints in an effort to find the best composition to fill the frame.

ACTION

There are many occasions in travel photography when people are the camera's subject and they are moving rather than static. Generally the movements are restricted to walking or perhaps running and the only response needed is to increase the

A study in activity as men work on the restoration of The Summer Palace in Peking.

A different sort of hammering. I photographed these drummers as they followed behind their tribal chief in West Africa.

Big is beautiful. Mother prepares the dinner in a village alongside Lake Volta, West Africa. She was flattered that I should wish to photograph her.

shutter speed comensurate with the speed and direction of motion. Thus a person walking at fast pace across the field angle may need a shutter speed of 1/125 while one walking towards the camera may need no more than 1/30. A person running across the scene may require an increase to 1/250 if the subject's movement is to be frozen. Just how frozen movement should be is always debatable. There is no doubt that some blurring will improve the dynamic quality of a picture but experiment and personal preference are the only guides.

In the course of travel, a photographer may come across other moving subjects where rather more than a change in shutter speed is necessary. Such subjects as local dancing, outdoor theatre or a religious or sporting occasion, spring to mind as examples. Although the question of shutter speed will still need answering, the more taxing problem is essentially one of composition. To obtain the best (i.e. most pleasing) results, the photographer needs to be able to predict movements so that he can press the shutter button at the very moment the action is at its most photogenic.

If possible, the photographer should attend the event more than once to familiarize himself with the sequence of movements of the performers. When this is not possible, he will need to exercise considerable powers of judgement if he is to get satisfactory shots. Fast shutter speeds may be needed if the speed of movement of the subjects is variable. If light is poor and flash cannot be used, the *natural* freezing that occurs at, say, the end of a dance routine, may have to be used.

It is at, for example, a Spanish bullfight or a Fukienese puppet show or when witnessing a ketjak (monkey) dance on Bali, that the need for motor drive becomes most apparent. To be able to shoot at five frames a second removes much of the element of chance when shooting scenes like these but also, I suppose, dispenses with a little of the skill which should be the pride of the photographer.

AT WORK

Of all the shots of people which evoke a sense of place there are few more successful than those showing people at work. A letter writer at work in the street on an ancient typewriter balanced on a rickety table, a man painting flowers on a paper umbrella, the local barber, a wood carver, a potter

At work. Woodcarver in Sri Lanka.

Lapp woman sewing reindeer skin slippers. Photographs of people engaged in their daily work are naturally authentic.

– many of the subjects will in some way typify the character of a place far better than shots of mountain ranges and waterfalls. Some appropriate techniques have already been discussed in Chapter 6 under Villages.

Sequence photography is well suited to this sort of work, especially when the product of the subject's labours goes from its raw to its finished state in his hands. The making of batik, for instance, could be photographed through all its stages with the accent firmly on the craftsman or woman working the cloth. There are countless other examples. It must be remembered, however, that the person at work should not be interrupted,

but if he is, then some payment should be made in compensation. Often this is most appropriately made by the purchase of a piece of finished work. In other cases, the offer of payment can be made before starting to photograph.

Of course, it is a different matter if one is simply photographing people going about their daily tasks and there is no real contact between the photographer and his subject. There is no need to offer payment in these circumstances although street vendors will often expect something if the photographer makes it clear that he wants a shot of the seller and his goods.

9 Back Home

When the travel photographer arrives back home, he cannot put down his cameras and put up his feet. There are still a number of tasks to be completed if he takes his work seriously. The six main jobs yet to be done may be summarized as processing, cataloguing, indexing, storing, showing and selling.

PROCESSING
Whether or not a photographer processes his own film, his first concern must be to get the latent images of his exposed film fixed in the form of negatives or positive transparencies. If film is to go to a laboratory for processing, it may be better to deliver it by hand than to trust the precious cargo to the postal services. However it is to be processed, it must be clearly labelled and in such a way that there can be no confusion later. This is especially true of material sent to outside agencies. All the careful recording and labelling done in the field will be to no avail if it cannot be carried through to the negatives or transparencies.

If film is to go to a laboratory, a record must be kept of what is sent and the dates of forwarding and return. If any film is mislaid, it should be traceable through the field record book.

Some of the dangers of leaving exposed film unprocessed have been explained in Chapters 2 and 3, but I find travel photographers who return from difficult climatic regions such as the humid tropics, who will leave exposed film to wait for processing for weeks if not months and then wonder at the loss of quality. This is the one post-tour job that *must* take priority over all other tasks.

Often the photographer will have some un-exposed film left in a camera. With two or three cameras, this may mean a significant number of unexposed frames. The only solutions are either to waste the unexposed film or to use it immediately one returns. Whatever happens, the cameras should be unloaded as soon as possible, and that means on arrival home.

Using colour reversal film gives the photographer little choice as to how the film is to be processed in the sense that he will probably opt for a positive transparent image – the slide. It is unlikely that any other processing (for example, the making of prints from the slides) will be carried out immediately. The only choice is likely to be between mounted and unmounted slides and, perhaps the style of mounting. I find unmounted transparencies less easy to store and use, and unless I am frequently to use particular transparencies for projection, I prefer card mounts to plastic or glass mounted slides. The reasons are simply that it is very easy to write on card mounts (there are no sticky labels to fall off) and that picture editors prefer slides not to be mounted between glass.

With black and white film, the most sensible and economic processing is to produce negatives and contact prints. Negatives without prints are often difficult at the cataloguing stage and enlarged prints can be made from selected frames later.

CATALOGUING
Cataloguing is an art and, as such, must reflect the personal tastes and preferences of the photographer. Whatever the chosen method, the initial task is to edit the films after they are processed.

Editing colour transparencies requires the use of a light box, preferably with a magnifier to detect any imperfections or perhaps to check definition and focusing. In some cases the magnifier will be used to identify detail in the transparency which is not clear to the naked eye. To edit black and white film the contact prints can be used but it may be necessary to go back to the negative if the quality of the print is doubtful.

When working with negatives or transparencies, it is important to wear light cotton or silk gloves and to use tweezers to prevent any fingerprint damage to the surface of the film. Transparencies are especially susceptible to permanent damage if fingered on the emulsion side of the film and the inconvenience of working in gloves really is worthwhile.

At the editing stage all poor quality photographs

can be weeded out. It is not necessary to be ruthless because it may be possible to correct exposure faults by copying transparencies or by more careful printing of black and white film. What will need certain banishment to the ash can will be photographs that are out of focus and those in which there has been a problem with the subject matter or composition. For example, if someone has moved into the field angle unnoticed and blotted out the main subject of the photograph, there is no correction that can be made. All the same it is worth considering the effect of cropping on a photograph if there is sufficient useful subject matter remaining.

If several shots have been taken of a subject from the same viewpoint (with, say, different exposures), it is wise to keep all the shots in case spare negatives or transparencies might be needed later. Only if the photographs are of irremediably poor quality should they be destroyed.

While editing, the field record book (described in Chapter 2) should be checked simultaneously. Any discarded photograph can be struck from the record and any anomalies and ambiguities in the book put right. I often find some discrepancies, for example when I have bracketed for exposure but only recorded a single frame in the record book.

After editing, the Herculean task of cataloguing begins with the choice of a system. For the travel photographer, the choice often starts with a decision in the matter of geography versus theme. Should one adhere rigidly to a locational basis for cataloguing or should one adopt a thematic approach and group together all the photographs under a single subject heading irrespective of where they were shot? Most photographers choose to compromise and this is wise. If locations are ignored then so too is the elusive sense of place.

Retrieval will almost certainly be more difficult unless there is some locational basis to cataloguing and storage of material because a traveller thinks in terms of place. His memory reflects his experience and his experience followed an orderly locational pattern. That shot of a village wedding party is remembered not just as a group of people but as a group associated with other memories of the village. The photograph is simply part of a general sequence of recollections of a particular place.

My own method of cataloguing photographs after a trip or expedition is to start by dividing the route I have followed into consecutive segments, sub-dividing the segments into smaller sections, as necessary. Within each section I adopt a thematic approach for all subjects, keeping to a set order of themes and type of photograph. I treat all major settlements as individual sections as I do all places in which I have stopped to make a particular photographic study. Thus a town may be one section and a glacier another. If I have been concentrating my work on an individual town, I may well treat its component districts as discrete sub-divisions for cataloguing purposes. Similarly, work in a game reserve can be sectionalized according to species of animal.

Within each section or catalogue unit, I decide the theme headings according to the sort of subjects I have been shooting. (I accept that there nearly always will remain some shots which defy the system and have to be classed as miscellaneous!) For each theme I begin with air shots (if any), followed by bird's-eye views (e.g. from tops of mountains or buildings) and then catalogue the ground shots. For individual subjects I start with general shots and work through to close-ups and detail shots.

A travel photographer returning with perhaps 5000 colour shots and 2000 monochrome may need to spend weeks on the production of a catalogue or record of his collection. As with processing, the sooner it is done the better. I know from experience that the more one delays the longer the work takes. The reason is simple, memory fades. If a cross-reference catalogue is to be drawn up with themes and locations separately listed, the work is even more protracted.

As the photographs are assembled in an orderly manner, brief details will be recorded and each photograph will need to be numbered. The details (captions) can be brief but should include as much information as will be necessary, not only to identify the photograph, but also to record important detail included in it. These captions will be taken largely from the field record book but every chance should be seized to check the accuracy of what was recorded at the time and to add further information. For example, using maps and reference books, place-name spellings should be checked and such details as heights of mountains, dates of buildings, names of plants, and so on, can be added.

Most photographers adopt a system of numbering or of lettering and numbering for their collections. As the number of photographs increases, lettering becomes less and less appropriate unless restricted to the indexing of major sectional headings. One plan is to use letters to indicate country of origin rather in the manner of vehicle international registration letters. Alternatively, numbers used for each photograph can include a

947328	Pokhara: Valley: gen. view from W la/o
947329	Pokhara: Valley: terraces & river incision la/o
947330	Pokhara: Valley: river terraces, slumping, deposits la/o
947362	Pokhara: Valley: Kali Valley: gen. view b/w
947363	Pokhara: Valley: Kali Valley: gorge & meanders
947364	Pokhara: Valley: Kali Valley: gorge: strata
947365	Pokhara: Valley: Kali Valley: gorge: padi on slip-off slope b/w
947410	Pokhara: group of women shoppers. Dress b/w
947411	Pokhara: woman selling ground nuts
947412	Pokhara: close-up: 947411: head/shoulders
947413	Pokhara: close-up: 947411: hands filled with groundnuts
947414	Pokhara: girl with basket b/w
947415	Pokhara: detail 947414: head strap b/w

Fig. 5

code to identify not only the country of origin but also the year (and even the date) the photograph was shot. Numbers can be stamped or written on transparency mounts and on the back of contact prints.

A typical catalogue entry is shown in fig. 5. If a particular collection includes both colour and black and white photographs, some cross-reference is desirable. This need be no more than adding *b/w* or *col* (for black and white and colour), as appropriate, to the catalogue description of photographs (see fig. 5). The fact that *b/w* is added to a colour caption need not mean that there is an *incidental* black and white photograph in the mono catalogue, but simply that there is a near-equivalent shot. Various abbreviations can be used such as *l a/o* (see fig. 5) for low aerial obliques or *fe* for fish-eye lens shot, and so on.

One problem makes the production of a catalogue of black and white photographs more difficult than one of colour transparencies. Strips of contact prints and negatives in 35mm format are best left uncut with six or eight frames per strip. They are most easily stored in this way (see below) and the negatives more readily usable in this form for printing. Unfortunately, the photographs in each strip will be in chronological order and not necessarily in the order of the catalogue. It is necessary, therefore, to number the strips sep-

arately from the basic code used in the catalogue but to add the strip code to it. Thus a number 76248/932 would indicate that black and white photograph number 76248 could be located in contact/negative strip number 932. The next photograph in the catalogue would be 76249 but the strip number could be quite different and the entry read, say, 76249/919.

Such is the importance of the catalogue that it is almost as valuable as the original photographic transparencies or negatives themselves. If it is lost it may be impossible to re-write with anything like the same degree of accuracy or completeness. As a safeguard, it may be thought worth while to type the catalogue on loose-leaf paper (which can be put in a file) and to photo-copy or take carbons of each sheet. Two or more copies of the catalogue can be kept at different locations and in this way reduce the risk of loss by any means.

As has already been said, my personal view is that technical data need not be recorded unless the photographer really feels he needs it and he has had time to note it in the field. I would find it not only irksome but often impossible to keep records of every shutter speed, aperture and lighting condition when working. It may be a relatively easy task in the studio but not so for the travel photographer working in what are sometimes quite difficult or even hazardous conditions.

INDEXING

What has been suggested so far is a catalogue relating to a particular trip or expedition. Over a number of years, in which a travel photographer will not only continually be adding to his collection, but, possibly, be visiting some places several times, a card index may be the best answer to the problem of location and retrieval of photographs.

The general method for producing an index is not very different from that described for a catalogue but this time the numbering system should be devised to suit the style of index chosen by the photographer. A system similar to that used for book library indexing can be adopted. Now it is possible for a photograph to appear under more than one heading. For example, photograph number 947365 (see fig. 5) might appear in the geographical index under *Asia*, national division *Nepal*, regional division *Pokhara Valley*. But in the thematic index it would have two entries under landscape: *river gorge*, and under crops: *padi*.

Obviously index cards can be made up from each trip catalogue and the photographer's needs will dictate the number and type of separate classes to be used in his index. Any good book shop or library should be able to provide information about guides to indexing and a travel photographer starting an index would be well advised to seek advice before deciding on a system. If the wrong choice is made it may be almost impossible to change at a later date without a considerable amount of work being involved.

STORING

Original colour transparencies and monochrome negatives need and deserve careful storage. The three main enemies are excessive heat, dampness and light. The ideal storage conditions would be a room of constant temperature (isothermal) around ten degrees Celsius and one in which the relative humidity was always below fifty percent. Storage drawers, cabinets or cupboards should shut out all light sources. In practice, a workroom or living room will usually satisfy these requirements but if it is to be left unheated in a cool climate for any length of time then the film materials may need to be moved. Likewise if there are problems with dampness, silica gel crystals can be used as a drying agent in the storage cabinets or drawers.

There is a wide variety of commercially produced storage systems for colour slides, from illuminated display cabinets costing many hundreds of pounds or dollars to the use of small plastic boxes holding 20–40 slides. One of the most popular methods in recent years has been to store transparencies in special plastic filing sheets which can be suspended in standard filing cabinets. The advantage of these systems is the fact that the sheets can be laid on a light box for viewing. The disadvantages are that metal filing cabinets and plastic sleeves will exacerbate any damp problem and it is not very easy quickly to remove a transparency from the sheet.

A very safe method of storage is to use specially constructed indexing cabinets. These chests of drawers can be added to as a collection of transparencies grows and access and indexing are easy. A cheaper alternative is to use simple sets of plastic drawers made for the DIY enthusiast to store nuts, bolts, screws, nails and the like. Some of these sets of drawers can be found to be the right size for colour transparency mounts.

To store black and white negative strips, the most convenient system is to use the special sleeves or envelopes that are made for the purpose. Also available are loose-leaf binders which hold sheets of negative sleeves in a most convenient manner. As with colour transparencies, it is possible to store negatives in an ordinary filing cabinet by using negative sheets to which a filing bar is attached.

Unmounted colour transparencies, colour negatives or contact prints can be stored in the same way as monochrome negatives.

All original film materials ought to be insured but it may be very difficult to obtain realistic cover at an acceptable premium cost. It is worth asking an insurance agent to obtain a number of quotations rather than accept – or reject – a single quotation.

SHOWING

Stories are legion of bored audiences at slide shows of travel and holiday pictures but the fault usually lies not so much in the quality of the photography as in the amateurish way in which they are presented. There will, in any case, be few travel photographers who will not wish to show something of their collections after they have properly been edited and indexed.

It is not proposed to deal here in detail with the complex matter of photograph exhibitions and slide shows. However, it is appropriate to outline some of the points which a travel photographer might bear in mind when considering the showing of his work.

It is very unlikely that any showing of travel photography will do more than cover the cost of the exercise. It cannot be considered as a source of direct revenue unless perhaps the photographer

If planning a slide show, particular subjects should be borne in mind while travelling.

Above left, sand ripples, and right, cobblestones, are examples of simple pattern subjects to be used for continuity or the superimposition of titles. Below, a 'natural' title to introduce a new region.

has been attached to an important expedition or his work and name are generally well known. Nevertheless, the exposure of his work can lead to commissions, invitations to lecture and write, and to other assignments which might be financially attractive.

The two most likely forms of showing will be an exhibition of prints or a slide show. Exhibitions require an immense amount of preparatory work, the making of high quality prints, the physical arrangement and display of the photographs, the preparation of captions, and, of course, the organisation of exhibition space. Costs can be considerable especially if the photographer is not processing his own material. Prints should be large, even poster size, and this may mean special equipment as well as high quality negatives.

Some of the organisations which might be approached to mount an exhibition of travel photographs include: large department stores, travel agents, public libraries, educational institutions, galleries which accept all the visual arts, museums, hotels (especially those with a large foyer or with conference facilities), and municipal or commercial offices. Arrangements should be clear, especially with regard to such matters as costs of mounting the exhibition, charges for viewing (if any), security and insurance.

It is often appropriate to an exhibition of travel photographs to include various items of the material culture of the area in which the photographs were shot. Many travel photographers will have collected such objects on their journeys and other suitable pieces can probably be borrowed. Maps should also form part of the display.

With adequate advertising before the exhibition opens and press cover on the opening day, these sorts of shows can have considerable impact and fruitful consequences. A week to three weeks is usually considered to be sufficient time for an exhibition to remain open.

In many ways, a showing of colour transparencies is much easier to arrange but its impact may be less. Unless the photographer feels confident enough to hire a hall and deal with all the advertising and other arrangements himself, he is advised to seek the co-operation of an organisation which might be interested in his work. This time the organisations which might be approached would include: photographic clubs and societies, travel clubs, organisations associated with the area in which he has been travelling, and educational institutions. Additionally there is a great variety of clubs and societies which meet to hear speakers on all manner of topics and which welcome a photographer who can speak well and also show slides.

It is very important to make up a slide programme with the particular audience in mind. A very technical programme might be appropriate for a critical photo club but this would not suit the local business men's society meeting after a heavy luncheon.

A great deal of sophisticated hardware is now available for the showing of slides. Dissolve systems and multi-media equipment is expensive but repays the capital outlay by the greater professionalism of the show. Much of this equipment can be hired if the expense of purchase cannot be met. In addition, travel photographs particularly lend themselves to the making of multi-image slides and to the variety of masks that can be made or bought commercially. A travel slide show is often improved by slides of maps which migh also portray the routes followed by the photographer.

If a travel photographer takes his slide shows seriously, he will have had them as an objective during his work on location. In this way he will have been looking for, say, shots which could produce dramatic dissolves, or for photographs of sign posts which could be used to identify the location of a series of transparencies. It is really very much easier to produce a good slide show with a smooth dissolve programme if some consideration has been given in the field to the potential of shots for this purpose.

As has been said above, this is not the place to go into the details of exhibitions and slide shows and a travel photographer contemplating showing his work in these ways is recommended to read the existing literature on the subject and to look at what others are doing.

SELLING

Travel is costly and so too is photography, but can the latter be made to pay for the former? Each week, the photographic library with which I am associated receives yet another batch of letters and telephone calls from hopeful travel photographers wanting to sell their work. Through the year the number of enquiries grows to hundreds yet we can take on the work of just a tiny fraction of those who wish to make their travel photography pay.

Some photographers write in advance of a trip, often seeking commissions, others wait until years after they have returned before seeing their work as a potential source of income. Two apparently contradictory facts must be recognised: there is a very good market for travel photography but

Photographs like this, of the Polarna Hotel in Mozambique, sell well for travel brochures but need to be in colour.

selling is not easy. The reasons for this apparent contradiction are that there is tremendous competition and, secondly, the potential customer does not easily make contact with the seller.

Apart from expedition photographs, very little travel photography has news value. If one is *lucky* enough to be travelling through a country when a revolution starts, it is just possible that some topical news pictures may be shot – but so too may be the photographer! No, the market for travel photographs is largely with the stock libraries which feed material to publishers of all kinds and to the various communications media. In addition to the sale of photographs on their own, many professional travel photographers combine photography with writing. In these cases, photography tends to play a subordinate, supportive

role and it is not proposed to discuss the travel writing market here.

The first important question a travel photographer has to ask himself is whether he is able to sell his own work or whether he needs to use the facilities of an agency or picture library. The advantages of selling one's own work are mainly that there is no loss (by way of agency commission) and one can retain control over the materials. The disadvantages are the probable (certain?) loss of potential markets and the considerable amount of work involved in selling.

The answer to the question 'do I sell my own photographs or use an agency?' must be left to the individual photographer and it will depend, to some extent, on such factors as the size of his collection of travel photographs, the specialist

nature of his work and the degree to which he relies upon sales for his income. If a travel photographer has a very large collection which is also very specialized (for example, 10,000 photographs of modern Soviet Russia east of the Urals, or 5000 colour photographs of the flora of equatorial Africa), there is a good chance that he will be able to market his own work *once his collection has become known to potential buyers.* For most travel photographers, amateur or professional, it may be much easier and more lucrative to use a picture library.

If the choice is to use an agent, lists of picture libraries are available in such publications as *The Picture Researcher's Handbook* and *The Writer's and Artist's Yearbook*. Agencies differ quite markedly in the ways in which they deal with their photographers' work. Some will insist on holding a specific number of photographs for perhaps three years. Others will deal only with work from established professionals. Most insist upon having exclusive use of a photographer's submitted collection and on physically retaining it on their premises. A few picture libraries, such as the one I direct, allow the photographer to keep his own photographs and simply call for them when a client requires them. Strangely, the level of commission taken by the agent is the one near-common factor. It is almost always around fifty percent of the gross fees received from a sale.

Whether photographs are sold by an agent or a photographer, it cannot be stressed too strongly that the sale should be only of Reproduction Rights and not a sale of the Copyright. Only in quite exceptional cases should it be agreed to assign copyright to a publisher or other purchaser. The whole matter of Rights (governed largely by the 1956 Copyright Act in the United Kingdom and by the Copyright Statute 1978 in the United States of America), is exceptionally complicated and there will always be a small number of unscrupulous publishers only too keen to use photographs without payment of fees.

What sells? Almost anything from travel photography *may* have a market, assuming the quality of the photograph is high when measured by technical criteria. The 35mm format is generally acceptable to all but certain advertising and calendar markets which require large formats. It is not true that the more exotic the location the better

For the calendar market, colour and good weather are essential.

Simple subjects often have interesting stories to tell. This Eskimo grave in east Greenland could be the subject of a lecture.

the chance of a sale. In fact, photographs taken well off the usual tourist routes do not have an especially favourable market although when these sorts of photographs are required the competition is likely to be smaller. Educational and specialist publications will most often be looking for very specific subjects and the content of a photograph may be more important than its technical quality. On the other hand, advertising and postcard markets will require photographs of a very high quality, that is, eye-catching.

Travel photographers working the well-worn tracks of Europe and the USA have a hard task in selling their work, not because of a lack of demand, but because competition demands that they should keep looking for new approaches to old subjects. The Eiffel Tower and the Statue of Liberty have been photographed millions of times by amateurs and professionals. The shot that sells today is the one coming from a photographer with the imagination and flair to produce a *new* image.

On the other side of the market is the demand for pictures to satisfy specialist publishers. These are often best produced by travel photographers who have some specialism outside photography and who can combine their two skills to good effect. Expertise in one or more of a wide variety of fields can be of immense value. The subject of interest matters less than the ability to know what to look for and how to photograph it effectively. Thus, the naturalist, geologist, geographer, architect or agronomist, to name just a few, are one step ahead of the photographer who has no other skill, when it comes to shooting specialist photographs. Of course, it has to be assumed that the technical expert can also produce good quality photographs.

Overall, the travel photography market is one of very mixed demand. For example, only two days before I started writing this section on selling, I was dealing, in the course of one hour, with three very different enquiries. One was for a shot of the Taj Mahal: 'a very general but attractive shot which must evoke the spirit of India'. Next came a request for a close-up shot of the ears of a particular strain of wheat grown in Nigeria. Then there was a call for a shot from Sweden which 'must be rural,

I photograph advertisements and notices for sale to educational publishers. Above, even when the language cannot be understood, the illustrations on this Family Planning notice speak for themselves. Below, the African's equivalent of suntan lotion?

She is selling little piles of groundnuts. He makes simple knives. The poverty of this couple in Upper Volta is only too obvious. Travel photography from the Developing World must inevitably record scenes like this.

timeless and give the *feeling* of a warm summer's evening'. The first photograph was for an advertising brochure, the second for an educational television programme and the third for a dust jacket. This is typical of the variety of photographs a picture library is dealing with. All could be satisfied by the cameras of travel photographers.

If a photographer is handling his own work, he should be fully aware of the sorts of fees to charge and how to find his way through the labyrinth of Rights, picture sizes, territorial limitations, first rights, flash fees, exclusive rights ... just a few of the determinants of the scale of charges. It is equally important to present material attractively for viewing and to keep a rigorous check on all original material. Every transparency, negative or print which leaves his hands must be logged and a record kept of its history. It is not uncommon for prints and colour transparencies to be kept for up to a year or more by a publisher and holding fees

may have to be charged to off-set loss of potential sales. Sometimes a negative or original transparency may be lost by a client and this possibility must be covered by an agreed rate of damages. There is a *lot* of paperwork involved.

Whether selling his own work or using a picture library or agency, a travel photographer can look upon his photographs as a source of income, although he must accept that there are no quick fortunes to be made on the shots he brings back from his first trip. A very large collection, built up over years of travel can, however, be a way of financing future trips.

Right, while writing a book in northern Scandinavia, I lived for some time with the Lapps. This little study was taken inside a Lapp tent. It is wise never to ignore the everyday and the simple.

Another, even simpler study inside a Lapp tent. I lay on my back to take this shot of reindeer meat hung for smoking in the apex of the tent.

10 A Personal Record

The case studies below are not intended to be models but will illustrate, it is hoped, just some of the aspects of planning and execution of a travel photographer's work. They are little more than sketches and circumstances and photographic objectives will always dictate detail, making each journey and each photographic experience unique.

A GENERAL VIEW OF HELSINKI

Quite recently I flew to Helsinki intending to add to my stock library of photographs of Scandinavia. Although I had spent a considerable time in northern Finland, on a number of visits, I had not previously had the opportunity to do much photography in that country's very fine capital.

There is plenty of written matter on Helsinki, countless illustrated guide books and potted histories. Maps were no problem and I chose one which showed the centre of the town pictorially and, on the reverse side, covered the environs of the city in a general map. The pictorial map was especially helpful because, not only did it name the major buildings, but the drawings illustrated their south-facing elevations so clearly that I had no difficulty in recognising them on the ground.

Working without an assistant, my plan was to spend five to seven days in the city and allow the weather to be the deciding factor in determining when I should leave. I was without my own transport and, as the city centre is not especially large, I decided I would do most of the work on foot,

Helsinki: From a roof-top viewpoint, Parliament Buildings.

hiring taxis as and when I needed. I was lucky in that the weather was almost perfect for photography throughout my stay and my only disappointment was due to bad planning. I had hoped to do some photography from the air but left it until I arrived in Helsinki to make the arrangements. Despite a long round of telephone calls, I was unable to get an aircraft and the necessary permits. Of course, I should have made the arrangements before I left home.

Day 1

I started the day with a visit to the Tourist Office to collect brochures, check some timings and make enquiries regarding access to public buildings. As the Office was close to the main city market and a particularly busy and attractive esplanade, I was able to judge something of the photographic potential of that part of the town. I knew a little of the city already so a general reconnaissance was not necessary. Instead, the rest of the morning was spent going through my notes, checking distances on the map and generally planning my work. I decided to operate around my city centre hotel in the afternoon. I had seen that, within a radius of about 400 metres of the hotel, I could cover such subjects as the main bus and railway stations, the Parliament Building, a number of monuments of interest, the National Art Gallery and much of Helsinki's Regent Street or Fifth Avenue, the Mannerheimvägen. Realising that this was too ambitious a programme for an afternoon's work, I had set aside further time for the same area at a different time of the day. I determined to go back to at least three points of special interest later: the Art Gallery, because I felt the light might be better in the morning, and the bus and railway stations because they were so rewarding in the photographic subjects they provided. I got back to the hotel early to investigate the photographic possibilities of a roof-top camera position and was not disappointed. The roof gave me a 360° view of the city although I judged the light as right for only about a third of that. I calculated the times of day I would need to return to the roof to get all round coverage.

From the roof I picked out buildings and areas I was intending to photograph from ground level and used a 200 mm telephoto lens to obtain bird's-eye views. I also found vantage points on the roof to take shots of the street scenes below and of activity around the bus station. I had taken a semi-fisheye lens with me and I experimented with this to shoot large sections of the city beneath me and stretching away into the distance. A 28mm lens proved more useful, however, as it was difficult to compose a satisfying frame in the fisheye lens which tended to include too much sky and too little town. The flat landscape around the town added to this problem.

Day 2

Markets start early and that is usually the best time to record them on film. When I eventually pulled myself away from Helsinki's quayside market I found it was still only 9.30 am. At 60° North, the sun rises early in the Helsinki summer. Before leaving the market area, I spent some time in Senate Square. This is one of the city's architectural gems and I returned to the square to use the afternoon light on my last day.

I had plenty to photograph on my way back from the market and I returned to the same area I had been working in the previous afternoon, photographing subjects which were more pleasingly illuminated by the morning light. By the time I had finished at the Art Gallery, I was ready to move on to my afternoon's schedule: north-west of the centre to Finlandia House, the National Museum and other public buildings. Walking back by a different route enabled me to take in the famous Temppeliaukio Church. Carved out of a granitic mound and enclosed by a copper dome, this unusual church presented me with considerable lighting problems. I decided to use available light and time exposures for the interior. Its circular shape I emphasised with a wide-angle lens and I waited until the sun was low enough to be seen through the glass sections of the roof. Using an etched special effects filter with a rotating frame, I was able to photograph the sun as a burst of colour through the window frames.

Day 3

The third day was devoted to two rather different areas near the centre of the city. In the morning I walked south, through the main shopping area, up to the rising ground at the southern end of the peninsula. I concentrated on street scenes in the shopping district, working from pavements, pedestrian traffic islands and from windows of flanking buildings. As I moved further south, the streets became less interesting than the buildings and I turned my attention to architectural details and some particularly fine churches such as St John's and Mikael Agricola. From vantage points along the waterfront I was able to shoot pictures of the docks and chose a section of elevated road to get views that I knew I would be covering later in the opposite direction, by sea.

Helsinki: The Sibelius Monument, a view skywards through the sculpture using a fisheye lens.

To the north of the city centre, the railway divides the town into two and I chose the area east of the rail tracks with its public park, lakes and fountains, for my afternoon's work. As the ground rises slightly to the north, I was able to obtain complementary views of buildings to the west that I had photographed the previous day.

Day 4
After a day of foot slogging, I decided to take it easy and booked a half-day coastal cruise which would enable me to see the town from the open sea and also allow me to get shots of the off-shore islands and the suburbs along the coast. Before I embarked I found a tall building near the harbour which I guessed would afford good views of the nearby market, the President's Palace and Senate Square. Helsinki's two cathedrals would also be visible from the same position. I persuaded the building's caretaker to let me go on to the roof and arranged to go back in the afternoon when the sun would be more favourable for some shots and when I could photograph the market as the stalls were dismantled and the cobbled roadway was swept clear.

I exposed nearly 200 frames on the brief cruise, having carefully selected a position on deck at the stern of the small motor vessel. I felt that this would be the most advantageous viewpoint because it would give me more time to compose my shots. Quite apart from Helsinki's nudist beach there was plenty of interest to photograph!

Back on shore in mid-afternoon, I still had time to return to the office block I had used in the morning and also to work my way along a further stretch of the eastern waterfront.

Day 5
I wanted to include at least one suburb in my collection of photographs and I chose Tapiola. This 1950s *garden city* typifies much that has brought international acclaim to Finnish architecture. Because the day was almost totally cloudless, bright light served to highlight the colour contrasts, especially between the white buildings and the dark and light greens of their natural settings. As usual I sought out a high building, it was a rooftop restaurant in this case, to give me commanding views over the suburb before I set to work on ground shots.

I had also chosen Tapiola because my map

Helsinki: Apartment blocks in Tapiola. Exploiting perspective.

showed me that I could get my driver to make a circular trip, out along the coast and back around the bays which are characteristic of Helsinki's shoreline. Two particular subjects I wanted to photograph on the return journey were the Sibelius Monument and the Olympic Stadium. Described as 'a symphony of welded pipes', the monument does not sound like an especially attractive photographic subject. In fact, it is, because the pipes not only form a most intricate pattern but they are also highly textured and shine like polished silver. I experimented with shots from a variety of angles and positions, my favourite now being the shot I took lying on my back looking up through the hollow centre of the monument.

Day 6
Before the sixth day, I went through the notes that I had prepared prior to my arrival in Helsinki and which I had annotated further during my stay. I found I was still short of some shots I had hoped to get. Some of these were notable buildings in districts I had not visited, others were shots of the

human interest variety which I had failed to observe. A third group were subjects which I could have photographed but had considered the lighting sub-optimal.

I felt I would like to make this the last day of my visit as I had a provisional seat on a flight the next day and pressure of work called me home. Accordingly, I hired a taxi for the day and, armed with my street map and notes, drove from subject to subject, viewpoint to viewpoint, on a route designed to minimise the distance covered and to enable me to arrive at a particular subject at what I had decided would be the best time of day.

By the time I returned home the following day, I had added about 1 500 pictures to my library stock of photographs.

BOMBAY: A THEMATIC VIEW
After spending some time in north-west India, I flew from Delhi to Bombay to spend a week in the city. My aim was to add to my Indian Cities

Bombay: Photographed from a footbridge, a squatter's home alongside the track.

collection but also to obtain some specific photographs of housing conditions in the town for *Shelter and Subsistence* (Macmillan, 1976) which I was writing at that time.

No one Indian city is like any other and I felt I needed a local guide. I visited the Architects Department of New Bombay and was lucky to be offered the help of a young town planner who was given leave to assist me for just two days. I explained my objective to him: to collect a series of photographs illustrating contrasts in living conditions in the town.

I worked full time for the two days on this project but I found I still needed to fill in one or two gaps in the days that followed. I asked my guide to draw up a plan of action along with our driver and this he did, working from my notes and suggestions regarding the sorts of location I had in mind. His job was to make practical reality of my theory. He had lived all his life in Bombay and knew it well.

For forty-eight hours, or at least when it was light, we drove round the city from site to site, modifying the plan as we went. Modifications were needed on two main counts. Firstly, some of the locations were, in my judgement, not photographically *right*. Access was difficult or we arrived at the wrong time of day. In other cases, not surprisingly, my notes had proved inadequate or my guide had not interpreted my instructions correctly. It was impossible to avoid a considerable amount of double-tracking, covering some of the major roads time and again as we threaded our way through the traffic to my guide's next location.

We worked through an amazing range of lifestyles, even by Third World standards. We could not work to any logical sequence of subjects but allowed accessibility and geography to dictate our route. This made my notes especially important as we ticked off subjects as I recorded them on film. There were few photographic problems with higher class housing. Luxury appartment blocks on Malabar Hill or middle income housing in the Phanaswadi district could be approached for photography in much the same way as buildings in any urban community. Greater difficulty occured at the other end of the social spectrum.

Bombay: Home is where you make it. Here it is in unlaid sewer pipes.

Bombay has a very acute housing problem with a continuous influx of newcomers, arriving in the city to seek work. Street sleepers and shanty dwellers have infiltrated into almost every district. Alongside my hotel, with its bars and restaurants, hundreds of families had made their homes in a large squatter colony of wood and canvas huts, occupying a site cleared for development.

With such simple homes a much more sensitive approach was necessary. In my case I stood well back from the subjects and photographed the tumbledown homes through a telephoto lens, not wishing to embarrass their occupants who often were cooking or engaged in some other task outside the shanty. If I needed to get in closer to the subject I asked my guide to seek permission and I spent a little time talking with the people before taking any shots. So great was the variety of improvised homes that I quickly added to my list of objectives the specific job of photographing *types* of shanty dwelling. In the two days we worked, I was able to photograph people in all manner of strange homes, from a family living in a hollow tree to numerous families whose dwellings were unlaid sewer pipes. The sites showed extraordinary ingenuity and emphasised the dreadful shortage of space in the town limits. We found people living alongside the railway tracks and even one small group of squatters who had taken over one side of a stretch of dual carriageway.

For many, of course, home was where you laid down in a doorway or alongside a wall and, on the second day, we went out early to photograph the street dwellers while they were still asleep on the pavements of the city.

In every case, from the high rise modern apartment blocks to the doorway homes, I tried to compose the frames to put the dwelling in the context of its setting. In many instances, it was possible to emphasise the contrasts I wanted to record by including in a single shot two quite different sorts of home. At the southern end of the peninsula, which is Bombay's site, I was able to photograph people living under canvas with a distant background of skyscrapers. I used a wide-angle lens for these shots, partly to improve the depth of field but also to make the skyscrapers appear more distant than they really were. This allowed the picture to suggest how remote were such fine buildings from the poverty of the shanties.

Working with transport readily available and with time very short, there is always a temptation for the travel photographer to become less than careful in his choice of viewpoint. On this occasion,

I tried to spend as much time as I could afford wandering around each subject in order to familiarize myself with its setting and to look for particular vantage points. In the case of the shanties built beside the railway, for example, I was able to find a footbridge which gave me views of overcrowded trains running within a metre or so of the squatters' huts. Near the Central Railway station I found a boy asleep on the pavement. Waiting until passengers began to leave the station, I angled my camera to show the boy surrounded by just the feet and legs of the passers-by.

At the end of the two days' non-stop work, in temperatures often over thirty degrees Celsius, I was exhausted but more than satisfied with the range and quality of the photographs I had obtained. Without my guide, and without a vehicle, such an assignment would have been almost impossible. The ever-present car allowed me to carry the minimum of equipment on my person and to keep my film and spare cameras and lenses in a shady place inside the vehicle. Film changing and record keeping were relatively simple in the comfort and security of the car. More than that, I had made a new friend, my guide, whose help I was able to repay, when he left India to study for a higher degree in Europe.

FJORDLAND

Some of the most spectacular scenery in the world is to be seen in western Norway. In many ways it is the travel photographer's dreamland. High snow covered mountains, deep majestic fjords, lakes and forests, picturesque villages ... all one needs is plenty of natural light and not too much rain. I was lucky. With the objective of collecting some three or four thousand marketable colour transparencies, I spent five to six weeks in the west of Norway with hardly a drop of rain and temperatures breaking all-time records for the area. Luck does sometimes look on the travel photographer.

Because I knew much of the area from previous visits, I was able to plan my route to take me through as varied a landscape as possible and to include specific locations I wanted to shoot in. I was working with an assistant, using a car and camping to allow for a very flexible programme. I could not guarantee the weather in advance and I expected to have to vary the schedule according to conditions. As it happened, this was not necessary and I made the trip a very leisurely one.

It is always comforting to have your own vehicle. There need be no restrictions on the amount of equipment that can be carried, and

Fjordland in reflective mood.

record books, small tape recorders and other impedimenta are easily stored. More important than that, maximum mobility allows one constantly to make changes in the programme, to go back to a location when the light is from another quarter, or even to vary the viewpoint quickly if need be.

The plan was to work out of Bergen and then travel on a roughly anticlockwise route to take in two major fjords, the Hardanger and Sognefjorden, to spend some time in the area of Norway's second largest ice cap, Jostedalsbreen, to reach the western coast and visit at least one island and to include in the itinerary such specific subjects as the village of Lom and the famous hydro-electric plant at Vemork. All this was easily accomplished in the time I had set aside, and because the weather was kind, there was plenty of time for relaxation as well

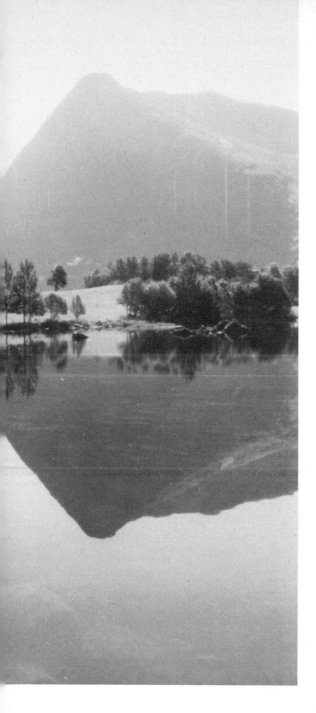

as to give mirror-like images or whether to wait until a breeze rippled the water giving more artistic effects. What proportions to give the subject and its image in the viewfinder was another question for discussion. So perfect were some of the reflections that it was possible to split the frame in half and the resultant transparency could be inverted without the viewer being able to tell which half was the reflection. Purposely, I often included some subject in close-up in the foreground just to emphasise the perfection of the reflected image.

Shots of fjords do not always do justice to their scale. A good viewpoint is essential, and that means finding a high position. With the Sognefjord this proved troublesome but in the case of the Geirangerfjord we went to the top of Dalsnibba where, from a height of nearly 4600 feet, we could look down into the waters of the fjord. Using a 400mm telephoto lens it was possible to take shots, not only of the fjord, but of mountain roads, massive screes and other features. Moving in closer to the fjord we waited for some activity on the water and were rewarded for our patience when a motor boat broke the calm of the surface with a perfectly formed V-shape wake.

I have a personal interest in glaciology and, with the thought that photographs of ice and snow sell well, I was determined to spend some time in the mountains of Jotunheimen as well as around the Jostedal ice cap. This forced us to abandon the car for much of the work and to walk and climb for our photography. A large scale map was essential and I had prepared a list of particular glacial features I wanted to shoot. Because movement was slow (there was even one quite large river to be waded) I allotted extra time to this project realising that my rate of shooting was bound to drop as I sought new subjects and viewpoints in quite difficult country. In addition to photography of the features I had listed and, as a matter of course, general landscape views, I added other subjects as I came across them: cotton grass reflected in small pools, lichens and glacial striations on rocky outcrops, and even rare glacial phenomena like the snow caldera we came across by chance. I carried my ice-axe, which doubles as a monopod, and this proved useful at times when I wanted to take technical shots of ice features and needed to put some indication of scale in the picture.

Because the Jostedal ice cap is so large there was little chance of covering more than just some of its edge on the ground. I decided, therefore, to go to Sandane and hire a seaplane. From the air it was possible to photograph not only the ice cap itself but also to get some excellent shots of the

as work. Using the excellent Cappelen road maps at a scale of 1 : 400,000 as well as larger scale maps, purchased as we travelled, daily planning was no problem.

Days of continuous bright sunshine gave us ideal opportunities to photograph the reflections of landscapes and other subjects seen in the waters of fjords and lakes. It became a subject for debate as to whether to photograph when the water was so still

Fjordland: The village church spire and gable ends match the geometry and shapes of the fir trees.

surrounding country including a number of locations we had already covered at ground level. With two of us operating cameras, it was possible to shoot from both sides of the light plane more or less simultaneously. This meant we did not have too much trouble with sunlight and there was no need to fly over the same ground more than once.

With brilliant sunshine every day, I felt I would like to spend some time in harsher weather conditions and these we found eventually in a high mountain valley, Mårådalen. Snow was still thick here and cold katabatic winds blew down the mountain slopes and funnelled into the valleys. Our tent had to be anchored with rocks and, in the mornings, the valley filled with icy mist and low cloud. From here I could shoot pictures which would contrast with the sunlit landscapes I had been photographing elsewhere, reminders that western Norway is not always quite so fortunate in its weather even in summer.

Fjordland: Photographed from the air, crevasses and ice-falls on the edge of an ice cap.

A WEST AFRICAN VILLAGE

I had been travelling around Ghana with a party of geographers. My own special interest now focused on research for a study of life in the north of the country (since published as *Town and Village in Northern Ghana*). Local information lead me to a small bush village, Datoyili, which was reasonably accessible and seemed an ideal place for my purposes. Because I was engaged in more than photography, I was able to spend a period in the village before I needed to get out my cameras. In this way I was already accepted by the people when eventually I started the photographic part of my work.

As always in these circumstances, I took out my cameras first and let them be seen, not as something through which I was looking at the people and their village, but just as other items of my equipment, like my notebooks and maps. When I started to shoot pictures I did so de-

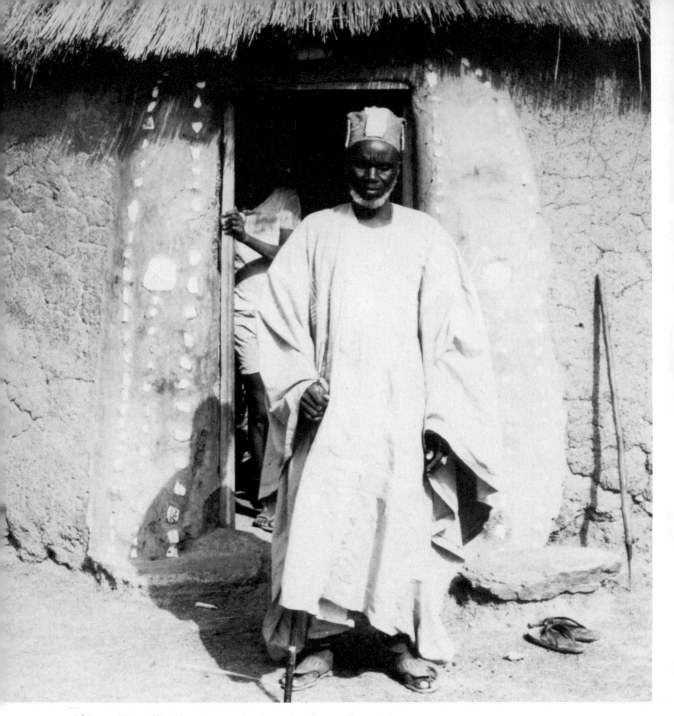

African village: The Headman was pleased to be my first subject.

liberately and openly. I invited the village chief to be my first subject, standing outside his round laterite hut. As explained in Chapter 8, this ploy rarely fails and I had no problems with either men, women or children from that moment onwards.

I tried to capture something of the daily life of the village. Women fetching water from the distant well, boys looking after the cattle, women and girls preparing the meals in the dry season *kitchen* in the open centre of the compounds of huts. Crops such as tobacco were growing around the village and various sorts of grains. Boys brought me other crops from the food stores and then showed me where they were growing.

Once established in the village, I could move

African village: Inside the compound they were threshing millet.

freely, even into the huts and compounds. My electronic flash had apparently suffered from heat stroke (it was 35° Celsius or more on most days) I had to make do with time exposures in available light once inside the tiny huts. As these had no windows and only rather small doorways, I had to choose my viewpoint with care in order to avoid over-contrast between the bright exteriors and the shadowy interiors. I was pleased to see how clean were the huts. No furniture but infinitely more hygienic than the bug-ridden room I had been occupying in the nearby town of Tamale.

One common feature of the village was the subject of a series of photographs. This was the typical round hut which formed the one and only type of building in the settlement. Walking round

African village: Boys brought me crops and took me to where they were growing.

the compounds I found huts in various states of building and disrepair. By selecting my shots from a number of sites, I was able to make a collection of pictures to illustrate the structure, fabric and method of construction of the huts.

I thought it important to include shots of the village's setting and spent some time in the dry bush which characterises that part of Ghana. By moving round the village, but some 200 metres or so from it, I photographed the groups of huts as seen through the savana grass and woodland which surrounded them. I went, too, with the women on their twice daily treks to a well which they shared with another village. They pointed out features which lay away from the well-worn path and which might easily have escaped my notice. Massive termite mounds, quaint thatched food stores and a deserted mission chapel were subjects for the camera. There is no doubt that if one is prepared to follow people as they go about their everyday tasks, unique photographic opportunities will occur. Such practice also helps the photographer to be more readily accepted.

With communities like that at Datoyili, a rich source of subjects is in their material culture. Among the items I found worth photographing were an old piece of railway line being used as an

anvil, mortars carved from tree trunks and handmade hoes. Some of the families had decorated the lintels over their huts' doorways with pieces of broken crockery set into the mud. These coloured fragments of plates, cups and saucers, contrasted with the dull red-brown huts and were ideal subjects for colour photographs. As usual, I took both close-up and general shots. Close-ups give the detail necessary for technical photographs and the general, or context, shots show the use or setting of the subject.

As luck would have it, while I was in the village there were calls from two itinerant tradesmen, a barber and a blacksmith. They were most impressed and flattered as they enthusiastically consented to being photographed at work.

As part of my study, I wished to link the village life with that in the neighbouring town, Tamale. I already had shots of the town's markets and I now looked for subjects that would make the connection and interdependence clear. I chose pictures of produce being prepared for market and then followed the women down to the road and photographed them surrounded by their wares, as they waited for the mammie wagon to take them to sell their goods in town.

By the time I was due to leave Datoyili, I not only

had a satisfactory photographic record of the people, their way of life and their homes, but also, I felt, I had made some new friends again. This is what travel photography should be.

SINGAPORE PORT

I was on my second visit to Singapore, having flown in from Sarawak. I had a considerable collection of photographs of the city and of the island. All the classic locations and subjects were already on film, Raffles statue and Raffles hotel, China Town, smart shops in Tanglin Road and the night markets. I had been out to the new developments at Jurong and to the incredible housing estates. I had travelled along the Straits of Johore and into the interior of the Island. What was missing from my collection? The answer was all too obvious. The whole of Singapore's thriving economy rests on its trade and trade means the Port of Singapore.

To obtain a permit to enter the port I needed to visit a police station. After a few questions and telephone calls, arrangements were made. During the negotiations I continually stressed that I did not want only to look around but to take photographs. This is always important because a permit to enter but not to photograph will be of little use to a photographer.

The main port of Singapore is concentrated around Keppel Harbour and, at the Port of Singapore Authority's offices there I was given a guide for the day. He was a clerk in the offices, knew his way around the port, spoke good English and was a pleasant companion. Before I left the offices I asked if I might photograph some of the notices on display which laid down the rules for the length of a man's hair! The most amusing was one over the enquiry desk, a picture of a man with collar length hair carried the warning: 'If you look like this we will serve you last'! Notices and advertisements are wonderfully expressive of the contemporary scene.

For a day I walked the port. With temperatures always in the thirties Celsius, it was an exhausting business but my permit was strictly for a single day. I had a plan of the dock layout and had already decided to work from west to east, from the shipyard area, along the main wharves and docks, across the container port and to finish with the small boat harbour at Telok Ayer.

Singapore Port: The quaysides were always active.

Singapore Port: Container crane, a detail.

I tried to divide my attention between ships tied up along the marginal wharves and in the dock, subjects on the quaysides and activity off-shore. Photography of large ships at close quarters poses the same problem as tall buildings or mountain landscapes. It is largely one of perspective. Of course, it is easy to emphasise the size of a ship by using a viewpoint near the bows, shooting with a wide-angle lens and producing a picture of a ship which appears to be about to mount the quay but which tapers away to a very small stern. Some such shots are effective but it must not be overdone.

To obtain more natural perspectives, a viewpoint at about deck level is needed and this is especially so for a line of ships along a wharf. If access to a ship can be had, it is possible to shoot other ships in the same line but to the exclusion of the ship one is aboard. This is not really satisfactory. I found, as elsewhere in other ports, a far better viewpoint is a perch on the gantry of a crane. With one arm securely wrapped around the vertical iron ladder I am standing on, I can

photograph from almost any height up to the crane driver's cabin. Here I had to use unmanned cranes but there were plenty of these. For some shots I would have preferred to use the roof of a transit shed or go-down, but there seemed no way up. My crane viewpoints gave rather acute angles to lines of ships but not so acute that a standard lens could not be used effectively. Beyond the wharves, the Keppel Control Office provided another elevated viewpoint and, still further east, I used the giant container cranes for the same purpose.

From the quayside I used a telephoto zoom lens for shots of lighters at work in the harbour, ferrying goods and men from ships anchored off-shore. None was too far away to need a focal length greater than 210mm and the zoom allowed me to compose my shots more freely than had I been using a fixed focal length lens.

The telephoto lens also came into use in photographing details of ships and ship activity along the wharves. It is remarkable what wonderful pattern photographs can be had by looking out

for what might be described as *engineering still life* subjects.

Singapore is a very busy and efficient port so there was always something going on to provide activity photographs. I paid particular attention to freight being loaded and unloaded. Many of the crates had some description of their contents and some raw materials were without any cover and easily identifiable. Shots of imports and exports help to build up a picture story of the port. Some of the best action photographs can be taken as the cranes release their loads, allowing them to spill into an open hold.

The large container port, out on East Lagoon, was as active as any other section and, working in colour, I was pleased to find the great metal boxes in every hue of the spectrum, including lots of reds to warm the heart of any picture editor. I took a series of shots here to illustrate the operation of this side of Singapore's trade: containers lining the decks of the colossal ships, being off-loaded by cranes, transferred to straddle carriers and being stacked or loaded on to waiting trucks.

There was no afternoon rainstorm that day, unlike so many others I had experienced in Singapore, and I was able to work uninterrupted. Light was good but shadows were deep, especially around midday. I found I was constantly seeking new positions from which to photograph. Until mid-afternoon, I attempted to reduce the contrast between well lit and shadow areas by using reflective surfaces to fill some of the shadows. If I could not find such a position, I looked for field angles which cut the shadow to a minimum or where I could make some creative use of it. There was a little thin cloud and, despite my tight schedule, I was prepared at times to wait until the sun was just masked and I could photograph in more diffused light.

By the end of the afternoon I was feeling pretty exhausted. My guide, who was carrying my equipment case, had taken the precaution of slipping into the nearest shade every time I was engaged in shooting. He was beginning to look at me as though doubting my sanity as I stood in the sun to get yet another shot. Fortunately, my last location, the Telok Ayer Basin, provided me with enough tempting subjects to give me renewed strength. The harbour was a magnificent jumble of assorted tugs, lighters and junks.

My guide refused the offer of payment for his day's labours so I took my last photograph, his portrait, and agreed to send him an enlargement when I got back home. Before I left the port, I managed to arrange with the authorities to take a trip later in the week in the Harbour Master's boat so that I could photograph the port from off-shore. These photographs, together with some aerial views I had already shot on a previous visit, completed my record.

VILLAGERS IN MALAYA

I was working my way up the China Sea coast of Malaya when I came into the small town of Kuala Tregganu. The town itself was attractive, completely unspoilt and with a delightful tropical beach. At various times during the day, small fishing boats would put into the harbour and the fishermen off-load their catch. This done, they repaired their nets and generally set about getting their fish to market.

The fishermen, as photographic subjects, fascinated me and I spent many hours around the shore recording their work and taking group and individual shots. After a while I realised that some of the boats did not stay in the harbour but went up the estuary almost fully laden. With a fellow photographer, who was travelling with me, I made enquiries and found that there were a number of villages up river where the fishermen lived, making a living from the land as well as from the sea.

A few more enquiries and some protracted negotiations led to an agreement with a boat owner to ferry us up the River Marang to one of the jungle villages, Kampong Tengah. Next day we embarked on our voyage of discovery.

I had two aims in view. One was to make a study of the economy of the village (since published as *Kampong Tengah, a Malay Village*) and the other was to concentrate my photography on the people of the village. I was keen to get more studies of the Malays of the east coast.

Photography started immediately I climbed into the boat. The fishermen share the use and costs of the boats and the catch is divided amongst them in proportion to their investment. The sharing of the catch made my first subjects. I shot from the bows of the boat with the sun behind my shoulder and plenty of light directly from the sun and reflected from the river waters. The men took no notice of me and I was able to obtain completely natural photographs.

As we made our way up river, through the jungle of casuarina forest, we pulled into the banks several times allowing some of the fishermen to leave us and return to their villages hidden in the forest. Their fish carried in buckets, they made off through the mangrove and disappeared from view. These departures, and shots of people in passing

boats, made more subjects for my cameras. The light was very strong so I was able to use fast shutter speeds to eliminate vibrations from the boat but, at the same time, make a choice of apertures to vary the depth of field.

When at last it was time for us to disembark, we paid off the boatman and began to walk to the village. The route led first through jungle and then over more open ground, cleared for agriculture. It was here that I was able to resume work.

Most of the fields were given over to padi but were fallow at this time of year. The bunds (banks) between the fields were used as pathways linking the villages to one another and to the river. Now, and later, I was able to take shots of people as they walked between the fields or under the shade of trees that had escaped the farmer's axe. I preferred photographing in the diffused light which filtered through the trees rather than in the harsh, contrasty sunlight of the open fields. No one seemed to object to being photographed, nor were they embarrassed by finding a total stranger in their midst.

In the shade of a tree, I would wait until I saw someone or a group approaching, wave to them and show my camera, and then begin to compose the shot. Really, it was too easy. I knew precisely which direction they would take, because they were unlikely to leave the path. As they were walking towards me, a fast shutter speed was not necessary and I used a zoom telephoto lens to vary the composition of the frames I was shooting. The only problems occured when the villagers decided I would prefer them to stand still and pose, when I wanted them walking naturally and without paying any attention to the camera.

From these viewpoints I photographed women with painted sunshades, boys with baskets of fish and family groups on their way to neighbouring villages. Almost every person or group was distinctive in some way or another and a new subject was created.

Malay village: Fisherman returns with his catch.

Malay village: When he came down he presented me with a refreshing coconut.

Malay village: The village sugar 'factory'.

In the fields around the kampong I was disappointed that there was so little activity. It was the wrong time of the year for much farming. However, there were some villagers drying rice in the sun and the most charming group I took consisted of a grandfather, mother and three small children. I felt these shots ought to show something of their activity and I balanced the composition between the people, the grain and the background of dark trees.

It was when outside the village that I again was struck by the importance of looking upwards for shots. By chance, I glanced up into the trees (I think my attention was attracted by the cry of a bird) and was startled to see two elderly women sitting about ten feet off the ground on a platform built in the branches. The only satisfactory viewpoint was partly back lit by the sun. I could see thin cloud moving across the sky so I waited for this to cover the sun before I took a shot. My waiting was doubly rewarded because the women were no longer looking at me but gazing unconcernedly into the distance. Quite what they were doing there I shall never know. Perhaps they are there still.

Most of my work was, of course, in the village. I made myself known and accepted the offer of a guide who spoke a little English. It was one of the most welcoming and happy places I have ever visited. Not all of my time could be devoted to photography but I seized every opportunity that offered itself to build up a collection of shots of the people and their way of life.

Because the village was set among trees, my biggest problem was light. I found that, contrary to my usual practice, I was shooting a great deal of film around noon. The reason was quite simply that only then was there sufficient natural light. But I had to be careful to get my subjects into such a position that shadows could be exploited for modelling rather than exaggerating their features. With such willing and co-operative subjects, there was no difficulty in arranging shots to this end.

Any village is likely to provide a rich potential of subjects as its people go about their day to day tasks, and Tengah was no exception. I varied my compositions and styles from portrait-type shots of individuals, especially children and old people, to studies of them at work or play. The former often

required time and effort to arrange while the latter had to be shot as the opportunity occurred.

Sometimes a shot would be rewarding in more ways than one, as when I photographed a man climbing a palm tree and he brought me down a magnificent coconut, cut it open and presented it to me. I can still remember how cool and refreshing was the drink in the scorching heat of an equatorial sun. The village store, a small sugar 'factory' and a basket making workshop were some of the village locations which provided action shots, but by far the most productive site was the village primary school.

I decided I would use available light in the classrooms. Typically Malayan, the children were

smartly dressed for school and well behaved! The only trouble I had was deciding how to use the light. It was, it seemed, always bright outside the school and shady and cool inside. The lighting contrasts were very marked. I decided to bracket exposures but accepted that the open windows and doorways would suffer burn-out, at least to some degree, if I was to expose correctly for the interior. I wished I was working in black and white rather than in colour, for then I could have corrected exposure in processing.

I did not want to disturb lessons unnecessarily so I made my preparations outside the rooms, staying in the classroom only long enough to shoot a few frames and to talk to the teachers. In fact I doubt if

they would have minded if I had spent a whole day in each class.

Luckily there were some groups of children always being taught outside the building under the shade of trees in the school grounds. Light was no problem here and I complemented my interior shots with some outdoor work.

When the time came to leave the village I was sorry to go. As I have written elsewhere, 'the people were some of the most friendly and warm hearted I have met anywhere in the world'. They enabled me to obey that golden rule for all travellers taking photographs of the people they meet: that they should be seeing friends in their viewfinders.

Index

(Note: Subjects marked * are referred to throughout the text and only selected entries are shown below)